PRACTICAL GUIDE TO
PAINTING

D1413226

PRACTICAL GUIDE TO
PAINTING

Vicenç B. Ballestar
Jordi Vigué

WATSON-GUPTILL PUBLICATIONS/NEW YORK

FIRST PUBLISHED IN THE UNITED STATES IN 2002 BY
WATSON-GUPTILL PUBLICATIONS,
A DIVISION OF VNU BUSINESS MEDIA, INC.,
770 BROADWAY, NEW YORK, N.Y. 10003
www.watsonguptill.com

ORIGINAL TITLE: GUÍA PRÁCTICA DE LA PINTURA
© 2002 GORG BLANC, S.L.
VIA AUGUSTA, 63
08006 BARCELONA, SPAIN
www.gorgblanc.com

LIBRARY OF CONGRESS CONTROL NUMBER: 2002108956

ISBN: 0-8230-4089-5

IDEA AND CONCEPT: JORDI VIGUÉ

EDITOR-IN-CHIEF: VIRGIN STANLEY
PAINTING EXERCISES: VICENÇ B. BALLESTAR
COLLABORATOR: MYRIAM FERRÓN
PHOTOGRAPHS: ESTUDI ENRIC BERENGUER
PHOTOGRAPHIC ARCHIVE: ARCHIVO GORG BLANC, S.L.
PHOTOGRAPHIC COLLABORATIONS: JORDI VIGUÉ,
VICENÇ B. BALLESTAR, PHOTO STOCK
GRAPHIC DESIGN: PALOMA NESTARES
PHOTOGRAPHIC DOCUMENTATION: ALBERT MUÑOZ
PUBLISHING COORDINATOR: MIQUEL RIDOLA
TRANSLATORS: BI-CULTURAL

MODELS: JOSEP COSTA, MONTSERRAT PLANELLA, SERGIO W. HURTADO,
M. DEL PILAR DOMÉNECH, ALEJANDRA BARRA,
SÍLVIA COROMINES, RENATA BRAHIM, VERÓNICA BLANCHET

PRINTED IN SPAIN
GRÁFICAS IBERIA, S.A., BARCELONA

1 2 3 4 5 6 / 07 06 05 04 03 02

Painting is an extensive field, a broad discipline open to all kinds of possibilities. *Practical Guide to Painting* presents traditional themes of fine art along with a presentation of the diverse techniques for making it.

Technically, painting has its traditions, styles, tricks, and craft, all of which require extensive knowledge. This allows the composition to be balanced, have the correct perspective, display harmonious colors, and be an integrated whole. As important as this knowledge is, it is not enough. For a painting to be not only technically accomplished, but also a work of art, an artist must give it a quality that is unique and impossible to reproduce.

An artist is someone who sees reality in a different way, perceiving it in a particular form, feeling it in a specific dimension, and transcribing all this with his or her own personal identification on canvas. That is why all artists manifest themselves through their work, learning about their feelings, and opening themselves up. This makes painting a kind of sacred ritual through which the true artist opens the door of his sanctuary and reveals himself.

This book will undoubtedly provide basic knowledge of painting techniques and the principles on which they are based. Additionally, however, the book offers someone who knows technique how to become a true artist. To accomplish this, the reader is shown an approach by following the guidance of the artist, Vicenç B. Ballestar. Throughout his life, Ballestar has made painting a philosophy, a way of perceiving, of feeling and expressing himself. His paintings are never cold, synthetic, or prefabricated. Observing his work, it is instantly possible to discover the immense feeling that his colors and brushstrokes reveal. He is a very sensitive painter with a superb technique.

The objective of this book is evident. It provides a series of concepts and conveys a specific way of perceiving reality, not only to paint well, but also to be able to express oneself as an artist.

Jordi Vigué

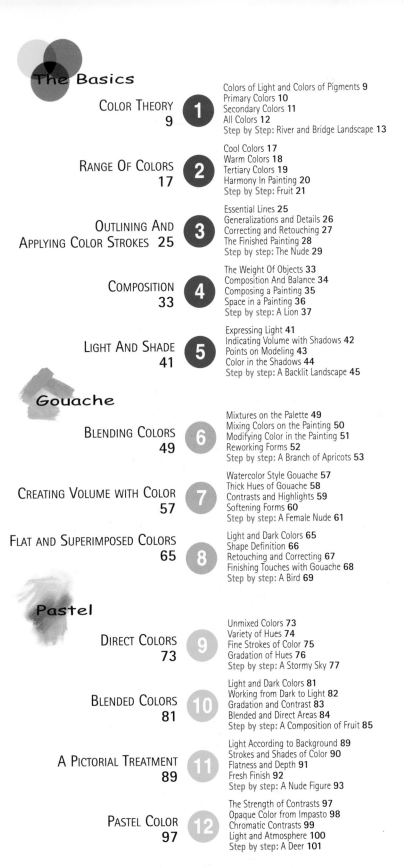

Watercolor

Oil painting

1 COLOR THEORY

 The Basics

COLORS OF LIGHT AND COLORS OF PIGMENTS

Photography, television, and computers are technologies based on light, which produces the colors of the spectrum. In contrast, the art of painting is a *representation* of light. The intention of the artist is to use pigments to mimic colors found in nature. The infinite varieties of colors of natural light derive from the mixing of rays from the spectrum; the result of nature's blending of bright blue, red, and green is white. In painting, mixing the primary colors (magenta, cyan, and yellow), results in a very dark hue, similar to black.

Color theory is based on the breakdown of white light into a spectrum of the distinguishable colors that compromise it. A rainbow is an example of this phenomenon. The rainbow acts as a prism that breaks down the light into the radiant colors that make up the light. Isaac Newton was the first scientist to observe and experiment with the breaking down of light. He filtered a small beam of sunlight through a slit intercepted by a prism and formed the colors of the spectrum.

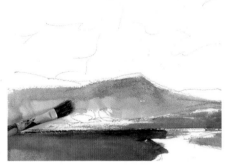

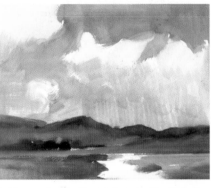

1. On a computer, hues are layered to obtain bright colors, but in painting, light is represented by either making use of the whiteness of the foundation, or by mixing white into certain kinds of pigment. To demonstrate this, the medium of gouache is used showing how to utilize the brightness of the paper to represent light.

2. The mountains are painted with diluted gouache, allowing the white paper to show through in the area of the stream. Then, the neutral colors painted on the sky create an atmospheric effect, which varies depending on the transparency of the colors. The white of the paper produces the brightest hues.

3. To finish the painting, contrasting hues are painted in the sky and clouds, as well as in the foreground. The two different procedures for obtaining brightness - either diluting the gouache for a transparent effect or mixing the paint with white - produce different results. White mixed with other hues always tones the colors down, and using diluted hues expresses the light reflected in nature.

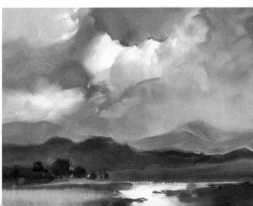

Primary Colors

The foundation for a painting is usually a square or a rectangle onto which an artist develops a representation of reality. With the beginning sketch, there is no need for a great deal of precision. Soon the composition begins to fit together; forms and complex elements begin to take shape.

1. In this painting of a landscape, the artist simplifies the chromatic complexity of nature by using only the three primary colors. To accomplish this, yellow is used for the sky; the mountains (creating a sense of distance) are painted in blue, and the land and foreground, red. The most concrete forms such as the path and the trees will be left the white of the paper.

2. Black is used to darken the elements and to create contrasts. Areas that change from light to shadows are simplified, just as the main colors were. Black is used to represent the grooves in the path and the darkness of the trees, so that their shapes stand out more.

3. To finish the painting, all of the areas of the composition are filled in. Blue completes the tops of the trees and, in combination with black, provides a clear sense of volume. By using only the primary colors and black, the artist has contrasted hues in the landscape.

SECONDARY COLORS

Secondary colors are those that result from mixing two primary colors in equal amounts. In painting, secondary refers to orange-red, violet-blue, and green. Red is a color that results from mixing yellow and magenta; violet is achie-ved by mixing cyan with magenta; and green from the combination of blue and yellow. If the proportion of primary colors used is not equal, the result will be oranges, blue-greens, violets, etc., which are not *pure* secondary colors.

1. The artist further develops the previous exercise by adding secondary hues to enrich the color of the landscape. Green tints are added to the treetops and to the esplanade in the left margin. Because green is one of the colors most common in nature, this new hue results in a more realistic image.

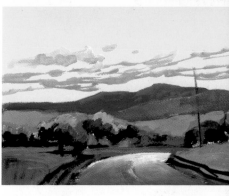

2. Violet is added to the sky to outline the clouds, providing a strong contrast with the yellow used in the background. Then the artist applies white to tone down the hues. In the pathway, the white blends with black to form gray.

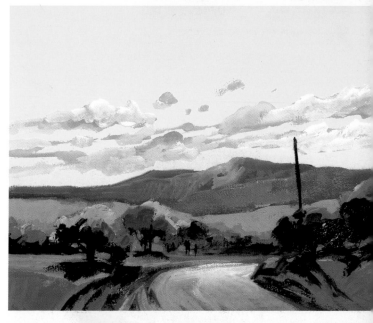

3. To finish, green is added to the trees and to the esplanade on the right. By mixing green with other hues, the white applied earlier is toned down. This creates a sense of volume in the clouds, trees, pathway, and distant mountains.

ALL COLORS

The color wheel shows all of the possible variations using the three primary colors. In the divisions of the color wheel, secondary colors are found between each of the primary colors. The more the circle is divided, the more colors that can be orserved. If white is added to the combinations to brighten each hue, or black is added to darken each one, the palette be-comes practically infinite. The working principle is that the primary colors can be mixed to form all other colors. The richness of a palette lies in the painter's ability to create mixtures of colors from the color wheel.

1. This new landscape exercise incorporates all the combinations necessary for a naturalistic image. Various proportions of yellow, blue, and black are used for the trees to achieve the variety of greens that appear in nature.

2. Green and yellow hues are progressively used throughout the painting. The greens reflected on the water and in the bushes are subdued with a small amount of black, giving it a brownish aspect. Black also shapes the volume of objects and the forms contrasts in the reflections on the water.

3. Adding the principal details completes the painting. Vertical brushstrokes of brown and orange imitate the tree trunks. In the foreground, gray brushstrokes reinforced with black form the rocks. These finishing touches create contrasts and help define forms.

River and Bridge Landscape

MATERIALS

Drawing paper, Graphite pencil, Gouache colors, Synthetic brushes of various sizes, Water container, Paint rags

To paint a landscape, an artist must understand nature and be able to emphasize the senses of color, light, sound, and smell that all humans experience. Even though only visual effects can be represented pictorially, the artist's other play a part in the spirit and atmosphere of a painting. Because of the strength of light and color, landscapes constitute the best subject for learning to fully value hues.

Step 1. The artist begins the composition by quickly sketching an image, distributing the majority of the elements in the upper left hand portion. Lines are drawn to define the trunks and treetops. On the right, which contains more blank space, only the path approaching from a distance is drawn.

Step 2. Color is applied to large areas, covering up the white of the paper. The sky is a mixture of blue and white, with violet added for painting the areas that border the horizon. This gives the impression of distant vegetation. The same hue is used for the extension of the path on the right.

Step 3. Now, green is painted into the grassy areas. Green toned down with white is used for the area of grass on the horizon to create a sense of distance. In the middle ground, however, a pure, unmixed green is applied to make it appear brighter. Two hues can be distinguished in the trees, light grayish hues outlining the thinner trees and a very dark green hue on the leaves of the thicker, more leafy trees.

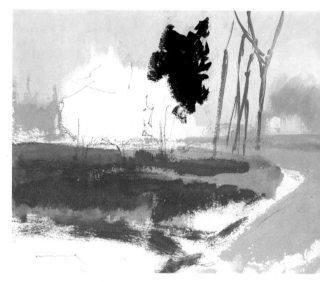

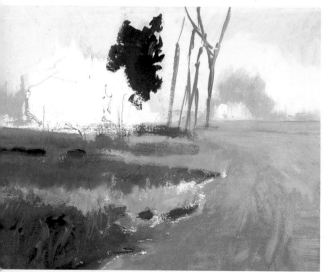

Step 4. The foreground is completed by continuing with the same hues used in the middle section. On the left side, black is used to darken the grass and to indicate the shape of the terrain.

Step 5. Several trees in the distance are outlined with gray. Adding pale orange to the background and a denser orange over the grass gives variety to the hues. The tops of the trees in the center are filled in with dark green. Be-cause of their position and color, the trees dominate the scene.

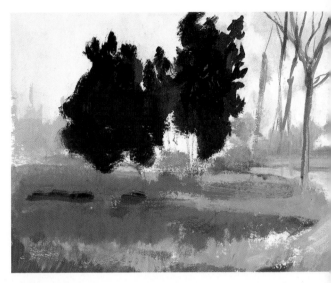

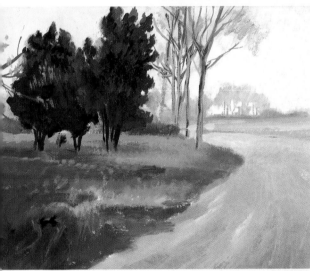

Step 6. The leafy trees are toned down by adding lighter greens over the dark green; the contours of the trees, as well as their trunks, are set off with black. Branches are drawn on the left side using a gray hue, and the same gray is used to define the higher branches on the slender trees close to the path.

Step 7. The form and dis-tribution of the dark tree's leaves are meticulously defined by incorporating new green hues that give the trees a better sense of volume. Brushstrokes of this hue are also included on the thinner branches in order to indicate the presence of leaves.

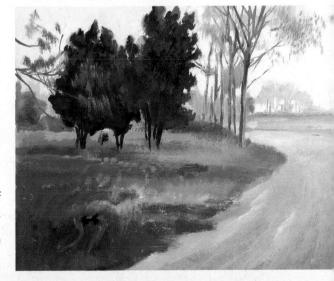

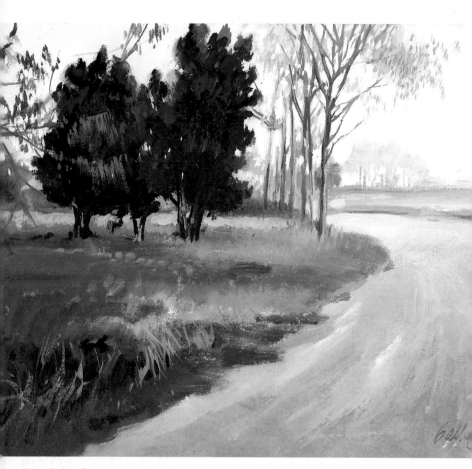

Step 8. Finally, using very fine brushstrokes, warm colors are added to the grassy area and on the tree trunks, giving variety to the general coloring and making the the grass in the foreground brighter.

Summary

• The colors of light behave differently from colors of pigment, which an artist uses to imitate nature's characteristics.

• Primary colors are pure color; in other words, they cannot be created from any other color. At the same time, they provide the basis for forming other colors; combining them yields other colors.

• The primary colors of light are dark blue, red, and green.

• The primary colors of pigment are cyan, magenta, and yellow.

• All other colors are derived from the three primary colors plus white and black

• Color theory is based upon Newton's experiments to break down sunlight into the colors of the spectrum.

• In painting, mixing equal proportions of each of the primary colors results in secondary colors, in other words, red (with yellow and magenta), violet blue (with magenta and blue), and green (with blue and yellow), corresponding to the primary colors of light.

COOL COLORS

Blue is the coolest color, although green and violets are also considered cool colors. The amount of blue in a color determines the coolness of the hue; the bluer a hue is, the cooler it will be. In the color wheel, the colors closest to blue form the cool colors. Not all greens and violets are considered as cool, however. If warm colors are part of the makeup of the green or violet, the less cool they will turn out to be. Yellowish green tones, or other warm tones mixed with violets which are very close to red in color, will be warm.

Colors can be divided into a variety of hues within the color wheel. Cool colors range from blue to magenta, and warm colors from magenta to yellow. Cool colors have effect of creating distance, while warm colors result in a sensation of closeness. It is common to regard grays as cool colors and browns as warm, but this is somewhat an oversimplification. Generally, if a hue has a larger amount of red or yellow in its makeup, it will be warm. If the hue is bluish or lilac, it will be a cool color.

1. This still life will be used to illustrate cool colors. The shapes in the picture are outlined in blue, and the colors are then blended together. Notice in the yellow color of the first apple, the colors have acquired a very cool effect. The quickly and firmly applied strokes of color emphasize the cool blue color and give the fruit their curved form.

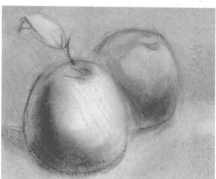

2. The tones are now blended to create a pastel-like color. Applying hues to fill in the apples brings out the importance of the blue outline. The first apple, which is very yellowish, appears cool when surrounded by greens. Now, violet, another cool color, is painted into the background.

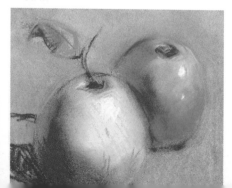

3. To finish the exercise, the artist paints the background with a violet hue. The blue outline, defining both the shape of the fruit and its projected shadow, has served as a reference for the composition and as a base for blending hues.

WARM COLORS

Warm colors produce a sensation of warmth and closeness. The warm palette includes yellows, reds, and oranges, as well as earth tones. Although ocher and brown are tertiary colors, the predominance of red and yellow in them make them very warm colors. The color of an object in nature is determined by the way it is affected by light. This means that according to the warmth or coolness of the light they receive, objects can appear to be predominantly cool or warm, and objects closest to the viewer are perceived as having warmer hues.

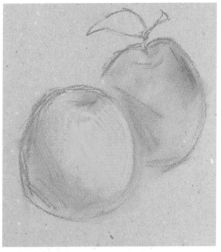

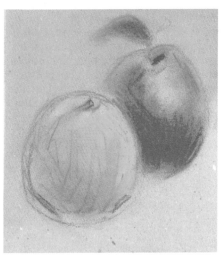

1. This exercise studies the effects produced by warm hues. The pieces of fruit are outlined in red, and the closest one is filled in with orange. Orange, a warm color made up of red and yellow, is the complement of blue.

2. The apple is painted with a deep red, applied more heavily in the shaded area and gradually thinner as it nears the lighted area. The background is painted with orange hues to give a warm sensation to the whole picture.

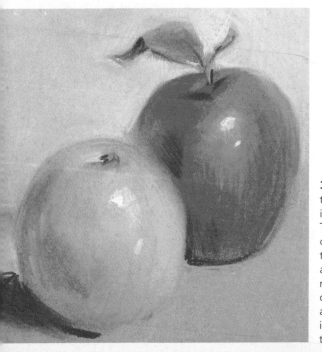

3. Pure orange, very similar to the color of the first fruit, is used for the background. The presence of the shadow at the lower left causes this color to stand out. Red and a small amount of blue reinforce the sensation of darkness. Now, the red apple is painted, and white is used to add highlights to the shapes.

TERTIARY COLORS

Brown and gray are called tertiary colors. These colors are obtained by mixing the three primary colors, but not in equal proportions. In grays, there will be a larger amount of blue, while reds and yellows dominate brown colors. According to the amount of one color or another, the resulting hue can be either sienna, which is quite red, or ocher, which is quite yellow. Adding black to pure colors is another way to obtain a variety of hues.

1. The artist creates a composition with fruit of various shapes and colors, drawing them with a reddish color. Then the base of the pomegranate is painted with an orange hue: Green and yellow are used to paint the fruit on the plate. When these colors are blended with their red outlines, the hues of the fruit will vary a great deal.

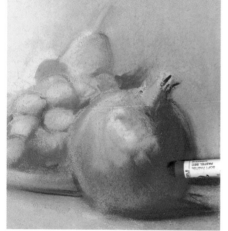

2. The pomegranate is given detail by adding brown hues, creating texture and causing a shadow effect. The hues of the grapes and the pear are blended to acquire green hues that are closer to tertiary colors, since they blend with the red that was previously used. In the background and on the plate, gray and blue are added forming new tertiary hues, but this time, the tertiary hues are cool.

3. The image is made more concrete by adding white to make both the pieces of fruit and the plate shine. In general, tertiary greens can be observed on the bunch of grapes. Browns are used on the pomegranate and for its shadow. A variety of gray hues are applied to define the projected shadows and to deepen the background.

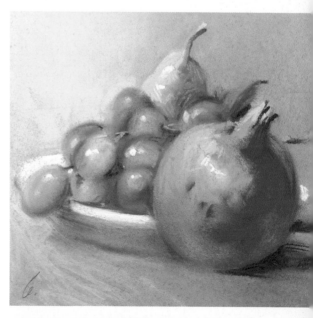

HARMONY IN PAINTING

An artist who understands the concepts of cool versus warm and primary versus secondary colors can use as many combinations to create a chromatic composition as desired. Using similar hues always creates harmony, while using opposite hues contrasts and complements them. An artist looking for harmony and unified atmosphere in a composition should know how to place each color considering the role each plays in relation to the others. To decrease contrast, hues opposite to each other can be blended so they do not stand out.

1. This still life will illustrate how different hues are blended together to form a whole. The pieces of fruit are outlined in red and orange. Yellows and greens are incorporated over these colors. For this composition, warm colors, which combine and harmonize perfectly, are used.

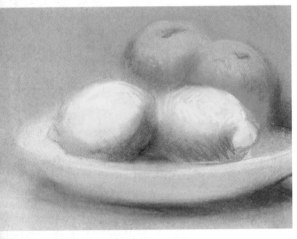

2. Now cool colors are added and blended well with the other colors. The background is shaded with violet, a color that blends well with the warm colored fruit. Dark blue, used for the shadows, is blended in well so that it doesn't stand out but simply gives the impression of darkness.

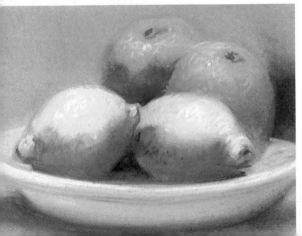

3. The hues of the fruit are darkened in the shaded area. The blue shadow now fits in well with the general darkness of the painting. In this demonstration, many warm and cool colors are used, but because they are blended in the correct way, they create a sensation of harmony.

Step by Step

Fruit

MATERIALS
Fine-grained Paper for pastels, Pastels, Paint rags

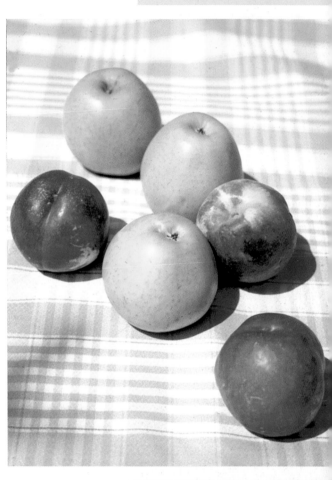

Spherical shapes cannot be indicated as simply as can flat objects. Even though rounded forms follow a light to dark gradation, the light and dark should progress in the same shape as the circular outline. A change in tone develops around the specific point at which the light falls on the sphere. The artist adds consecutively darker hues in circles until maximum intensity is achieved. When these hues are blended, the shape of a sphere is recognized.

Step 1. The artist uses pastel blue to sketch the scene, in which fruit is viewed on a tablecloth in perspective. The pattern of lines creates an awareness of the flat area on which the simple, rounded forms of the fruit are placed. The lines act as a guide to show the distances between the pieces of fruit.

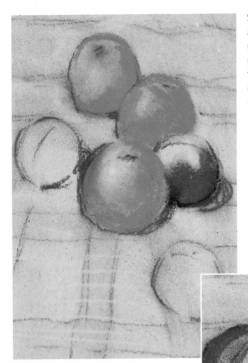

Step 2. The apples are painted green, and they begin to offer a hint of their volume, highlights, and shadows. One of the red apples is painted red at this stage so that the artist can see the effect of the contrast produced when the two colors, red and green, appear next to each other.

Step 3. The other apples are painted red, leaving the brightest areas of each one unpainted. In some areas yellow is added, since it forms part of the apple's shadow. The green apples are blended so that the foundation color of each is completed.

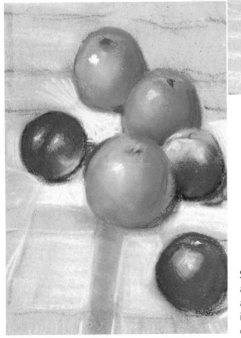

Step 4. The hues of the red apples are blended to reveal their volume and their texture. Some blending is done on the tablecloth to indicate the pattern of the squares.

Step 5. The artist continues to blend the plaid pattern of the tablecloth. In this way, atmosphere and unity are given to the whole composition. Then black is applied to reinforce the contrast of some of the fruit and to intensify the shadows that the fruit projects onto the tablecloth.

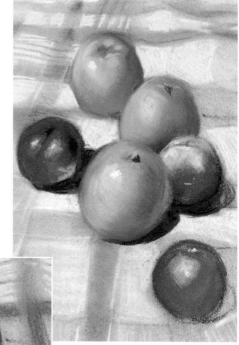

Step 6. The artist continues to work on the tablecloth defining the squares in more detail. In the background, the forms are blurred and less defined, giving the illusion of depth. In the foreground, the painting is given more detail, causing the image to appear to be closer.

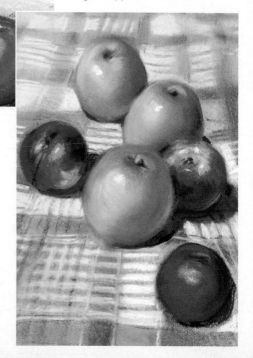

Step 7. The red apples are made to appear more solid, and contrast is added to certain areas. Black is used for the shadows and to create volume. It also serves to define the details of the areas in relief.

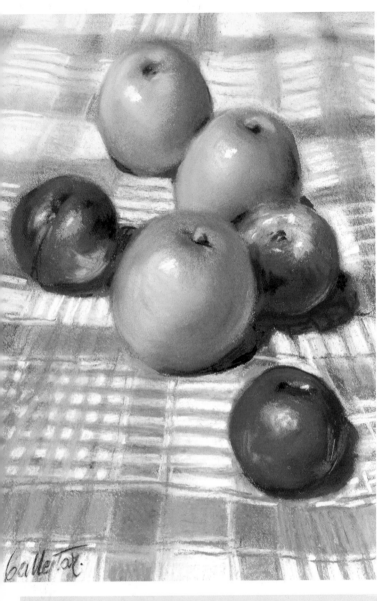

Step 8. The artist adds the last strokes of the brush to the painting. To complete the foreground, white is added to the tablecloth, and the small squares and lines that define the drawing are given finishing touches.

SUMMARY

• .The color wheel is a representation of the palette's colors. The more divisions that are made in the wheel, the more hues represented.

• Cool hues (containing blue) and warm hues (without blue) are completely separated in the color wheel.

• Blending a primary hue with a complementary hue neutralizes it and allows the painter to achieve a sense of harmony in the picture. This way, contrasts will be more subdued.

• Cool colors give the impression of distance, while warm colors make the elements appear closer.

• Tertiary colors are those that result by mixing primary colors, or by combining a pure hue and the color black.

• Tertiary colors can be cool or warm according to the amount of blue, yellow, or red hues they contain.

• Colors which are similar to each other create a sensation of harmony whereas opposite colors produce contrast.

3 OUTLINING AND APPLYING BRUSHSTROKES OF COLOR

ESSENTIAL LINES

When working on an exercise, all the elements should be composed within the boundaries of the paper. As the artist studies distances and proportions, the shapes are distributed and the composition evolves. Lightly drawn sketches are made to establish the foundation for the painting. There is no need to give detail to the shapes since during the painting process, the forms are made successively more concrete until final representations are achieved.

In the art of painting, all exercises follow a sequence of steps from beginning to end. A painting starts with the underlying guidlines. Elements are outlined on the paper or canvas without considering their concrete form. Then details are progressively added until an accurate drawing is achieved. Finally, brushstrokes are applied to form the images, and shadows are painted to give the objects volume. Finally, finishing touches are added.

1. The artist sketches a quick outline of a part of the human form. In this case, the shape is a simple one, and the contour can be defined with a few simple lines. Then, with a loaded brush of watercolor, the outlined contour of the body can be filled in.

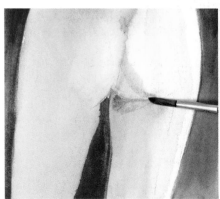

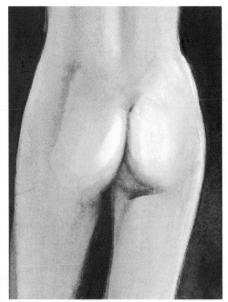

2. The background is painted in a dark hue up to the outlined contours of the figure. Applying brushstrokes as in this example of simple, curved formsis is much easier than in artwork with more complex or precisely defined shapes.

3. Brushstrokes are applied to paint the figure, establishing the color of the skin and subduing the areas of shadow, thereby producing the light and dark tonalities. The painter determines which shapes need to be the brightest so that they stand out in relief. The hue of the shadows combines perfectly with the dark of the background.

GENERALIZATIONS AND DETAILS

Developing a work of art involves doing a general sketch of the subject and then giving value to each individual element. The artist begins by generalizing (sketching, outlining contours) and concludes with the most concrete elements (details, tracing, and, above all, using brushstrokes of color to determine volume). In applying strokes of color, the artist follows the same steps as in sketching. First, hues are introduced and then, more exact shades are applied until the desired tone is achieved.

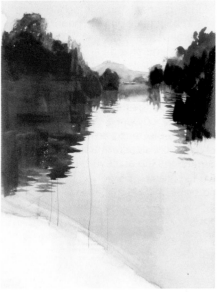

1. In the development of this landscape, brushstrokes of color are applied in a very general way. The warm tonality of the sky and its reflection are painted with a generous coat of red ocher over the entire surface of the paper.

2. The various color areas making up the image are defined. To achieve this, new hues are painted into specific areas. Blue painted over the warm background creates the forest mass and its reflections. In the forest, the color are blended, but in the river, the hues are applied with short, unblended horizontal brushstrokes.

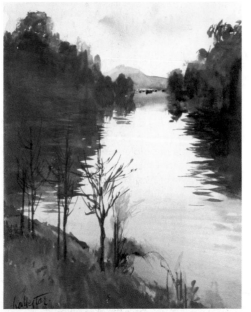

3. Finally, details are added and shapes are made more specific. Because of the closeness of the foreground, a much more precise treatment is given to it than to the background. In general, the process starts with the background and ends with the foreground where detail and more specific shapes are visible.

CORRECTING AND RETOUCHING

The work of an artist entails a continuous struggle to mold the representation of the reality of what is seen. Often, the artist must alter shapes to form others without expecting the current brushstrokes to be the last.

Paintings constantly evolve until objectives are achieved. The modification of a work of art depends on the nature of the medium being used, as an eraser is applied to drawings. In painting, different methods for modifying a work depend on whether transparencies or thickly applied hues need to be altered.

1. Since watercolor is difficult to correct, brush strokes should be as accurate as possible from the very beginning. In this painting of an apple, the volume is not correctly established. Because the correct drying time was not observed in applying the color, the areas of light and shade do not adequately depict the spherical form.

2. To correctly paint the apple, color should be progressively applied leaving the brightest areas untouched until the darkest shadows have been painted. In areas of highest relief, direct brushstrokes of color are pap-papplied to depict the most significant details.

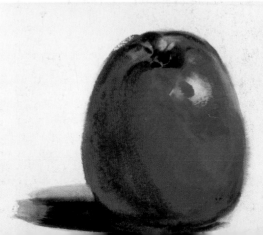

3. Here, the correct volume and outline have been accomplished because strokes were applied accurately from the very beginning. The red color serves as a base to show the shape of the apple. Black is blended to express volume, and it is applied in unblended brushstrokes to define details and the projected shadow.

THE FINISHED PAINTING

A painting's finish depends on the artist's intention. It is necessary to distinguish between sketches (notes, brushstrokes that determine gestures and establish forms) and definitive finished pieces (full of details and hues). Finished works of art require very specific application of brushstrokes and careful creation of volumes. An artist who wants to paint images that comepletely represent reality can achieve this goal if his or her compositions are given a multitude of details and hues.

1. For a completely finished painting, the underlying drawing is essential for the brushstrokes to be accurately applied. Colors are painted freely in the sky to create clouds. When painting the mountains, space is reserved that corresponds to the house. Here, the brushwork must be more controlled than in the skys area.

2. In a finished painting, correct details can be observed in each individual area. In this painting, a meticulous elaboration of the background can be distinguished perfectly, both in both the depiction of the houses and on the surface of the ground.

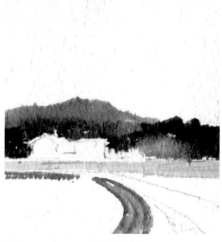

3. The final painting is the result of the correct application of brushstrokes of color. These are general and amorphous in the sky and be-come more specific until the most linear details in the houses and in the branches of the trees are depicted. The way the brush has been used to apply strokes of color is the means for depicting the nature of each element.

Step by Step

The Nude

MATERIALS

Fine-grained watercolor paper, Graphite pencil, Watercolors, Sable or Ox hair brush, Water bowl, Paint rags

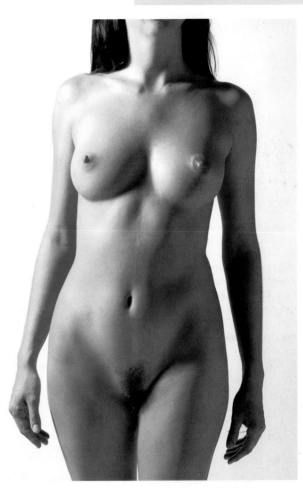

Unless adequate notions of anatomy are known, representing the human body is very difficult. The female body is characterized by curved lines and rounded volumes without much muscular mass and offers a very harmonic view. The correct distribution of color is essential for depicting the three dimensioonal reality of the figure. Contrasts are also decisive in expressing volume and in defining each part of the body.

Step 1. First, the figure is outlined accurately. Using a pencil, the artist expresses both proportion and the basic anatomical shapes. Brushstrokes define the breasts and interior shapes, as well as the outline of the hips and arms. These outlines mut be correct to well-proportion the figure's anatomy and its musculature.

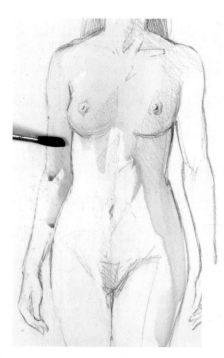

Step 2. When a good basic sketch is finished, the first brushstrokes of color can be safely applied. In this case, a light glaze of yellow is applied loosely. The lines of the pencil can be distinguished, and the color establishes a warm base where new hues will be added.

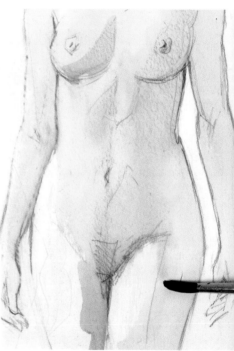

Step 3. The color has been extended to fill the whole body area. Here, the importance of the underlying drawing can be observed. Brushstrokes are determined by this clearly distinguishable pencil outline; the lines serve as a guide for adding new strokes of color without losing the details defining the figure.

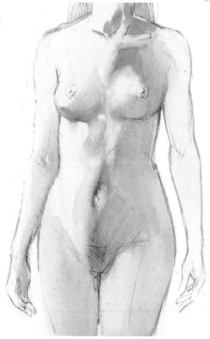

Step 4. A new hue is added to the yellow base so that volume begins to form. The artist uses a smooth sienna hue to create the first light and dark effects. The brushstrokes depict the relief of the collarbone, the breasts, and the abdomen. The warm, intermediate hues enrich the color of the skin.

Step 5. Contrast is increased in a carefully controlled manner. The colors are blended somewhat in the middle of the figure and made more pink in the upper area. Due to the position of light on the figure, the right part of the figure remains dark while the left part is bright. The left arm is darkened using the same hues as on the body. On the wrist, contrast is increased to define the smaller parts.

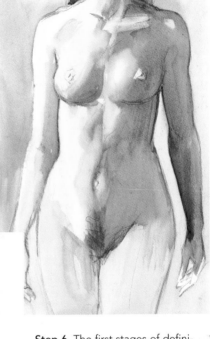

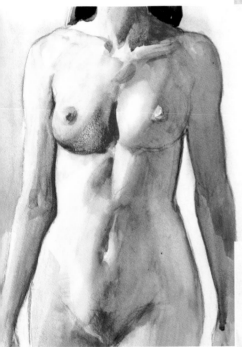

Step 6. The first stages of definition of the figure have been achieved. Now, the artist proceeds with the final shades. Through a variety of earth tones, the body is given contrasts and volume. Direct brushstrokes are used to depict the breasts, the muscle masses, and main outlines.

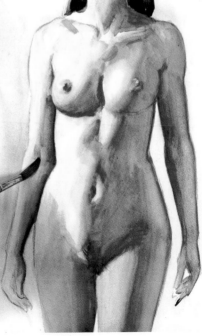

Step 7. Black is added to the image to enhance the contrast. The separations between the body parts are depicted by contrasts in light and dark that result from a lateral source of light. The artist stresses shadows in the shape of the arms and the separation of the legs. Black is added to more clearly distinguish the hues of light and shade on the figure.

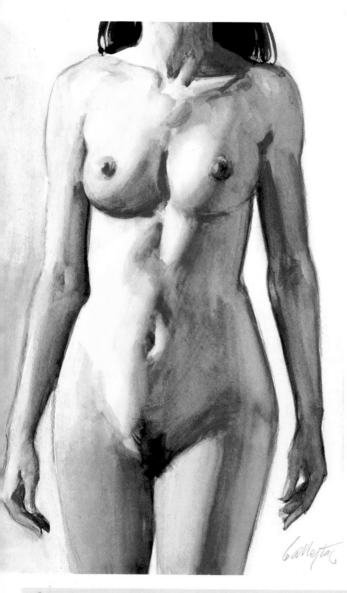

Step 8. Contrasting all the areas and adding details finish the work of art. In broad areas such as the torso and the legs, shades are blended to create rounded relief. In the wrists and fingers, a definite and concrete shadow is produced to refine the details.

SUMMARY

• The process of creating a work of art starts with generally developing a theme, followed by giving specific value to each element.

• Both the drawing process and the color application process must proceed from general to specific.

• In the evolution of a work of art, sometimes it is necessary to destroy some shapes in order to construct others.

• The painting process starts with essential lines, which form the basis for the composition and for outlining the forms.

• The underlying pencil lines are essential are usually done faintly so they can be modified or emphasized, if necessary, in the course of the painting process.

• Complicated subjects like painting the nude require a very well elaborate underlying sketch to acurately apply color brushstrokes..

• The finish of a theme depends on the artist's intention. He or she has the option of a very loose representation or one that is precise and detailed.

THE WEIGHT OF OBJECTS

The significance, or weight, of objects in a painting is determined by various factors, such as their position in the composition, the quantity of these objects (the less there are, the more significant they are), and their distances from the foreground (the nearer the object, the more weight it has). Elements give an impression of weight if they are on the right side of a composition; also, they appear heavier at the bottom of the picture and lighter if they are at the top.

Composition in painting refers to the distribution of elements within a representative space. In either figurative or abstract paintings, the composition is correct when it is visually balanced. The number of objects that make up a painting is a decisive factor in its composition; a painting will be increasingly complex as the number of objects increases.

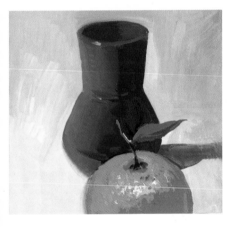

1. Here, there are only two objects. This means that they have a lot of weight in the composition. Because they are drawn to appear close to the viewer, the orange doesn't fit within the confines of the paper, causing an incorrect composition; the elements have not been well placed within the space available. If the objects were placed more in the distance, they both would have fit entirely within the frame.

3. This is an example of a correct, visually-balanced composition. By placing the objects at an average distance, both of them fit within the frame. The jar in the foreground has the most weight, because it is to the right of the picture and the closer of the two objects in the composition.

2. In the composition below, the opposite occurs. These elements are very far away, giving them less weight in the painting. Clustering them in such a limited space doesn't leave room for details and causes another incorrect composition due to an excess of representative space. This problem could have been avoided by painting the objects at a closer range.

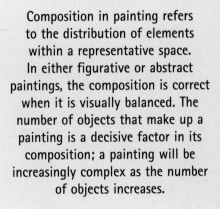

Composition And Balance

A painting is said to be balanced when its elements are well distributed. This balance involves the number of objects represented, the distance between them, and the spectator's point of view. If a work of art is divided into four quadrants, the lower right-hand section has the most weight and the upper left-hand section has the least. Such distribuion transmits a sense of serenity and strength, regardless of the subject matter being represented.

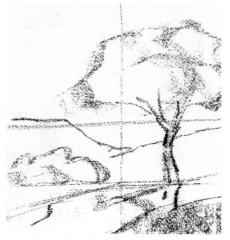

1. The landscape is drawn using basic outlines for each element. The space has been divided into four quadrants, and the objects that weigh more are placed in the right quadrants of the image. The treetop has a great amount of weight and is balanced with the thicket in the lower left-hand section.

2. The chosen colors are also elements of the composition, helping to add or take away weight from the objects. In this painting, the tree trunk painted with warm brown hues stands out from the group of objects painted with greens and blues. The blues cause the mountains and the sky to appear distant, and the green objects appear closer.

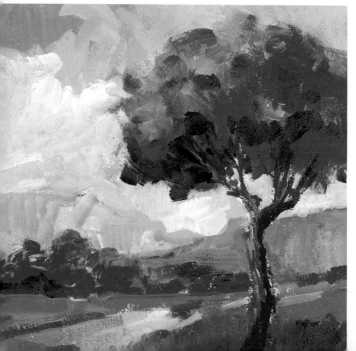

3. The painting is finished after the main volumes and tonal values are depicted. The horizontally placed wooded area to the left balances the composition, breaking the diagonal route of the path. Both the dark area corresponding to the grass on the lower right and the tree trunk have a great deal of weight due to the contrast between light and shade.

COMPOSING A PAINTING

There are many ways to compose a painting. Traditional compositions are based on placing the objects being represented around a center, what is considered to be the painting's midpoint. If there is only one element, it is placed in the center, and if there are more, they should be distributed with the painting's center as a reference point.

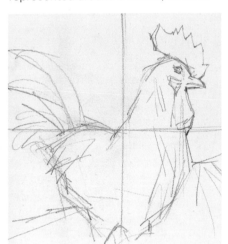

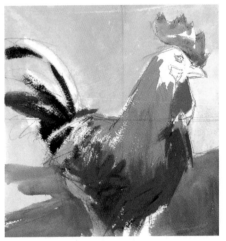

1. The position of a single element, in this case a rooster, will provide balance to the image. The various parts of the animal are treated as separate objects, each one of which should be balanced in an equal way. In this sideview, the head and feet fall on a diagonal line and the tail and body on another. A correctly composed and centered "V" is clearly visible.

2. The image is painted with hues corresponding to large areas of color. The background is filled in with neutral hues and the ground area is painted with violet. Warm earth tones are applied to the rooster's body. Very dark blues are used on the tail and pure red is applied to the crest and dewlap.

3. The painting is finished by giving detail to the rooster's head and the rest of its features. Tinalities of dark and light are used to create a sensation of volume in the body. The rooster has perfect balance based on the position of its feet and the "V" effect created between its head and tail. The darkness of the lower part of the bird is a establishes its weight as a whole.

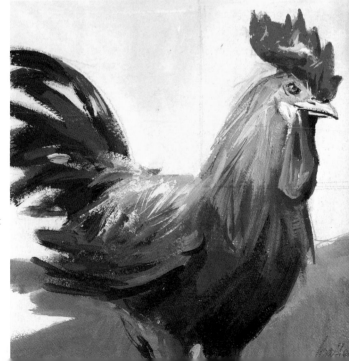

SPACE IN A PAINTING

A painting of the same size can represent a close-up, mid-range, or distant view, depending on its theme and on the method of treatment.

Large landscapes call for elements to appear at a distance, whereas simple still lifes with few elements require a close-up treatment of space, allowing for more detail in objects making up the composition.

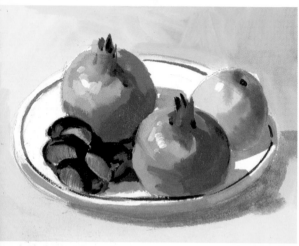

1. The artist's intention is what determines the space in a composition. In this example, there are few objects, and the distance from the painter to the subject is short. The artist has chosen an aerial point of view and placed the objects in a circle in order to develop the qualities of each individual object. If the painting used a flat, horizontal perspective view, the element, some objects would be hidden.

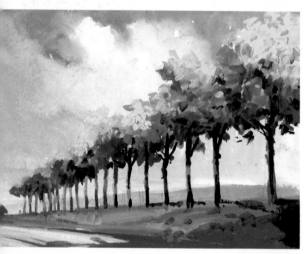

2. Landscapes are a typical example of the representation of large, deep spaces. This implies dividing the painting into background and foreground, from the farthest away to the closest. The perspective in the painting is well defined. The trees become smaller as they recede away from a spectator's point of view, and the distance between each tree is less the further away they appear.

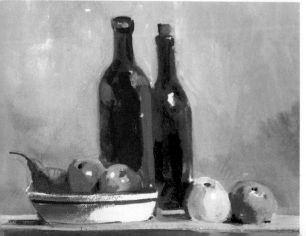

3. For this still life containing many elements, the artist has chosen an intermediate distance. The elements are distributed along a straight line instead of the aerial point of view discussed in the first example. The placement of the two bottles is fundamental to the composition. They appear as whole objects and help to establish the distance at which the still life should be placed within the limits of the painting.

A Lion

MATERIALS

Basic drawing paper, Graphite pencil, Gouache colors, Different size synthetic brushes, Water bowl, Paint rags

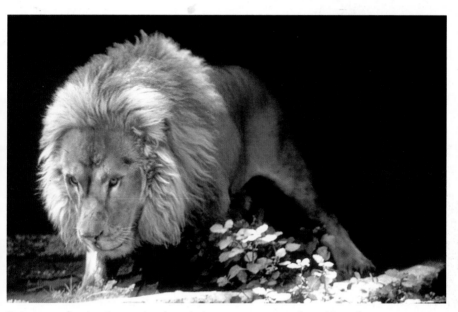

Paintings of animals require that their movements and positions be balanced in the composition. Animals, like humans, can adopt multiple positions, and each one of them requires a different spacial distribution. In this painting, a lion in an almost frontal position is the subject. The fact that a significant part of the lion's body is placed to the right causes the head to be represented to the lower left.

Step 1. The lion is drawn according to the rules of composition. Its whole body is represented and placed on both sides of the composition's central axis. The fact that other elements, such as the thicket, appear in the foreground makes it necessary to draw the animal partially in the background.

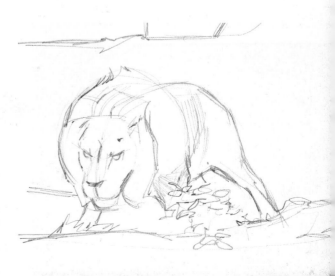

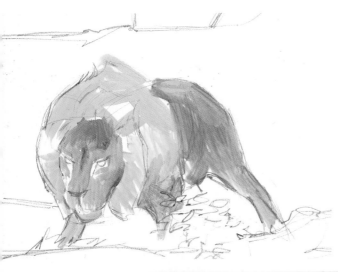

Step 2. The lion's entire body is painted with ocher and yellow hues. Yellow and white are applied to represent the mane, giving it brightness. Various brown hues are used on the face and body. Initially, the foundation colors are painted without volume in mind; the body will be given dimension in later stages of the work.

Step 3. The entire background is darkened to perfectly establish contrasts between the color of the lion's coat and the darkness encircling the animal. Dark brushstrokes of color are used to shade certain areas to depict the animal's anatomy.

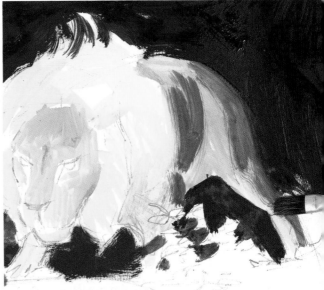

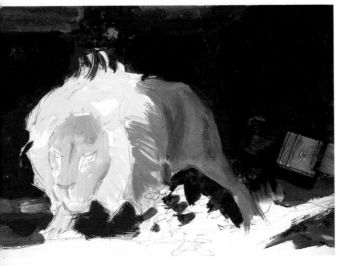

Step 4. Now, the lion's shape stands out strongly against the background. Volume has also been established by painting the fur, thereby defining the lateral and frontal planes.

Step 5. The hair of the lion's mane is painted and strokes of color are added to the lion's face. Brushstrokes of color outline the lion's bone structure. The thicket in the foreground is given turquoise-blue brush-strokes, defining its leaves.

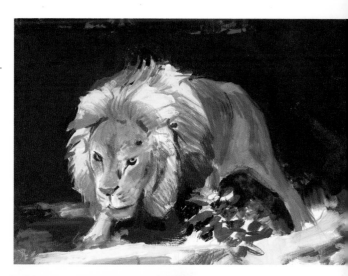

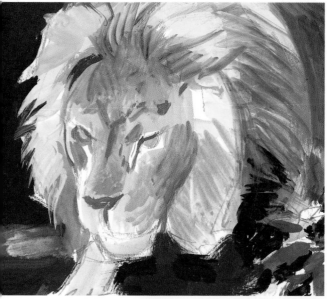

Step 6. A fine paint-brush is used to define the shapes of the eyes and muzzle. Then, definitive details are added to the facial features. Contrasts of light and dark are used at all times to set apart the light areas from the dark.

Step 7. The lion's face is completely defined. A fine paintbrush has been used to give the finishing touches to all of the animal's features. Finally, the skin tone is darkened to create a definitive hair texture.

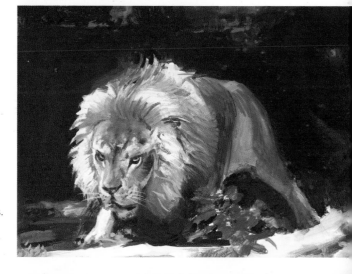

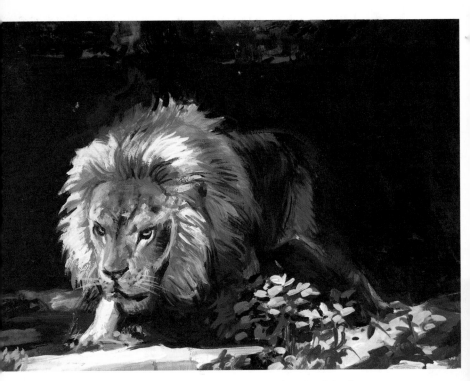

Step 8. Finally, detail is given to the thicket on the right side of the fore-ground. This area plays an important role in the composition because it balances the lion's image that tends toward the left. To make the leaves stand out, and also to strengthen the foreground, the lion's body has been darkened so that it stays hidden in the shadows.

Summary

- The composition of a painting refers to the distribution of the elements in a painting.
- Correctly distributing a painting's elements transmits a sensation of visual balance.
- The lower right-hand quadrant has the most weight in the composition and the upper left side has the least.
- The number of objects greatly influences the composition. The more objects involved, the less weight each individual element will have.

- When a single element is to be represented, it should be placed in the center of the picture. When there are many, they should always be distributed around this center.
- To compose a painting the artist begins by dividing the representative space into four quadrants that meet in the center.
- In a painting, the weight of the objects and their importance is related to their distance from the foreground; the closer the object is, the more attention it will receive.

EXPRESSING LIGHT

Light comes from both natural and artificial sources. Sunlight, a natural source, is projected in a parallel way, and shadows of objects under its influence follow the same direction. Artificial light is projected in a radial way. In painting, light can be expressed by either adding white to the hues, or by allowing the white of the paper to show through a transparent painting medium.

In painting and drawing, the first essential skill is based on an understanding of line and contour, implying a knowledge of proportion, space, and composition. A second level of skill in drawing involves understanding light and shadow. At this second level, an artist must indicate volume by representing light falling on a form and the shadows it projects, thereby defining its shape and volume.

1. This simple charcoal sketch illustrates the effect of light and shadow. The contours of the trees in this scene are traced, and the dark areas are shaded. White corresponds to the areas of the landscape receiving light, and those that are in shadow are indicated by dark marks of the charcoal.

2. The areas to be shaded are established, both in the horizontal background and in the treetops. The artist uses contrasting light and dark hues to indicate either brightly lit or shadowed areas.

3. Now, elements such as the shadows projected on the ground and the texture of the grass and leaves are added. Red is blended into the color of the bark and the shadows on the tree trunks. Brushstrokes of black express the shadows on the leaves of the tree. The yellow hue in the upper half of the painting corresponds to the areas where light falls.

INDICATING VOLUME WITH SHADOWS

The shadow projected by an object in a non-lit area is called "its own shadow." The shadow projected by an object in a contiguous space or over another nearby object is called its "projected shadow." A body's shadow depicts its volume. A flat plane doesn't have shadows, but a three-dimensional object resting on a flat surface has shadows that follow the direction of the object's external form.

1. To understand the importance of shadows in representing volume, the artist begins with a simple image of a lemon. Using charcoal, the artist sketches the shadow projected onto the floor and also the lemon's own shadow that encircles its elliptical shape.

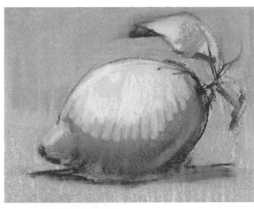

2. The background is painted with warm colors using broad brushstrokes. Bright yellow is painted on the part of the lemon that receives light, and for the area of the lemon in shadow, the yellow is blended with charcoal black to obtain a dark and integrated hue.

3. The exercise is finished by blending all the hues. The volume of the lemon has been depicted by the combined effects of background color and the light falling on the lemon to create its lower shadow. Note that the form of the lemon is very different from the leaf form, which is depicted using planes.

POINTS ON MODELING

To model an object, an artist must be able to transform the visual sensation of the object existing in three-dimensions onto a flat surface (paper, cloth, wood, etc.) An object's position with respect to light reflects either transparent, intermediate, or dark colors depending upon that position. Whatever technique is used, understanding how to model an object implies knowing the light and dark values the object acquires depending on the light it receives.

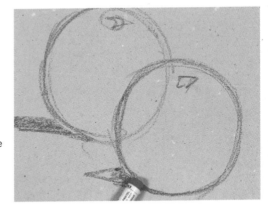

1. This exercise is based on a simple composition of two oranges. The outline and projected shadows are drawn with red without taking the modeling of volumes into account.

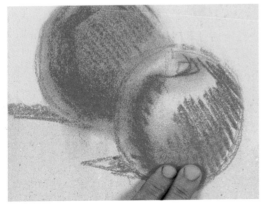

2. The artist now begins to depict the objects' volumes. To create a base of reference, the background is painted with a pale color. Two different reds that reflect different intensities of light are used in the fruit.

3. Orange hues are added to the lightest areas of the fruit to complete the exercise. No black or white has been used to convey the forms. Only pure, direct colors having their own distinct light values have been applied. Oranges and yellows are very bright colors, while reds tend to be darker.

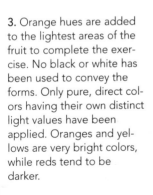

COLOR IN THE SHADOWS

When working in monochrome values, the shadows are treated like tonal variations of the main color. Depending on the medium being used–whether diluted watercolor washes, overlapping pencil marks, or colored brushstrokes- –the image is developed around tonal contrasts of one color. In painting, it is effective to develop more than one color for the shadows. There are a multitude of hues in shadowed areas, which, when taken into account in contrast to light, create a sensation of darkness.

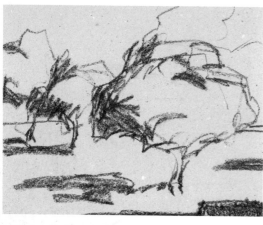

1. In this example, the artist creates a landscape using only two hues, the color of the paper and charcoal black. The outlines of the shapes are defined by black lines, and these lines also define the darkest shadows.

2. New tonal values are established when three hues are used. The color of the paper is used for the areas where maximum brightness is desired, like the clouds and the treetops. Blue is used for the intermediate hues fof the sky, the earth, and the leaves. Finally, black is added to define contours and to darken the shadows projected upon the ground.

3. The entire color spectrum is used to value the landscape. Warm yellow and green colors blend perfectly in the brightest areas. Blues and violets are combined for the shadows. Since they are cool colors, they contrast with the warmth of the light, and perfectly create the impression of a shadow.

A Backlit Landscape

MATERIALS

Pastel colors,
Fine-grained paper,
Paint rags, Eraser

Placing a light directly behind an object creates a backlight and causes the viewer to see objects only in silhouette. The front view appears completely darkened due to the contrasting background light. In the case of a very direct light like a spotlight, the object appears to have a very bright outline and be very dark inside the outline. In this landscape scene, the background light is very intense, making the wooded areas appear dark with no apparent volume.

Step 1. To begin the painting, various brush-strokes of gray are used to compose all the elements of the landscape. The artist applies strokes of color to establish light and dark contrasts from the very start.

Step 2. The background is painted with very light hues. White is used for the sky and gray for the area adjacent to the horizon, producing the illusion of distance. The artist then begins to incorporate dark gray on the trees in the center of the composition to create the first backlight effects.

Step 3. Dark green is added to the left side of the image, applied thickly in the leaves for a relief effect and with short, blended strokes for the reflection in the water. A small amount of blue is added to the trees in the center to give variety of color to the shadowed forms.

Step 4. Gray is applied to the foreground creating depth and an effect of distance on the water's surface. The trees to the right are darkened somewhat and light yellow brushstrokes are added above the water, creating the reflection that produces backlight.

Step 5. To cause the trees on the right to stand out from the group, the artist applies vertical strokes of varying thickness. Then horizontal strokes of black are used directly on the reflections in the water. To define the reflections of the trees on the left side, small horizontal strokes of blue and green are used

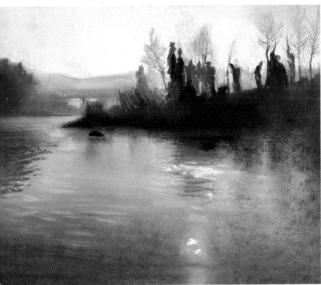

Step 6. Turquoise blue is added to the entire foreground, reinforcing the impression of water and making this landscape chromatically cool. In the bright central area, blue is combined with white using short, horizontal brushstrokes.

Step 7. To indicate the effect of the movement in the water, the artist uses short horizontal brushstrokes of yellow and white that correspond to the brightest area of the landscape. These strokes are superimposed upon the dark reflections of the forest, resulting in a very strong contrast.

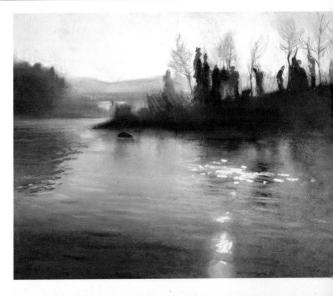

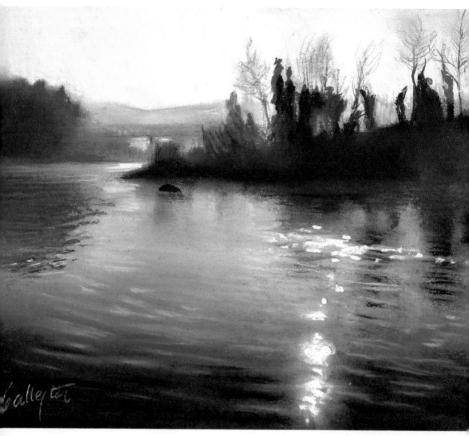

Step 8. Finaly, the artist applies brushstrokes of bright hues to the foreground. These colors stand out against the general darkness. They are not distinct, but instead, are blended with the fingers to merge with the background color. They take on a wavy shape, indicating the the movement of the river's current.

SUMMARY

- Light and shadow are elements in a painting which define volume.

- Knowing how to model implies observing and using variations of light and dark produced as light falls on a three-dimensional form.

- Colorful shadows are formed by chromatic contrasts between dark and light hues.

- In painting, light can be represented either by using the transparency of the medium with paper, or by adding white to the pigment being applied.

- Shadows that are part of an object and depict its volume are called an object's "own shadow," and those that the object projects onto a space or other object are called "projected shadows."

- Monochromatic volume is obtained using tonal variations of only one hue.

- Natural light projects in a parallel way, whereas artificial light projects in a radial way.

- Shadows are the absence of light. The stronger the light source, the more intense are the shadows.

MIXTURES ON THE PALETTE

Mixing colors on a palette is a very useful way to derive certain hues which can later be applied to the painting in a very deliberate way. This process is ideal in flat painting, for areas where colors don't require blending or toning down. Mixing colors on a palette allows the artist to study the chromatic range of new hues and to be very precise regarding the colors to be applied.

The medium of gouache has some of the characteristics of both watercolor and acrylic pigments. Thicker than watercolor, gouache is not as thick as acrylic. It can be diluted with water before being applied almost like a watercolor wash, and because of its thickness and opacity, it can be used to overlay colors. These properties make gouache a very versatile and malleable medium allowing for mixing on a palette, overlaying to block out other colors, or blending directly on the painting.

1. Gouache, or tube temperas, are among the purest and most concentrated of pigments. A small tube of gouache lasts as long as a tube of watercolor. Mixing with high quality gouache pigmnets results in very pure colors. It is important to buy these high quality brands instead of student grade intended for school use since these will not produce the desired results.

2. The landscape shown here was painted with colors mixed on a palette. Dabs of the mixed colors were then applied directly onto the support. This color was prepared on the palette with a mixture of primaries before being applied.

3. When the previous area of paint is dry, a second layer of new, thicker mixtures of colors can be applied over them. Here the clouds and the white reflections on the water were mixed on a palette and then applied over the blue base paint after the blue had dried.

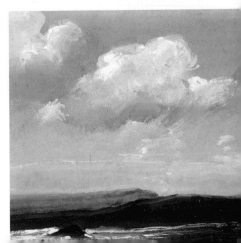

MIXING COLORS ON THE PAINTING

Because of the versatility of gouache, colors can be mixed or blended direct-ly on the painting. The paint must be fresh and an adequate amount of water must be used in order to accomplish this blending of colors. In this case, the artist mixes the colors using a paintbrush.

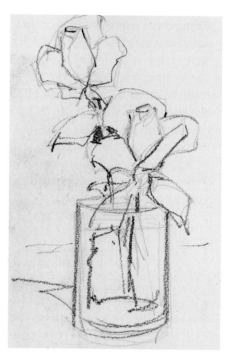

1. For this demonstration of blending colors directly on a support, a simple still life will be painted. The first step is to outline the image within the composition with a charcoal pencil, sketching and positioning the forms, without regard to their volumes. Later the sketched lines will be completely covered up by the gouache.

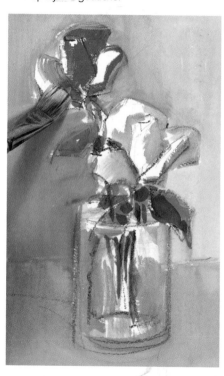

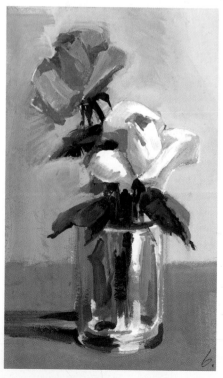

2. The artist now concentrates on the colors of the flowers. Since they are to be painted with pure hues, paint is applied directly from the tube. For the background tones, however, gray and blue hues are mixed directly with a paintbrush. This blending unifies the background and the main elements.

3. Giving tonal values to the jar, flowers, and leaves concludes the exercise. To convey these defined forms, pure colors of gouache are thickly and directly applied. For the smoother more blended areas, the artist works directly on the support.

MODIFYING COLOR
IN THE PAINTING

Gouache is a water-based painting medium like watercolors or acrylics. Unlike acrylic paint which can't be mod- ified if it has dried, gouache can be be altered. Even if a gouache painting has dried, water can be added to the paint and colors can be mixed into it again. This means that although gouache colors appear to be permanent, further changes are always possible.

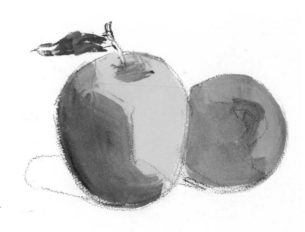

1. A simple composition of two pieces of fruit illustrates the effect of mixing water into gouache color. First, pieces of fruit are painted onto a dry surface. Using flat, unmodeled colors, the artist paints areas to be highlighted as well as those that to be shaded. These areas are clearly differentiated at this point, but later they will be blended.

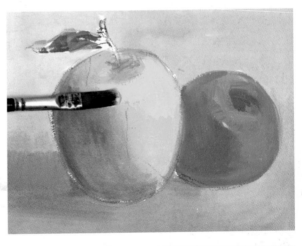

2. Now, water is painted into both hues to allow for blending. A large quantity of water is applied to the closest apple causing the colors between the bright and shaded areas to blend. Gray colors are used on the background to create a sense of depth.

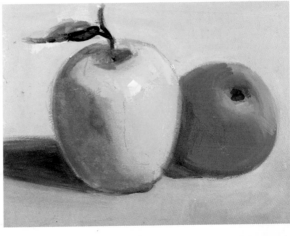

3. To conclude the exercise, the artist paints detail into the fruit and their shadows projected onto the base. Rewetting the colors has served to gradually blend the hues creating atmosphere in the painting. New, more intense colors are added to the image to produce a strong impact that draws the spectator's attention.

REWORKING FORMS

Because the texture of gouache paint is very thick, corrections and touch-ups are possible. In working with watercolors, such technique would be very difficult. Gouache can be applied either as impasto or by mixing it with water to utilize transparency.

If gouache is applied as a transparency, errors cannot be corrected because the underlying colors on the paper will show through. But if gouache is applied as an impasto, the colors previously painted will be hidden, allowing new lines to be incorporated and corrections to be made.

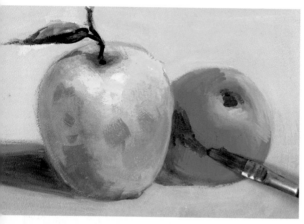

1. Red and orange hues are now added to the apple using the color as impasto. The artist takes advantage of the pigment's thickness to cover the underlying dark hues. Since dark hues will always cover lighter ones, they do not have to be applied as an impasto. In this painting, some dark brushstrokes are applied to the green apple.

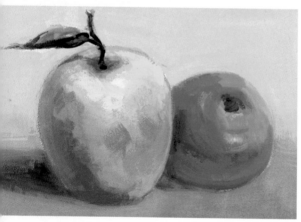

2. The artist blends the shaded areas of the second apple in order to depict it's continuous volume. By painting in circular gradations, the artist conveys the apple's rounded shape. Next, a lighter hue is applied to the spot on the apple where light falls.

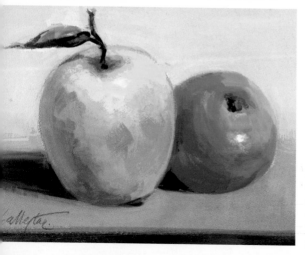

3. The projected shadows are completely defined using a dark brown hue. As well as providing contrast, this color redefines the contours of the fruit and clearly depicts their shape.

A Branch of Apricots

MATERIALS

Gouache, Synthetic brushes, Heavy drawing paper, Charcoal, Water container, Paint rags

Painting small natural forms is as valuable an exercise as working on the most ambitious subjects in paintings. Problems of conveying volume and contrast have to be resolved in these as well as in major works of art, and these small forms provide an exercise in observation and representation.

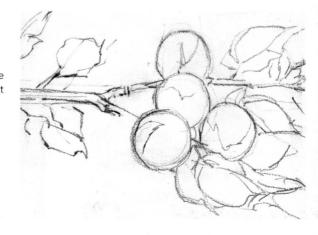

Step 1. The first step for the artist is to outline the object in charcoal without indicating any tonal values. In this sketch, the fruit and leaf shapes are simplified. It is enough to draw and compose the shapes. Because of the way the branch of apricots grows, this is a horizontal composition.

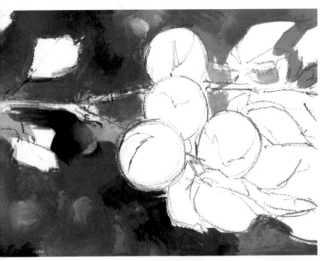

Step 2. Next, the abundant vegetation of the background is painted on a second plane. Various brushstrokes of greens and blues are applied, outside of the contour of the fruit. To obtain a variety of cool hues, different colors have been blended directly on the paper, intentionally blurring some of the colors.

Step 3. Now, the artist begins to add warm colors. Yellowish and bright green hues are applied to the leaves, providing a contrast with the bluish green background. Dark orange hues are used for the shaded areas and lighter orange hues for the bright areas.

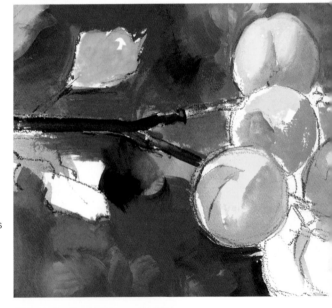

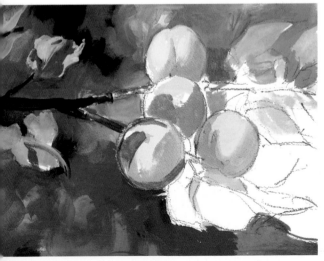

Step 4. Now for the left-hand side of the painting, dark hues are ppainted into the background, forming undefined shapes. These same hues are used to depict the branch from which the apricots hang. Bright colors are alternated with the new darker greens to make them stand out.

Step 5. Continuing on to the right-hand side of the composition, the artist paints with green hues, lighter ones for representing the bright areas and darker ones for establishing a separation between the various forms.

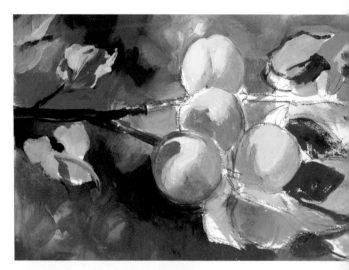

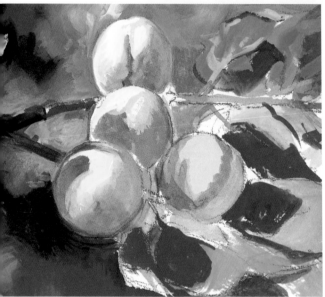

Step 6. Now, more detail is given to the fruit by adding reds and lively oranges. The right part is made more specific using intermediate hues of green to progressively show volume; contrast is used to separate each individual fruit from the others.

Step 7. By combining colors, the artist creates the sense of a sphere to depict each apricots' general volume. The points that form part of the background are painted with blue and help to depict the form of both the fruit and the leaves.

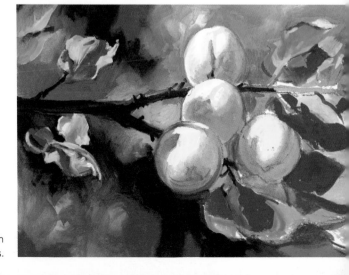

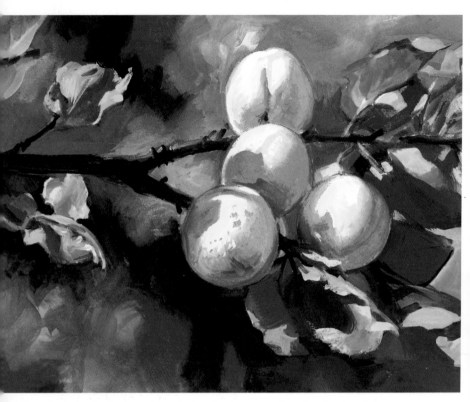

Step 8. In the final stage, the right-hand side is completed. A fine brush is used for details on the leaves like the veins and stems. The fine brush is also used to give texture to some of the fruit by painting a series of dots.

SUMMARY

• The characteristics of gouache are similar to those of watercolor, which are more liquid, and to acrylics, which are thicker.

• The medium of gouache allows for both mixing hues with water as well as overlapping previously applied colors with thicker ones.

• Mixing on a palette is a good way to achieve hues for painting flat, unmodeled areas of color.

• More continuous, atmospheric effects can be developed by mixtures on the painting itself.

• When colors are mixed on the painting itself, the artist must use enough water to allow the colors to integrate.

• Dried gouache pigment is soluable in water.

• When gouache has dried on the painting, it can be dampened again by adding water to the hues and then modified .

• Working with impasto allows the artist to cover previous layers, thereby making any necessary modifications and correcting mistakes.

WATERCOLOR STYLE GOUACHE

To tone down a color when working with gouache, a large amount of water should be added. This is similar to working in watercolor. The diluted colors blend in such a way that boundaries between hues are not marked, and the homogeneous hues create an impression of volume. The more water that is used, the more transparent the colors will be, and, conversely, the more pigment added, the more intense the color.

Volume is represented through changes in value from light to dark. It can be expressed in many ways, among them, painting homogenous changes in bright colors by gradually incorporating shadows with fading colors. Also, volume can be expressed by superimposing different hues. Gouache is a mixed technique that allows the artist to work with wet surfaces to create gradual changes or with dry ones which are applied by impasto.

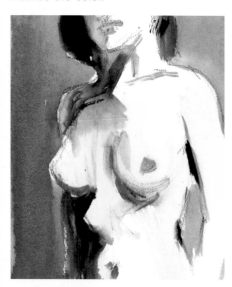

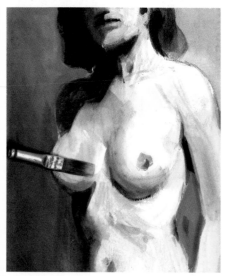

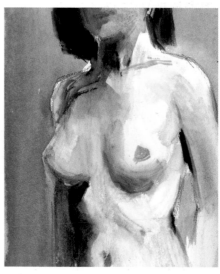

1. In this illustration, light falls on the figure from the right, and the breasts and abdomen are very bright. The artist applies a mixture of very little pigment and a large amount of water to these areas. Less diluted gouache has only been used in the projected shadows

2. Intermediated hues are applied to define the skin. In the most accentuated volumes, only transparent colors should be applied. The face and neck are darkened in order to highlight the light areas.

3. The artist adds shadows to the background, causing the much lighter figure to stand out. Since concentrated gouache allows light colors to cover a darker base, the artist applies white to the bright areas.

THICK HUES OF GOUACHE

When working with thickly applied gouache, the artist employs a technique in painting that few mediums can offer. Colors derived through transparency can be toned down or combined with new hues obtained by using more concentrated mixtures. Light hues are combined with white and then painted over dark colors that have already been given transparency.

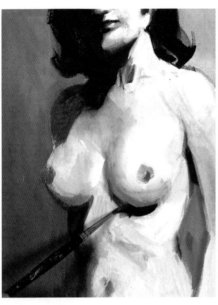

1. In this illustration, the dark colors stand out, especially the shadow of the breast on the body. The previous colors, which were very dilute, didn't have the intensity of more concentrated gouache.

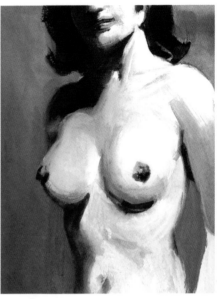

2. Precisely applied, barely diluted black depicts the contrasts on the face and in the contours of the body. It is important to use small, detailed lines so that the contrast created is not too strong.

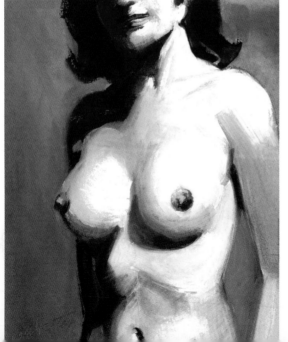

3. The artist completes the modeling of the figure by highlighting with gouache pigment. The foundation brushstrokes in this painting were made with diluted paint. Then, thicker hues were added for the contrasts. White was used for the brightest volume and black for the darkest shadowed forms.

CONTRASTS AND HIGHLIGHTS

Contrasts in a painting are based on the intensity of the light that an object receives. When the light is very intense, the dark areas will also be very strong. If, on the other hand, the light is distant or diffused, the shadows will be soft and well integrated with the color of the object. In concentrated gouache pigments, even white and the light hues are opaque and can cover any other color, regardless of how dark it is.

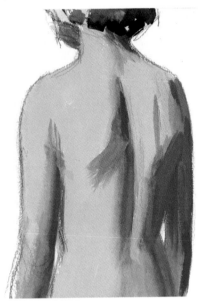

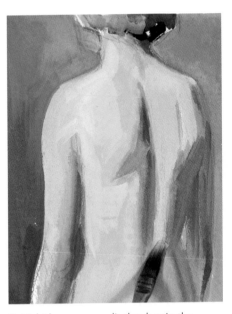

1. In this figure painting, a neutral hue corresponding to the color of the model's skin is applied to the entire form. The shaded areas are then covered with brushstrokes of brown, which mix well with the general color.

2. Light hues are applied to begin the process of creating of contrasts in the painting. A little white is added to the general skin color mixture, and new hues are superimposed into those areas where light falls most directly due to the raised areas of the anatomy.

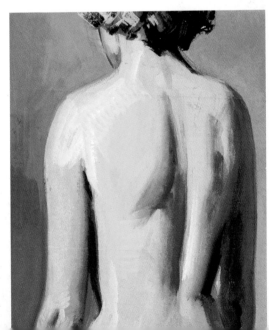

3. Very dark brushstrokes that clash with the brightness of the rest of the body are added for contrasts. Emphasis is placed on the darkness of the figure's hair, on the shadows projected by the arm onto the figure's left side, and on the right hand side of the image.

SOFTENING FORMS

The shape of an object and the direction of the light falling upon it determine the harmony between hues and form in a painting. Frontal light upon very flat or rounded volumes produce soft, undefined forms and undefined contrast. Softly rounded forms require a blurred and continuous treatment which can be achieved in gouache by working with very diluted pigment.

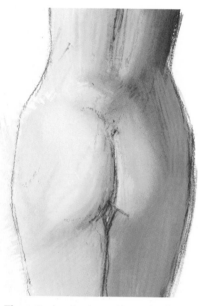

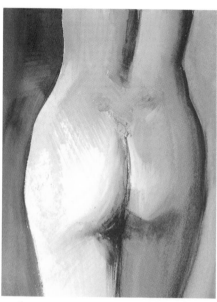

1. The artist begins by painting the figure on the paper with very difuse hues. For the left side, dilute pigment is used to attain transparency, and on the right, using an orange hue, a greater amount of pigment is blended in so that the color becomes more intense even though dark hues have not been used.

2. The color of the background is important for contrast with the hues of the figure. To create a harmonious effect, the painter chooses a neutral hue, neither very light nor very dark, in order to reinforce contrasts. The background colors are very light in contact with the shaded areas of the model and darker in the areas where light falls on the figure.

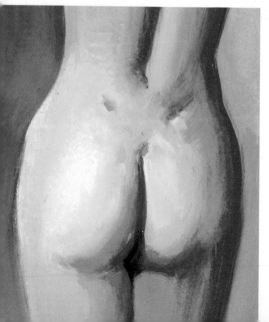

3. Now, the artist adds toned down shadows to very specific areas like the line dividing the buttocks and the legs and in the vertebral column. Generally, brown instead of black is used in order to preserve softness and harmony in the work.

Step 5. To cause the figure to seem warmer as a result of the color contrast, the background is painted with a neutral blue. In the areas where shadows meet areas of light, the colors are blended together. The entire abdominal area is treated in this manner.

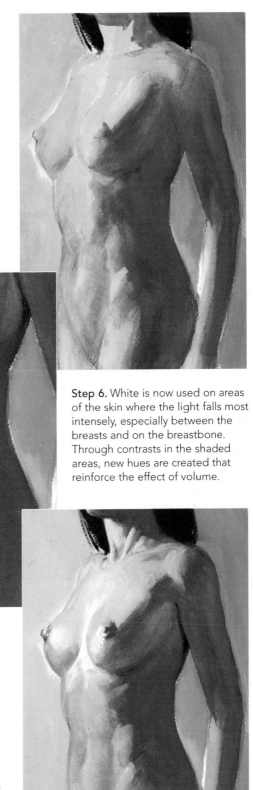

Step 6. White is now used on areas of the skin where the light falls most intensely, especially between the breasts and on the breastbone. Through contrasts in the shaded areas, new hues are created that reinforce the effect of volume.

Step 7. In this phase, the volumes of the figure are created through contrasts between shadows and light. In general, whenever white is applied, it neutralizes the warmth of the body's colors.

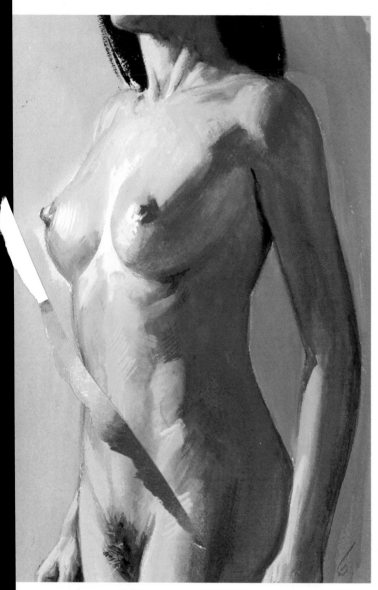

Step 8. The artist works on the lower part of the model, giving detail to the pubic hair and the upper thighs. Using various methods of applying gouache allows the artist to create both blending effects and contrasts, making the technique perfect for representing volumes and textures.

SUMMARY

• Painting with very diluted gouache hues allows the white of the paper to show through due to transparency.

• Watered-down gouache produces a blended, atmospheric effect similar to that produced by watercolors.

• When working with impasto, light hues can be achieved by progressively adding white to the color.

• Contrasts are based on the intensity of the light that falls on a subject.

• Thickly applied gouache is very opaque, and even light hues will cover dark ones perfectly, allowing light contrasts to be developed in the painting.

• Volume in gouache is represented by changes in hues between brightly lit and shadowed areas.

• To obtain contours and soft effects, the gouache paint should be very wet to allow for diffusion.

LIGHT AND DARK COLORS

Blue is the coolest color, although green and violet are also considered cool hues. The amount of blue in a hue determines its coolness: the more blue, the cooler the hue. In the chromatic wheel, colors closest to blue form the cool colors range. But not all greens and violets are considered cool hues. If warm colors are included in their makeup, the less cool they will be. Greens mixed with lots of yellow are considered warm hues, and violets with warm reds are also warm.

In addition to the effects produced by adding water to gouache, thickly applied gouache allows for complete opaqueness. For certain flat styles of illustration, it is very common to apply gouache in a single layer of smooth hues with medium density. This techniques allows the artist to layer one color over another. Since the pigment is so thick, it completely covers previously applied layers of paint.

1. To show the effect of layering, the artist draws a charcoal sketch of a bird on a branch. Thick gouache paint establishes the foundation color. Then turquoise is applied to the top part of the bird and yellow is applied on the lower part.

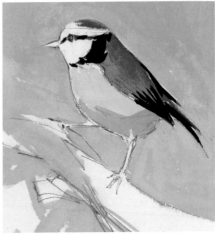

2. Brushstrokes of turquoise mixed with white are applied to the background. Since the hues need to be lighter in the lower part of the image, the amount of white is increased. The opaqueness of gouache allows colors to be overlapped.

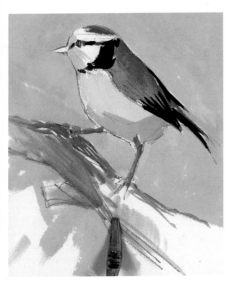

3. Turquoise is now mixed with red to define the branch. The resulting brown is spread over the left side of the branch. Next, orange is added to the lower area of the bird, and finally dark blue is used for the feathers on the neck and tail.

SHAPE DEFINITION

Gouache colors are very malleable; with the right paintbrush, the most minute details can be taken into account. For gouache painting, syn- thetic brushes are recommended since they allow paint to be spread fluidly. Acrylic brushes are too soft and bristle brushes are too hard. With very fine synthetic brushes, even the delicate linear forms can be painted.

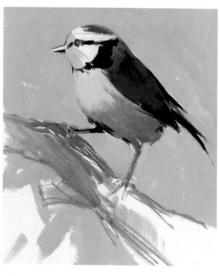

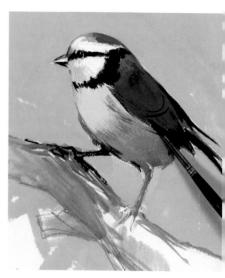

1.The artist gives the bird volume by uni- fying the colors on its body. When green hues are combined with yellow and orange hues, the green has a rounding effect giving the bird volume.

2. Now the artist uses a fine brush and the color black to paint the bird's most character- istic details. Brushstrokes corresponding to the feathers on the neck and the tail are applied, then the eyes and feet.

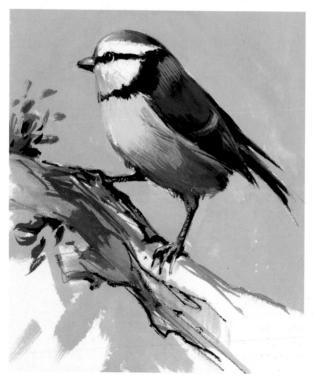

3. The artist finishes the work by defining the tree trunk and the rest of the bird's feathers. Small bluish-green feathers are added to the bird's back, and these colors stand out perfectly against the black hues. The surface of the tree trunk is painted with a dark brown hue, and small dabs of green represent the leaves.

RETOUCHING AND CORRECTING

The opaque quality of gouache make it advantageous for correcting mistakes in painting. This is also true in acrylic or oil painting. In painting with gouache, it is common to paint shapes searchingly, looking for appropriate hues and volume without considering the contour. Because of the nature of gouache, the contours can be established in later stages, and out of place lines can always be covered with new colors.

1. In this illustration of a green bird, the background is painted in orange, producing a strong chromatic contrast. The artist then applies various green hues to the bird, more yellowish on the head and darker greens on the back and tail.

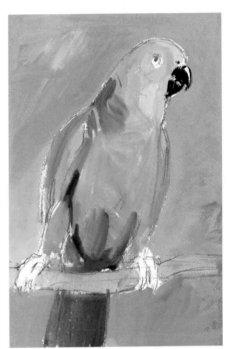

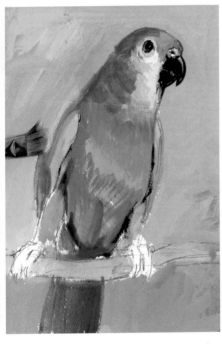

2. Now, concentrating on the background once more, the artist corrects the bird's outline. Using a brush of medium thickness, orange is applied once again. The contour is retouched to correctly represent the bird's shape.

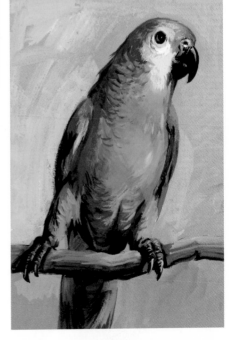

3. Next, black is progressively added to the contours and the lower part of the image, clearly defining the bird's volume. Finally, the feet are drawn correctly, and, with small brushstrokes, details of feathers are painted into some of the areas.

Finishing Touches with Gouache

Gouache pigments dry quickly making it possible to create a fresh and spontaneous painting defined by flowing outlines and overlapping brushstrokes.

Other types of opaque paints – like oil – require slower and more meticulous application. Gouache, on the other hand, offers more variation in its application; it can be used either watered-down or overlapped to utilize its opaque qualities.

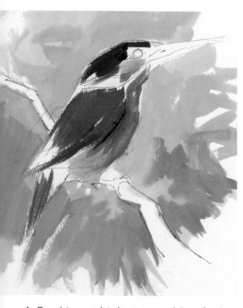

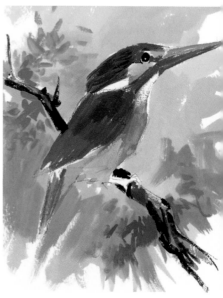

1. For this next bird painting, dabs of color are applied using blue and orange hues in a single layer. The treatment of the background, painted with loose and direct brushstrokes, gives the painting an impressionistic look. Vibrant brushstrokes suggest vegetation in the background.

2. Two brown hues of different dark shades depict the branch of the tree and establish areas of relief. Very short, spontaneous brushstrokes of green represent the leaves closest to the branch. On the bird, the colors are fused, and the beak is painted blue.

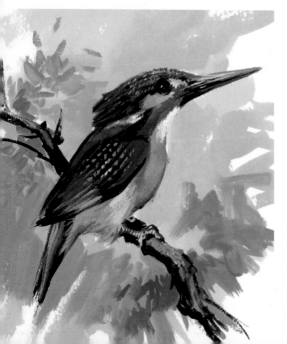

3. Using a fine brush, he artist now works on the details. The size of the brush used is proportional to the fineness of detail to be painted. In this case the artist use s a fine brush to energetically apply the strokes of gouache.

A Bird

MATERIALS

Gouache, Synthetic brushes,
Heavy drawing paper, Charcoal,
Water container, Paint rags

Representing exotic or wild animals in their natural environment or in a zoo is an appealing subject for some artists. Even a common bird offers many possibilities for practicing particular techniques of painting (in this case, gouache). Discovering the thousands of details encompassed in a bird's image and learning how to artistically extract its charm is not an easy task. This exercise offers the opportunity to achieve these artistic goals and to practice applying gouache in single layers and overlapping colors.

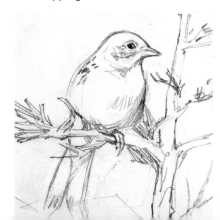

Step 1. The artist draws a detailed sketch of a small bird. The sketch will serve as a foundation for all the processes that follow. Here the feathers on the bird's back are defined and the shadows are darkened. Finally, the tree is defined by adding branches and leaves.

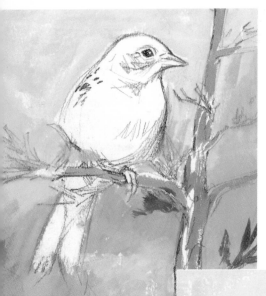

Step 2. A large amount of water is added to the pigment before it is applied to the background. This allows the color to be spread more easily. The yellow of the lower part of the image is a pure, unblended yellow. On the right, it is mixed with green hues, and toward the top, it is brighter. Now, the branches are painted with pure orange hues. At this stage in the painting, volume is not taken into account.

Step 3. The bird is painted with yellow hues that are somewhat more intense than those used on the background, making them clearly distinguishable. Sincce the brushstrokes are not applied uniformly, a textured effect is given to the bird's feathers. Then layers of darker hues are added for variety in the feathers.

Step 4. After the bird has been completely painted, the artist works on the branches and leaves, the foreground elements in the composition. Fine brushstrokes of green, representing leaves, are added to the oranges of the tree trunk. In the lower part of the image, a warmer green is used, and the leaves are bigger, requiring wider strokes to be applied.

Step 5. Now, the painting as a whole is darkened. Shaded hues are added on the bird to define the eye and the small feathers around it. On the tree trunk, green hues mixed with black are blended with the lighter hues to depict the contrasts between the brightly lit and shadowed areas.

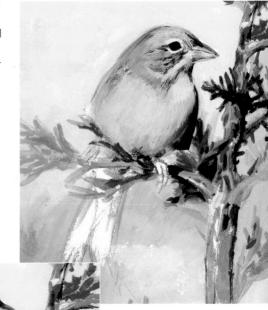

Step 6. Here, the artist works on the middle area of the painting. Spontaneous brushstrokes of orange are added to the feathers, allowing them to stand out against the yellow background. A very dark brown hue is applied to the feathers on the left-hand side, and, using longer brushstrokes, the same hue is applied to the bird's tail.

Step 7. The artist deepens the dark hues on the bird's tail, giving it the finishing touches. Dabs of green are applied to the branches in the center, and the feet are defined with a pale brown hue. Orange and dark brown define the relief areas of the tree trunk.

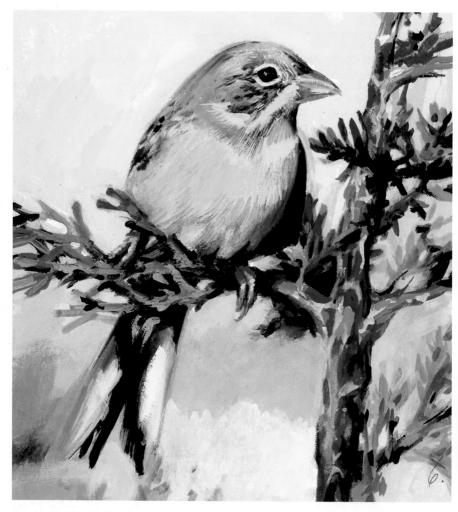

Step 8. Finally, all of the leaves on the left side of the image are depicted using green hues. To summarize, the artist started with the foundation colors, then progressively incorporated blends of hues until the painting's details were completly defined.

SUMMARY

• Thickly applied gouache colors allow the artist to take advantage of opaqueness to overlap colors. But unlike painting with acrylics, impasto effects are not possible in painting with gouache.

• Flat paintings, like those used for many illustrations, require gouache to be applied thickly for opaqueness.

• Synthetic brushes are best for working with gouache. Sable-hair brushes are too soft for gouache paint and ox hair brushes are too stiff.

• The intensity of gouache colors changes upon drying. The artist must wait until the painted areas dry before deciding if it is necesary to overlap colors.

• The covering capacity of gouache allows the divisions between the background area and the figure to be established at the end of the painting process.

• Gouache paintings turn out to be very fresh and spontaneous if the brushstrokes are distinct and the paint is loosely aaplied.

• The opaque quality of gouache allows lighter hues to overlap darker ones.

DIRECT COLORS

Pastel

UNMIXED COLORS

Working with unmixed colors always implies the use of splashes of pure color. Because the colors are not blended, the changes from one hue to another are very distinct. Here pastel chalk will be used to demonstarte the application of unmixed colors. These directly applied non-blended colors are very intense. Blending pastel colors causes them to lose some degree of intensity because the pigment is spread out instead of being left compact and concentrated.

Although the pastel technique has always been associated with color shading techniques, there are actually several ways it can be used. Pastel is especially suitable for outlining and for creating textural effects. Edgar Degas was one of the first artists to exploit the medium's texturizing qualities. In his pastel work, he juxtaposed colors with distinct, sharp strokes, directly applying colors and overlapping hues.

1. First, using pastel chalk, Prussian blue is applied to a gray colored paper to depict the darkest areas of the sky and the sea. Color is directly applied by strokes of the chalk using a verticle direction for the sky and horizontal for the sea.

2. Then, a new lighter blue is added to define the clouds. In this case, circular stokes of the chalk are used, creating a sense of rounded, atmospheric volume.

3. Finally, pastel chalks are used for directly coloring the entire surface. This way of working with pastels does not involve blending, and the result is more direct and simple than the blending method.

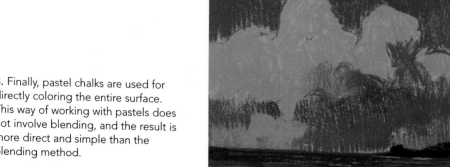

VARIETIES OF HUES

Pastels offers a greater variety of hues than many painting techniques. Most techniques require adding white manually to lighten a hue, but in pastel, the hues are already manufactured. Colors in a purchased box of pastels commonly included many shades of pink, blues, greens, oranges, lilacs, grays, and browns. All of these range in intensity from the lightest pale hues to those close to being pure colors.

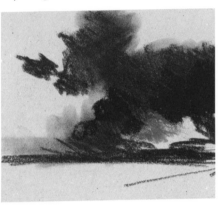

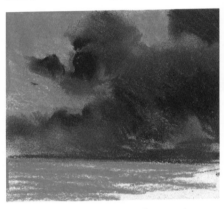

1. To create this composition of sky and sea, the artist uses a range of directly applied blue colors. Then, Prussian blue in all of its intensity is applied to create a dark hue, which in this case, adequately portrays a storm.

2. Light blue is spread directly onto the paper to depict areas of fine clouds, as well as to indicate the ocean's surface. The strokes of pastel chalk are applied horizontally this time.

3. To conclude, the artist determines all of the colors needed to faithfully portray the stormy landscape. Lilac and brown hues are added to the sky, and direct white strokes are applied to the sea to indicate the reflections of light on the water.

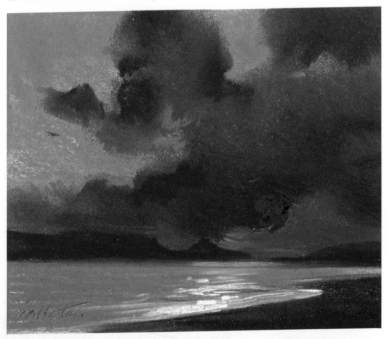

FINE STROKES OF COLOR

Pastel is an appropriate technique for working with fine lines and splashes of color. Color splashes tend to be used on large or medium-sized spaces. Finely drawn lines, on the other hand, show the direction of movement and indicate the details. In landscapes, the lines are indispensable for depicting vegetation.

1. The artist begins by applying fine strokes of color. Dark gray is used for the mountains, and areas where light falls are left uncolored. Then, the green colored foreground is sketched with a light horizontal stroke of pastel chalk. To continue, some fine orange strokes are used for contrast in the sky.

2. Using his or her fingers, the artist now blends all the colors to cover the paper's surface. Orange and pink hues are blended in the sky, and on the foreground, green is spread from one side of the paper to the other. A mass of dark color depicts the darkness of the mountain. Lighter hues can now overlap darker ones.

3. Now, in order to define concrete elements, fine strokes are directly applied to the large splashes of color in the background. Yellow and orange horizontal strokes are used in the sky to depict sunlight. At the horizon, blue strokes of pastel indicate vegetation. Finally, a white square shape is used to represent a house.

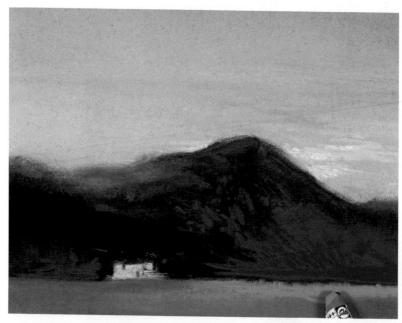

GRADIATION OF HUES

In the large range of pastel colors, there are many more light hues than dark ones. Many pastel chalks contain white since the pastel technique always allows for the overlapping of light hues over dark ones. Works in pastels start with dark backgrounds over which light is incorporated. The artist begins by establishing tonal values with black and white. Then the rest of the hues are incorporated. In using pastel chalk, these layers are easy to establish because the chalks are able to cover broad, extensive areas.

1. Pastels require a quite different treatment than those involved in painting. For covering large spaces with pastels, it is necessary to spread the colors, and for small elements, fine strokes of chalk must be applied. In this image, colors are spread out to cover the sky. Then distinct strokes are used for the land and the sea.

2. Next, the foreground mounds are colored with brown hues. Distinct strokes of green and reddish hues are applied over these to define the bushes.

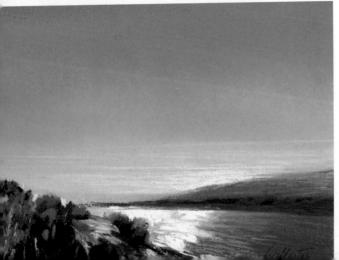

3. To finish, the artist creates intense contrasts by applying white to depict the light reflected in the sea and black to show the shaded areas under the leaves. These newly incorporated colors develop the tonal scale.

Step by Step

A Stormy Sky

MATERIALS
Pastels, Fine-grained paper, Paint rags

Paintings in which the sky is the main subject are a very appealing for many artists. An open window, or any space open to the outdoor nature, offers a wide range of pictorial possibilities. The artist can choose from foggy scenes with overlapping gray clouds, or warm orange-colored sunsets, or clear sunny days. In most landscape painting, it is customary to establish a horizon line, which helps the artist to determine the placement of the sky and serves as a guide for depicting the atmosphere of the setting.

Step 1. Dark gray is used to outline the forms. In the lower area of the image, there is a mountainous horizon. Since most of the space corresponds to the sky, the shapes outlining the clouds are now drawn.

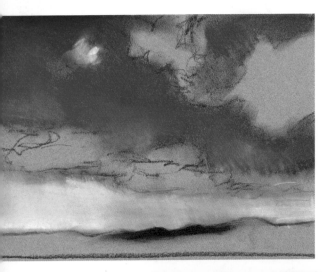

Step 2. Now, an intense blue hue is used to paint the upper area of the image. The areas corresponding to the highest clouds are left the color of the paper, and a bright light blue hue is applied to the area bordering the horizon. This area also forms part of the background.

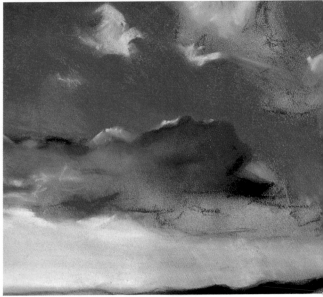

Step 3. The artist begins to define the clouds with different gray hues. Working on the left-hand side of the image, darker and more intense gray hues are added to contrast with the lighter lower area of the sky. Whitish hues are applied to the rest of the clouds.

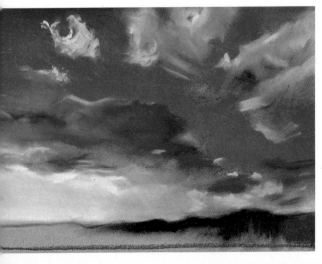

Step 4. To continue, the artist begins to add gray hues to the highest clouds, to give them volume. Next the artist darkens the mountains to contrast them with the sky and with the blue shadows on the right-hand side.

Step 5. Now the mountain are completely covered and the entire lower area of the picture is filled in. To increase the contrast, fine strokes of white are added to the left-hand part of the sky bordering the dark mountains.

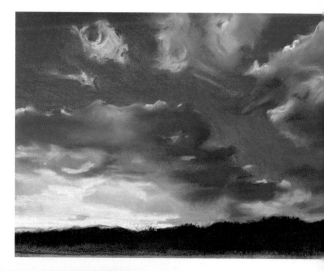

Step 6. The white hues are toned down to in order to unify the colors. Then fine blue strokes are added to define the fragments of sky that appear behind the cloud shapes.

Step 7. The blue splashes of color are now lightly-toned down, allowing them to be integrated with the sky's atmosphere. Fine yellow strokes are added to the white areas making them warmer. Overlapping pink hues are applied to the upper right-hand cloud. These hues harmonize with the already present grays.

Step 8. To finish, the mountain's darkness is intensified, maximizing contrasts. In summary, large masses of color have been established on the paper. Then, pure non-blended strokes of pastel were applied over these masses, creating changes to the hues in the clouds.

SUMMARY

• Pastels allow for the techniques of blending, detailed effects, and overlapping colors.

• Directly applying hues of pastel chalk creates splashes of pure color. These colors are not mixed.

• Values are achieved in pastels through using of dark hues. Lighter hues are added progressively over these dark ones.

• There is a greater variety of pastel colors than in other techniques because of the large number of pigments that are combined with white.

• A completely darkened pastel foundation serves for the later application of ligh colored pastel hues.

• Light hues and those that are mixed with white form diverse colors of chalk. "Pastel" is the name of these colored chalks.

• Splashes of color are applied to create backgrounds and to fill in large areas; fine strokesof pastel chalk are used for details.

10 BLENDED COLORS

LIGHT AND DARK COLORS

Because of the large number of pastel hues, mixing colors is unnecessary. Blending in pastels is used to unify colors, not to create new ones. For example, to create gradations of grays, black is not mixed with white, but instead, hues of different values are applied and then blended together with the fingers.

The pastel technique is very suitable for blending and blurring colors. Pigments are applied to the paper either by direct contact or by blurring. Both of these methods can be used to gradually spread colors over a surface. An artist can blend pastels with a cloth, a tissue, with specially made blending stumps, or even with the fingers. Because of the direct contact in this technique, the artist has more control over the strokes applied. And if the artist uses his or her fingers, their natural oil helps to better bind the color to the paper.

1. Here, three very different colors are blended by rubbing the colors toghther where they touch. Using the fingers to combine each of the together causes their dividing lines disappear. These colors become unified.

2. Depending on the area, colors will appear blurred to a greater or lesser extent. In this example of yellow bordering black, rubbing the area where the colors touch produces very little blending, and the change in colors remains obvious.

3. A paper stump is a tightly wound spiral of paper that ends in a point; it can be used to work with pastel or other pigment techniques like chalk or charcoal. These stumps can be used to move the pigment smoothly over the paper, thereby blending colors. They are especially appropriate for blending areas where two colors meet because the pointed end of the stump allows control of the blurring.

WORKING FROM DARK TO LIGHT

All techniques have their advantages and disadvantages. Pastels are fragile materials that can be very messy. If brushed against by mistake, a color can be erased or adjoining colors can be smudged onto the area where the artist is currently working, generally making it darker. Since the darkest hues are the messiest, the artist should work from dark to light. The artist only begins to work on the definitive and fixed hues after the general color strokes have been applied and the value scale has been established. Otherwise, excessive smudging can cause the colors to blend and lose their purity.

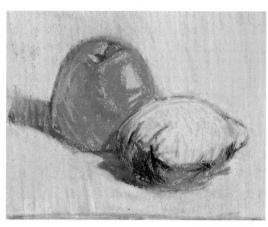

1. A simple still life in pastel demonstrates the way hues are blended as well as how dark colors are applied. To begin, all of the surfaces are painted using the appropriate strokes of color. In the background only one color is applied, but for the fruit, colors are alternated and various hues are overlapped.

2. The artist uses his or her fingers to unify the hues that touch one another. Dark hues tone down the lighter, pure colors as they are spread over them, creating shadows.

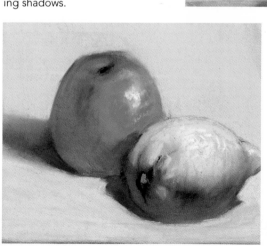

3. Blurring creates continuity and unifies the hues. The purest splashes of color, like those used on the background, remain unchanged, and the greens and yellows in the highlight areas have been left untouched. But wherever dark colors are spread over them, the green and yellow hues lose their purity. This happens in the lower areas where dark and tertiary colors develop, creating an impression of the lack of light.

GRADATION AND CONTRAST

In working with pastels, tonal gradations and contrasts are achieved in very different ways. Gradation is produced by blurring and blending lighter and darker or cooler and warmer hues. Smooth, flat areas can be achieved with this effect, and pigment can be spread in such a way that changes in hues are not noticeable. Contrasts, on the other hand, are achieved by directly applying color with a pastel chalk. These contrasts are produced not only by differences in hues, but also by layering pastel hues layered directly over others.

1. To illustrate gradation and contrast, the artist begins with a dark colored paper, indicating that strong contrasts will be created against the paper itself. Dark green is used to draw the branches and leaves, in the composition. Then the same hue is applied more lightly to outline the flowers.

2. The brightest color strokes are applied using yellows and reds. These create a strong contrast with the background color and the dark greens at the bottom of the painting.

3. All the colors are blended to create an atmospheric quality. The green hues are very dark, and blending these with the yellow hues causes integration with the surrounding colors. The yellows become subdued and merge with the vegetation.

BLENDED AND DIRECT AREAS

Works in pastel are created with a mixture of techniques, blending in some areas and applying direct strokes in others. It is very common to highlight a pastel chalk color by layering it directly over another color. Doing this blurs the underlying color. Usually the background colors are blended, then splashes of colors and defined strokes are used to establish the elements of the composition.

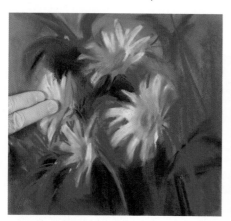

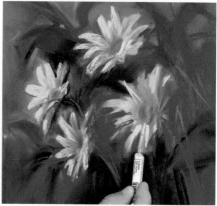

1. Black hues are applied in the center to achieve a sense of depth. These hues also help to define the large leaves distributed within this space. Greens hues are then blended with yellow hues on the petals to create a foundation depicting their volume.

2. Directly applied, fine strokes of yellow are applied over the petals. These are then blended with the hues referred to in the previous step, allowing the definitive bright colors to stand out and shine brightly.

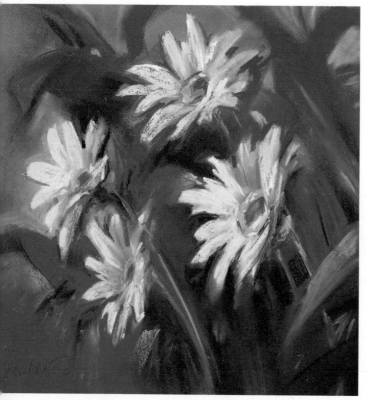

3. The final step is to add the fine details by applying direct strokes over the blended areas. This causes the stems, the large leaves, and especially the petals to stand out. Also, an intense contrast is set up between the petals and the surrounding colors.

Step by Step

A Composition of Fruit

MATERIALS

Pastel chalk,
Fine-grained paper,
Paint rags

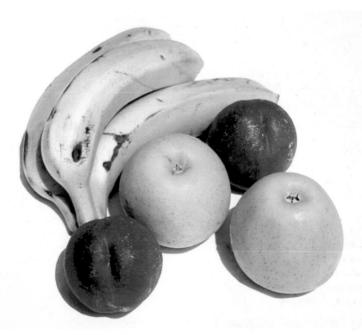

When painting a still-life, fruit of various colors and shapes makes a perfect theme. After the artist sets up the arrangement and decides the technique with which to work, the choice of lighting needs to be determined. Either natural or artificial light can be used, natural light being the usual choice. But because artificial light can be regulated to a greater degree, the artist has more control over the light, allowing the exact, unchanging light to be used in the composition.

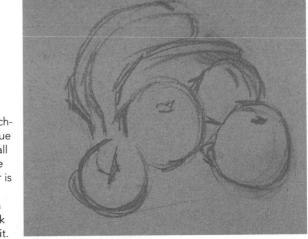

Step 1. First, the artist sketches a still-life with a brown hue using this neutral color on all of the fruit regardless of the kind. The background color is also very important, and a medium gray hue is chosen because both light and dark hues will stand out against it.

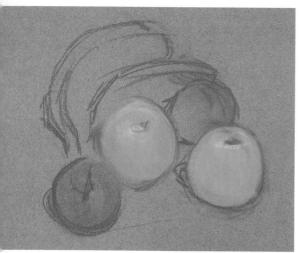

Step 2. The artist begins by distinguishing the round fruit. To do this, red, green, and yellow hues are alternated. In order to depict the volume of these objects, the artist applies the color strokes in the shaded areas more heavily and in the areas where light falls with lighter strokes.

Step 3. Next, an orange-yellow hue is applied to the bananas, following the direction of the wide curve of their form. Then, a dark brown hue is added to one piece of fruit to create contrast with the previously applied colors.

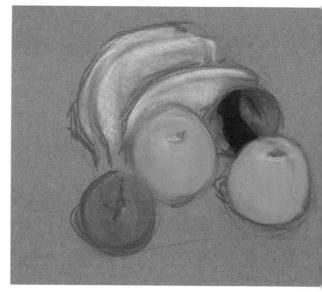

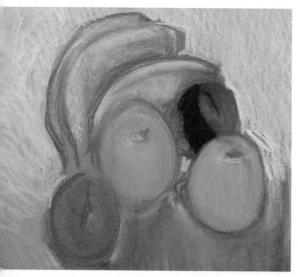

Step 4. Now, splashes of pale yellow and blue hues are applied to the background. Short, light color strokes are applied to the part of the upper half of the image that receives more light. A blue color is used on the lower half. Since it is a very strong color it is blended to decrease its intensity.

Step 5. Now, the pieces of red fruit are given contrasts with a dark brown hue. This hue is applied to the left side of the fruit and to the stems. Dark blue is also incorporated to depict the projected shadows.

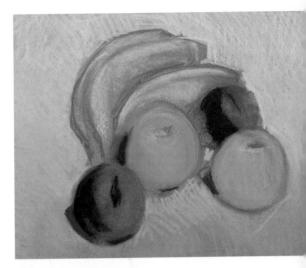

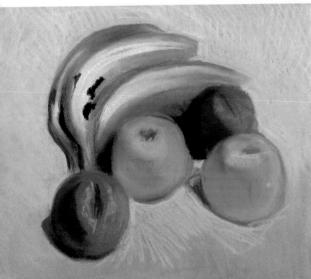

Step 6. Next, the contours of the bananas are defined by blending the yellow color with the brown hues used as the foundation. Then, green hues are added to the ends of the bananas. Finally, dark shadows are used to separate the pieces of fruit and to increase the contrast between light and shadow.

Step 7. The artist now finishes the details, the outlines, and the projected shadows so that the individual shaes can be clearly distinguished. Then, contrasts and volumes of the red fruit are strengthened. Also, fine, direct strokes are added to depict the black and brown spots on the banana peel.

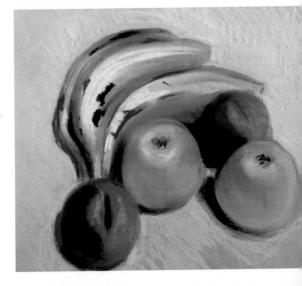

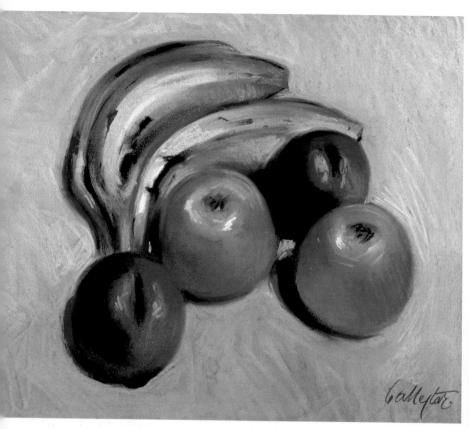

Step 8. To finish the work, the artist applies black for the final details and white to depict the shiny areas on the fruit. To summarize the important aspects of this exercise, color splashes are used to depict volume and fine strokes to define shapes. In the background, colors have been both blended and layered with light strokes over the blended blue color. The resulting composition has both an appealing texture and character.

SUMMARY

• Pastel, like painting in oils, is one of the most appropriate techniques for blending and blurring.

• Pastel's blurring process involves spreading the pigment out over the surface of the paper.

• Dark hues are applied first and over those, the lighter ones.

• Blending with the fingers is very appropriate because the skin's oil helps to fix the pigment to the paper.

• There are many different ways to blend pastels. For example, a cotton ball or cloth can be used on large areas, and fFor more detailed areas, a blending stump can be used. And, of course, the artist can use his or her fingers for any colored area.

• To blur outlines, the edges are rubbed in such a way that colors blend without the need to mix hues.

• Gradation is produced by blurring and blending, and contrasts are created by applying colors directly with the pastel chalk.

LIGHT ACCORDING TO BACKGROUND

Contrasts between light and shade are intensified according to the lighting which is present. The more light there is, the stronger the contrast. However, the type of lighting used, is also important. Diffuse lighting leads to faint shadows, and strong, direct light creates an effect of dramatic shadows. Light coming from behind the subject causes the entire image to be shadowed, but if the background is completely darkened, the subject will appear light against it.

From its beginning, the medium of pastel has been used for works of accurate realism. Blending with pastels allows the artist to create the same volumes as those achieved in oil painting, capturing every detail. With the introduction of Impressionism, pastels were no longer only used to create realistic works. Artists began applying the chalk with short, distinct strokes, and new stylistic possibilities unfolded for this richly colorful technique.

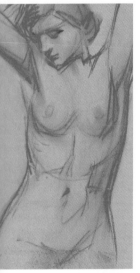

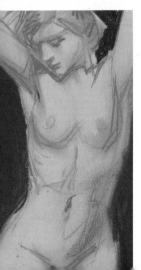

1. In this demonstration, the artist first outlines the figure with a bright red color. The artist knowledge of anatomy is taken into account to correctly proportion the model's body,. The same warm hue used for the background is also used for the figure.

2. Next, the background is darkened to allow the colors on the figure to appear brighter. Although light hues have still not been applied, the darkness of the background serves as a reference for the maximum amount of darkness in the work. Now the artist can choose colors to be used on the skin which will establish the volume of the figure..

3. Finally, cool colors are applied to the model's skin. These hues must be toned down because, otherwise, the image is excessively warm. Black is used to give finishing touches to the chiaroscuro details produced on the woman's hair and face.

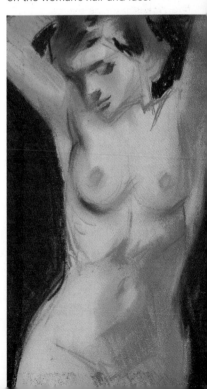

STROKES AND SHADES OF COLOR

Pastels are frequently applied with concrete, defined marks called strokes, and when these strokes are joined together to fill areas, they are referred to as color splashes. Strokes of pastel color give shape and texture to a com-

position. The artist must apply strokes o foundation hues to establish specific ele ments before concentrating on hues for light, shadows, and reflections. The gen eral strokes are now enriched with new hues called shades, which are blended c applied directly. Shades are the colors that combined to form volume.

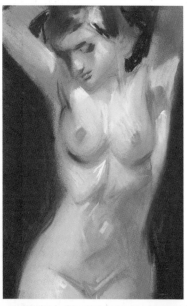

1. Here, new strokes of bright hues are applied to the figure. These strokes bring out the figure's volume. On the right, cool blues and violets are blended with the warm red outlining the figure. The main areas of light are placed in the mid-section.

2. The hues are now blended to create a smooth surface. White, when incorporated over the background color, leads to a light, bright flesh tone.

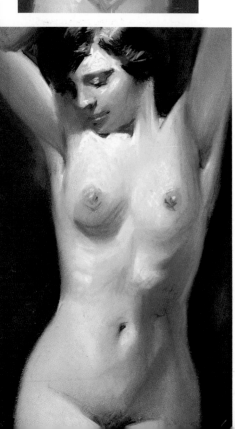

3. Next, all of the hues are unified and contrast is added. Then, dark hues are added to the left side and under the arms, creating dark shadows which define the figure's volume. Finally, the artist creates bright areas on the figure's forehead, cheeks, and breasts.

FLATNESS AND DEPTH

The depth of field is of great importance in all two dimensional media used to portray reality, including painting, drawing, and photography. The human eye is limited and needs to focus on one point or another in order to see correctly. If the eye focuses on an object close-up, background objects will appear blurry, and vice versa. In drawing and painting, it is possible to falsify this focus by defining details in both areas. In traditional painting, however, it is common to only enrich forms, colors, and details in the foreground. The background is generally blurred and made atmospheric, giving much greater depth to a composition.

1. In this demonstration, the contour of a model's back is sketched with dark gray hues. Deep blue paper is used for the background, creating a very cool atmosphere in the painting. Cool hues also cause objects appear farther away and help to create a sense of depth.

2. Next, the background is shaded with pink and green hues. These colors overlap the blue hue without completely covering it, and the colors are applied lightly so that the cool background hues will show through. Then, shaded hues are applied to define the figure's legs and spine.

3. Finally, light skin-toned hues are added to the top portion of the figure where the light falls. The blue color is left untouched in the shaded areas. The warm and bright skin colors contrast strongly against the background, making the figure appear close-up against the distant-appearing cooler hues.

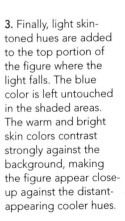

FRESH FINISH

Originally, pastels were used to produce detailed, realistic compositions. But when artists realized this medium could be used for overlapping and for fine strokes, pastel took on new mean-ing. Artists began using these new treatments in an infinite variety of styles. Since works of art in pastels rely heavily on the background color, which plays an important role in the final hue, they are characterized by the speed in which they can be created.

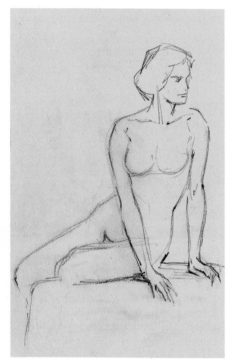

1. First, the artist outlines the figure, making sure that the composition is correct. The background color is similar to human flesh tones, which will be taken into account when applying the color strokes.

2. The artist now tries to create an impact by applying the first color strokes to the image. Greenish hues alternate with browns and oranges on the skin. But lighted areas are left untouched, preserving the color of the paper. Next, a deep blue hue is applied to the background without completely filling in the space. Blue is applied only in the area surrounding the model.

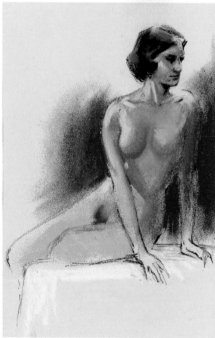

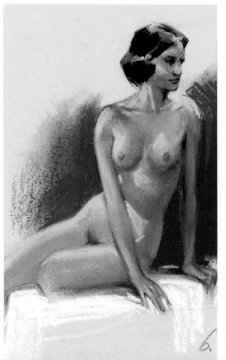

3. The artist finishes the work by adding volume to the hair and giving other details to the figure. The upper body is well defined, but the legs are hardly touched, giving them the effect of an implied sketch. Many areas in the painting are left unfinished, creating a quick and fresh impression in the painting.

12 PASTEL COLOR

Pastel

THE STRENGTH OF CONTRASTS

Contrasts can be established through the use of light and shadows or by using complementary colors. In an earlier discussion, the difference in strength between light and dark colors was mentioned. Here, contrasts set up by the nature of the pigments themselves will be described. Warm and cool colors can be combined in such a way that they clash chromatically when placed side by side, allowing extreme contrasts to be produced with complementary hues.

Pastel is one of the most gratifying mediums used to create pictorial representations for three main reasons: First, working with pastel chalks allows the artist to use gestures and strokes which are characteristic of drawing. Secondly, pastel chalks are made with high quality, dense pigments, guaranteeing a strong color impact. And third, the wide variety of hues offered by this technique allow for works of art which are rich in colors and shades.

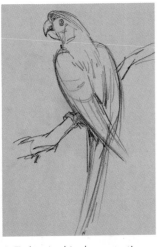

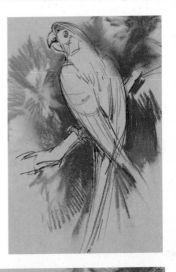

2. Next, fine strokes of green are used on the background. The bird's contour is left untouched so that the colors don't run over. The strokes are drawn freely and loosely to imitate the different directions of the branches.

1. To begin this demontration, a black charcoal pencil or pastel chalk is used to draw a macaw. This bright-colored bird serves as a good example for studying intense contrasts.

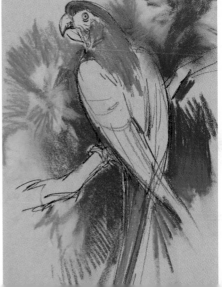

3. Now, the artist applies bright red hues to the feathers on the macaw's head and tail. Because the red is complimentary to the green hues used on the background, a very strong contrast is created from the very beginning stages of the process.

OPAQUE COLOR FROM IMPASTO

With pastels, the artist has the option of working directly with the flat side of the chalk. These wider strokes can later be used as a foundation for gradations of colors. Even if the colors for an area are not to be blended, using the flat side of the chalk will leave a lot more pigment and allow an area to be filled in much more quickly. By applying enough pressure when working with pastels, the artist can create an opaque, intense color.

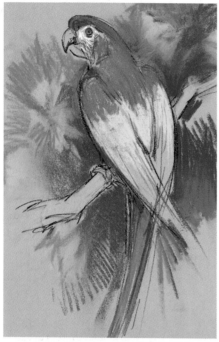

1. The artist continues working on the macaw by applying yellow strokes to the feathered areas. Then, orange is used to fill in the outline of the branch. Since the colors are applied without any blending, the hues obtained are the brightest possible.

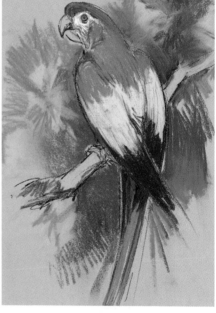

2. New feathers are applied with dark blue. Then, the artist retouches both the bird's contour and the branch to make them stand out against the background. Since the artist's intention is to highlight pure color, the pastels are left blended.

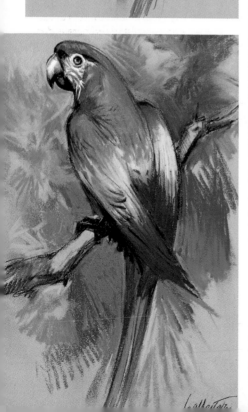

3. The painting is completed by adding black to the darkest features and to the concrete elements. Color is applied very thickly, giving it an opaque effect. And because the colors are not blended, the hues appear very pronounced and pure.

CHROMATIC CONTRASTS

In works of art in which color plays an important role, chromatic contrasts are set up as a foundation. In these works of art, the maximum color contrasts between complementary hues are emphasized. Consider bright colors, like yellows and their adjacent colors, light greens and oranges. If the complementary hues to these colors are applied against a dark background, the contrast will be more intense. This occurs, for example, when placing colors like deep red and light green, ultramarine blue and pale orange, or deep violet and yellow, side by side.

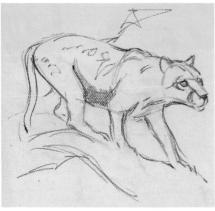 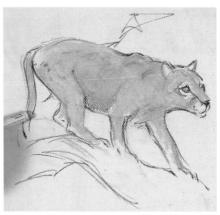

1. The artist begins by sketching a leopard perched on a branch. Loose strokes of chalk perfectly depict the animal's stealthy movement and the curves of its body against the background. At this point, the artist isn't concerned with the details of the animal.

2. Next, the artist applies thick color to the areas corresponding to the animal's fur, achieving an opaque effect. An orange ocher is spread over the entire surface, except on the face, where details need to be distinguishable.

3. Now, the background is given green and blue hues that contrast with the warm oranges and reds on the animal's coat. The contrast noted here is due to chromatic complements. And when black and brown strokes of colors are applied to the coat, even more contrasts with the rest of the colors develop.

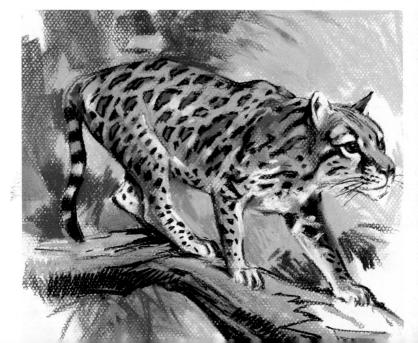

LIGHT AND ATMOSPHERE

In pastel, light colors are easily estab-
lished because white blends well with
all pastel pigments. A typical box con-
tains many light colors. The problem
lies in knowing how to apply these to
paper to achieve the desired result.

With pastels, the artist always works
from dark to light, beginning by apply-
ing color strokes to the shaded areas.
The lighter hues cover any other color
perfectly. When filling in large areas,
light colors can be gradated with the
darker hues to create the impression
of volume.

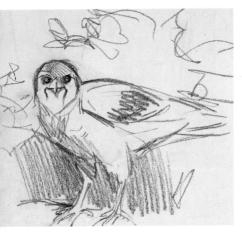

1. In this illustration of an owl, a gray
color is used which allows for the addi-
tion of both lighter and darker hues. The
artist draws a simple, schematic sketch so
that details can be added progressively.

2. Now, the artist works on the large
color areas. From the very beginning,
the effects of placing different colors
side by side will be observed. The black
hues shown serve as a reference for
maximum darkness. The rest of the
hues will stand out against these areas.

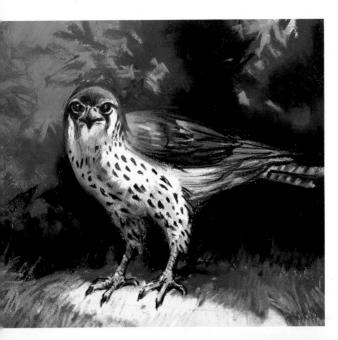

3. In the finished exer-
cise, it is obvious how
clearly the light hues
stand out against the
dark background. The
blue hues applied to the
brightened leaves con-
trast with the black used
on the shadowy back-
ground. The white color
applied to the owl makes
the bird stand out
strongly due to the light
and dark contrast.

A Deer

MATERIALS

Pastel chalk,
Fine-grained paper,
Paint rags

Artists who enjoy nature find portraying animals very appealing. In the past, animals were painted primarily for scientific reasons as a way to study morphological characteristics and to become familiar with an animal's anatomy. But soon, animals began to be incorporated into paintings with naturalistic settings, like hunting scenes. In these works of art, the focus tended to be on people rather than the animals. Now, this concept has changed, and the portrayal of animals has become a decorative or artistic theme, as valued as the portrayal of people in works of art.

Step 1. In this exercise, the artist uses a brown hue to portray a deer in a natural environment. The very detailed outline allows the animal's volume to stands out against the uneven ground.

Step 2. Next, new gray and brown hues are added to depict the deer's body. Then, the foundation colors are blended, and ocher hues are applied with fine strokes, to overlap these colors. Afterward, the artist begins to work on the background using light green hues. In this way, a primary chromatic reference between the background and the figure is established.

Step 3. The artist continues working on the background, which is an important part of this composition. Different green hues are alternated to create a sense of variation. Gray hues are now blended into the background, but in the foreground, colors are applied in unblended, direct strokes.

Step 4. The brown hues on the animal's coat are contrasted by adding black to the combination of colors. In this way, the animal's back is very bright because of the light brown hues that are used, whereas the lower part of the animal is now intensely shaded.

Step 5. The artist continues to apply direct vertical lines of black that cause the deer's head and antlers to stand out. Then, more green hues are added to the background, especially on the left side of the image. Afterwards, overlapping blue hues are added to this same area.

Step 6. Now, the colors applied to the neck area are blended to create uniform volume. Short, fine strokes are added to the back to give the appearance of fur. New green colored strokes, which are cooler than those used on the background, are applied to the grassy area of the image, creating an effect of depth.

Step 7. Next, gray and black hues are added to the areas corresponding to the rocks. Dark gray hues are used to retouch the lines of the antlers and to shade the deer's legs, giving them definition. Finally, the same hue is used to form the animal's shadow projected onto the ground.

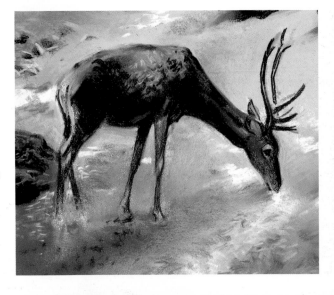

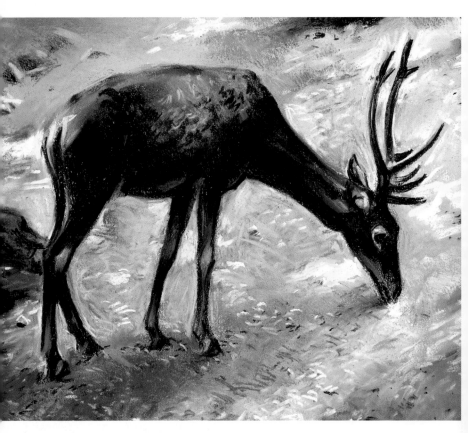

Step 8. To finish, black is used to define the legs and hooves. Afterward, the same hue is used to shade the head and antlers and to outline the ears. Fine strokes are applied to depict the texture and rich shadows that make up the grassy area.

SUMMARY

• Juxtaposing hues that are complements produce the most extreme contrasts.

• Pastel chalks are made of the highest quality pigments, offering chromatic richness.

• By setting up light and dark effects, contrasts in brightness are emphasized, whereas different colors placed side by side create chromatic contrasts.

• Working with pastel chalk allows a great command of stroke and gesture.

• Warm and cool colors contrast because they produce impressions of proximity or distance.

• Pure colors emit different degrees of light. Yellow and its adjacent colors are the brightest.

• While blended colors provide subtle shades; those applied directly can be opaque and will allow extreme changes in color.

Watercolor

DAMPENED PAPER

Painting with watercolors, the best wet technique there is, on very damp paper allows applying uniform brush-strokes without leaving marks of the brush. An artist can also produce very different effects in watercolor by letting the paint dry between colors or by using color blends. When the blends cover a large area, such as the sky, the artist begins by dampening the paper. Then, colors are added so that they automatically mix together on the wet paper. The results of applying watercolor in this way can be quite surprising.

The wash technique is used both for monochrome and multi colors. The artist's main concern is to control the density of the wash when applying brushstrokes of color. The hue must be spread over an area to correctly define each element. Command over materials in working with watercolors is more difficult than with other techniques, since the diluted pigments appear to have a mind of their own. This makes the watercolor technique both difficult and appealing for the artist.

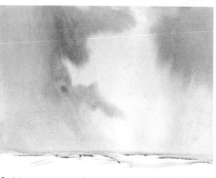

1. For this demonstration, the artist begins by dampening the paper. Then, a blue wash is applied to the damp surface. If the brush holds enough pigment, the result will be a solid mass of color filling the entire area, and there won't be any noticeable brush marks.

2. Next, new strokes are added over the wet area to create cloud shapes. Notice that, because the paper is damp, the blue hue spreads and blends with the first layer. No brush marks show, and the artist achieves a perfectly atmospheric effect.

3. Now, more specific brush strokes are added to the lower part of the image. There is a clearly observable difference in the blending of hues in these two areas, since the area corresponding to the ground was dry and the area in which the sky is painted was damp. The artist now finishes the painting by depicting details with more precise strokes.

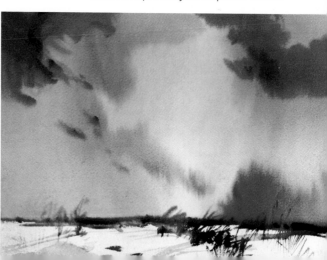

GRADATION IN WATERCOLOR

Watercolor is probably the best technique for the process of creating gradation of tones. The method of accomplishing gradations depends on the area to be covered. For backgrounds, where broad and homogeneous tones are frequently required, wide or medium brushes allow smooth, uniform brushstrokes. For gradating small spaces, fine brushes are used. In specific areas, such as clouds, the artist can create varied gradations by adding water. Since white is not used. Only the transparency of the paper itself is used to create lighter areas. The artist simply adds water to the paper without any other color.

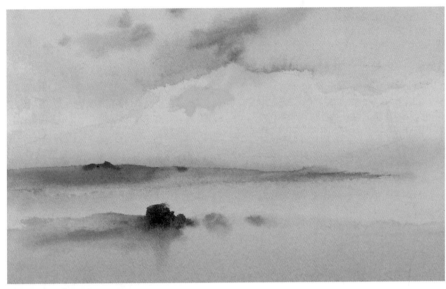

1. In this example, the artist applied a uniform color foundation and then brushstrokes of color. To achieve a uniform base, the paper was dampened, and the artist used a wide brush. Then, precise brushstrokes were added which blended with the other colors, leavimg a clear mark when there were changes in both the hue and the brush.

2. A wide brush, recommended for backgrounds, allows the artist to apply a large amount of paint. If a fine brush were used, distracting brush marks would be left on the image. These marks would appear because the paint would dry before the entire area was filled in.

3. In watercolor technique, colors blend due to transparency. The artist applies less pigment which then blends on the paper. In the area where the loaded brushstroke first touches, the hue is at maximum intensity. Subsenuently, the intensity is reduced by adding water.

DRYING TIME OF COLORS

When an artist has command of the medium, any subject or theme can be portrayed in watercolor. Of all brush techniques, watercolor is the most spontaneous. When enough water is used, blends are produced immediately. This factor makes the technique appropriate for painting landscapes and other forms found in nature. The paper can be dampened overall before colors are applied. To apply precise details, the artist waits for the previously applied layer to dry so that this blending on the paper does not occur.

1. To study the effects of different drying processes on the element to be painted, a landscape theme will be illustrated. To begin, very diluted colors are used on the sky and background, creating a color blend between the blues of the sky and the greenish hues used in the distance.

2. To produce a different effect for the main tree and the thicket, the artist follows a different drying process. The artist still intends to work on a damp surface to blend hues, but these new areas must be separate from the background and identifiable as independent elements. To accomplish this, the artist waits until the previous layer has dried before incorporating these new strokes.

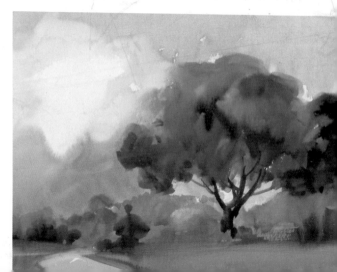

3. Finally, the lower area of the image is filled in with green hues which form the grass and paths. Since the strokes for the tree trunk need to be more precise, the artist waits until the background is completely dry before applying the new hue. This process results in clearly distinguishable brush strokes of color.

REMOVING COLOR

Occasionally, an artist decides that too much paint has been applied to the paper. If the intensity of a hue needs to be reduced, fresh water is applied and mixed into the painted area. Then, the brush is used to absorb excess liquid over the entire area. Since the brush absorbs pigment and water, it becoms very wet and should be frequently cleaned and dried with a cloth, ready to be used again. Removing color involves adding water to dilute the paint and then absorbing the excess liquid.

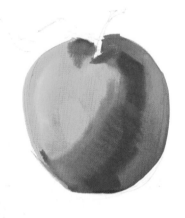

1. To demonstrate, color is directly applied to represent an apple, using several hues from the very beginning to give the apple the necessary volume. The brushstrokes follow the apple's round shape to help achieve this sense of volume.

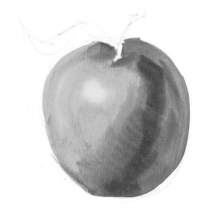

2. The artist then creates a bright area on the left center part of the apple. To achieve this new hue the artist needs to remove paint in this small precise area. A dry brush is used to absorb excess color and wetness from the foundation color.

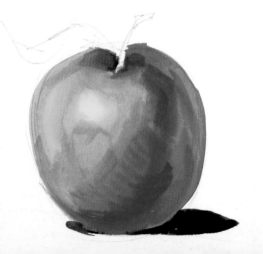

3. Adding black to the image strengthens the contrast. When these shadows are incorporated, the true brightness of the previously created area becomes obvious because of the contarsts that are set up.

A Landscape

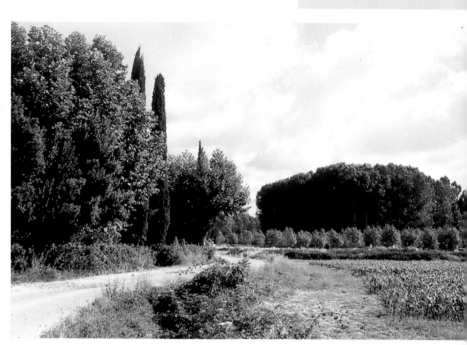

An artist can modify nature according to his or her own criteria. In the case of this image, for example, the clouds and vegetation include a variety of hues that the artist wants to convert into warm colors depicting a sunset. The purpose of this exercise is to study how watercolor can be used to define the texture of each one of these elements.

Step 1. The artist makes the foundation drawing with a sanguine crayon. From the very beginning, the landscape is established by this warm hue. The sketch now calls for using a wider range of warm colors applied with short, distinct strokes which will be blended after the wash is incorporated.

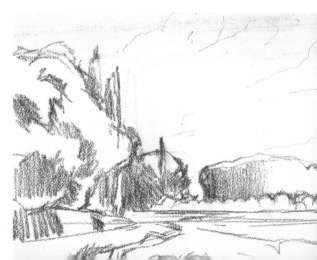

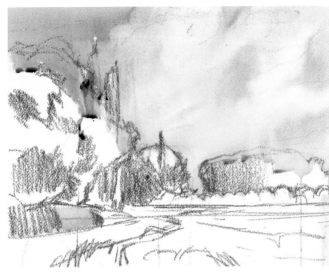

Step 2. The area corresponding to the sky is now painted with a diluted burnt sienna. A reddish blend now begins to develop. This blending occurs when the sanguine lines come into contact with liquid hues of watercolor, creating a very warm color.

Step 3. The artist now establishes a wet surface for creating the atmospheric cloud shapes. A sepia color is added to the background with blended brushstrokes that create various gradations. Working on wet paper is fundamental to painting the sky in a landscape because of the atmospheric effect the technique produces.

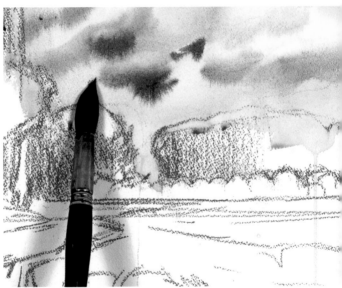

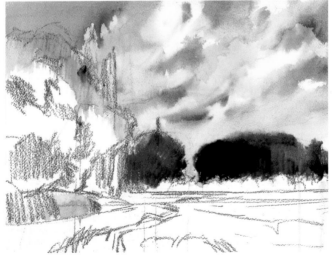

Step 4. The trees in the distance on the right are filled in with a sepia hue. Since these are areas of maximum darkness, the brush should be loaded with pigment. In order to prevent these dark shapes from blending with the hues of the sky, the artist allows the sky to dry before painting the dark hues.

Step 5. The area on the left side corresponding to the large trees is now filled in with a mixture of sienna and sepia hues. Then, a diluted sienna color is used for the areas where light falls. But here, the sienna hue is applied more intensely than when used for the sky. The artist continues to use a deep sepia color for the darkest areas.

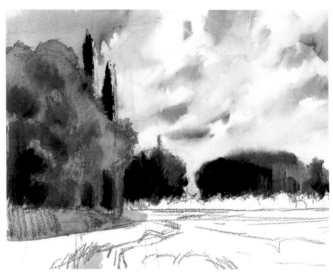

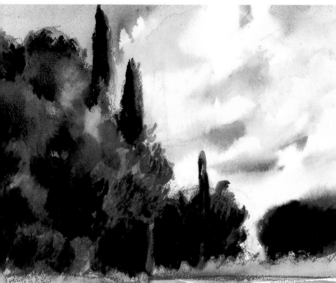

Step 6. Next, the trees on the left are given detail using precise brushstrokes to depict various shapes in the forested areas. Both shadowed and small bright areas are then added to these sections corresponding to branches and leaves.

Step 7. As the painting advances, the brushstrokes applied become more precise, requiring a fine watercolor brush. The artist must wait until each layer dries before applying another so that the strokes will be well defined.

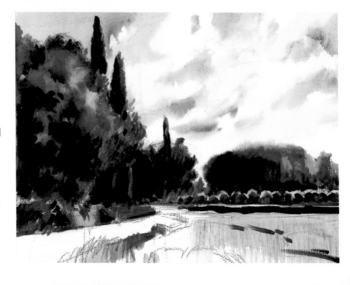

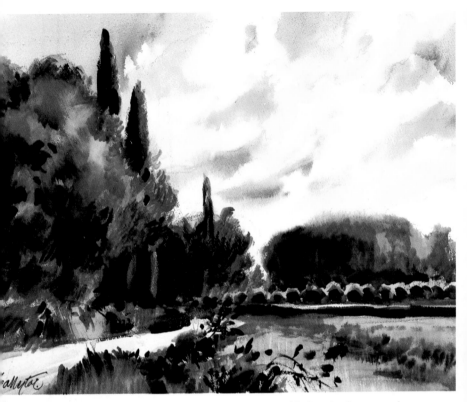

Step 8. Finally, details of the branches and leaves are added to the foreground with precise brushstrokes. In summary, the scene was created in monotone hues using a combination of the transparent and opaque qualities of watercolor. The exercise illustrates the behavior of watercolors when blended.

SUMMARY

• In wash techniques, it is very important to control the concentration of the pigment when applying brushstrokes to specific areas.

• Establishing various planes in a work of art gives it a sense of depth and a three-dimensional effect.

• To make an area of the foundation color brighter, the artist uses a dry paintbrush to remove excess water and pigment.

• Dampened paper allows the artist to apply uniform strokes without noticeable brush marks.

• Large blended areas should be worked on with a wide brush since it holds more color.

• Small brushes are appropriate for defining shapes and details or to gradate a very small area of color.

• In working with watercolor, if the quantity of water is increased and the amount of paint is decreased, a transparent effect is created.

• Because watercolor is difficult to remove or correct, the best advice is to apply only definite strokes from the very beginning. Also, the artist should work progressively from dark to light.

• To portray detailed shapes, the artist should wait until the foundation painting is completely dry, otherwise, the strokes will blend and become indistinguishable.

14 DRY WATERCOLOR TECHNIQUE

Watercolor

NEARLY TRANSPARENT COLORS

In watercolor, hues are most intense when very little water is added to the pigment. And inversely, the color will be less intense the more water that is added, thus producing dilute, transparent hues. These pale hues are used to create bright areas, and are mixed with more pigment to become progressively more intense. Transparent colors should always be applied first in watercolor, and dark hues applied over them.

Painting dry pigment onto a dry surfacehe is the classic technique for achieving exact and defined outlines in watercolor. The finished painting is characterized by distinct forms in which the brushstrokes and changes in hue are clearly noticeable.

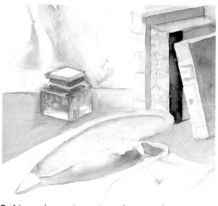

1. First, a gray hue is applied to the background, and then a pale red color is applied to the surface of the table. Because these hues are used in large and open areas, they are very transparent. Later, more definitive glazes and shades will be applied over these hues.

2. Now, the artist paints the gray hues corresponding to the white feather and its shadow on the paper. Because these areas are light, the colors are as transparent as possible. The first intense hues applied in the painting are then used for the books.

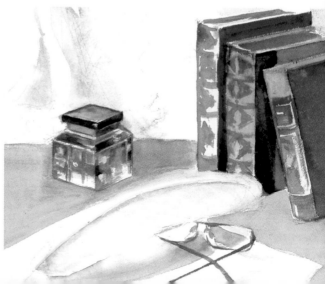

3. More intense hues are used for the books' foundation colors and their shadows. These colors are given contrast by using black. Finally, the hues for the inkwell are intensified with new gray hues that have a darkening effect. Throughout the painting, darker colors have been applied gradually until arriving at last at the darkest shades.

THE DRYING TIME FOR WATERCOLOR LAYERS

In watercolors, paint is progressively applied to the paper with successive color layers. Because this watercolor pigment dries quickly, the artist is able to make more immediate additions or changes than when using other painting techniques. To vary or tone down a color, whether it is with a stronger hue of the same color or a different hue altogether, the artist should wait until the previous layer has dried. Otherwise, the result will be a blended color rather than a glaze.

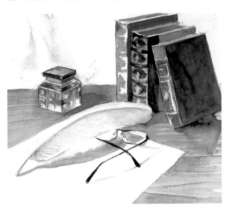 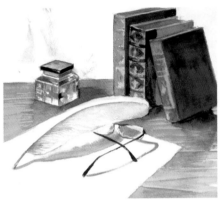

1. In the previous composition, new brushstrokes are used to define the texture of the feather. The artist uses very diluted paint to apply these shades of white. Then black is directly applied to the glasses with a fine brush. The surface of the table is then painted with glazes to simulate the grain of the wood.

2. Glazes are also used to intensify the shadows projected onto the table by the books and inkwell. A black hue is used for these shadows. The artist also works on the shadow projected by the glasses, using a somewhat diluted black color applied with a fine brush.

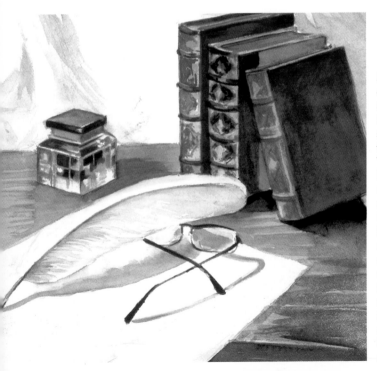

3. Details and contrasts are then added to the books on the right side and to the table's surface. The colors have been in-corpo- rated in stages, starting with large, light-colored brushstrokes and ending with dark- er, more concrete shapes. Each ele- ment of the com- position has been studied and paint- ed according to its individual char- acteristics.

AFFECT OF OVERLAPPING ON BRIGHTNESS

Glazing is the process of overlapping hues to vary hues already applied. Most brush techniques permit glazing. The only requirement is to make sure the first layer has dried before applying a glaze. The brightest colors are always the most transparent, and it is necessary to mix in more pigment every time a new glaze is added. The build up of many transparent glazes causes light to disappear.

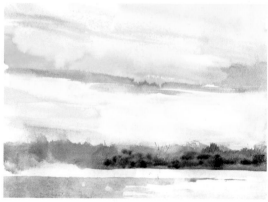

1. First, a bright colored wash is applied to the entire surface, using a great deal of water. Diluted yellow and pink hues are applied to the sky. A diluted blue hue is then applied to represent the water. Some areas of the sky are painted with a more concentrated yellow, and an intense blue hue is added to parts of the background.

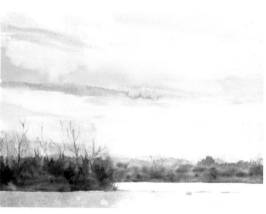

2. Light blue glazes are then used on the bushes. When the glazes dry, some shapes are made more concrete using a fine brush. The overall color of the forest area becomes darker and darker as the artist adds more and more glazes.

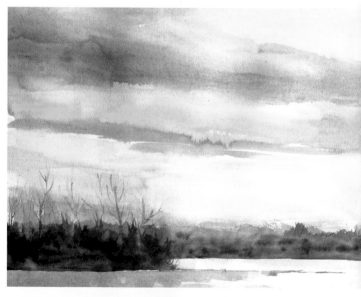

3. Now, strengthening the yellow hues and adding new violet hues intensifies the colors used in the sky. The new hues add color and darkness to the image. The most transparent colors are those in the brightest areas of the sky and in its reflection in the water.

The Importance of Light Colors

All transparent painting techniques rely on the background paper for an impression of light. In these techniques, shading is progressive, and white and bright colors are established with little or no added pigment. In other methods where thicker paints are used, the artist adds white to lighten the hues. In watercolor, the lightest areas are those where no pigment has been added to the background paper, and hues are added according to the amount of color an area requires. The proportion of water to paint determines color intensity. When working with light colors, only a small amount of pigment is used to achieve bright hues. These colors can always be intensified later.

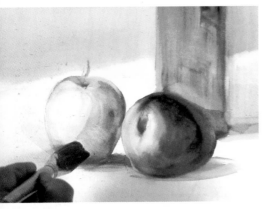

1. In this exercise, a single chromatic range of sienna and sepia hues is used. The light comes from the left in this composition, so the medium and dark hues are painted in the center and right-hand side of the painting, away from the light.

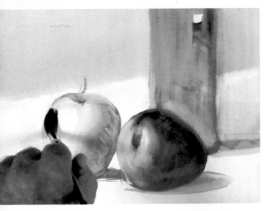

2. The brightest areas are reflected by the paper's whiteness. The artist paints with very diluted colors next to these bright areas so that the change in hues is gradually blended.

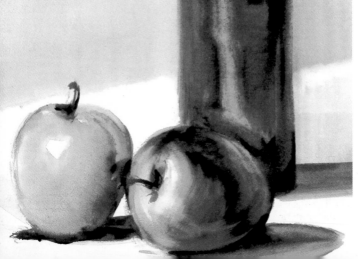

3. The shadow projected by the apple makes the apple itself appaer darker. Throughout this composition, the artist paints with glazes of the lightest hues. In the areas that are the brightest, whites have been left untouched, allowing the paper to show through.

Step by Step

A Still Life with Books

Fine-grained watercolor paper Graphite pencil, Masking liquid, Sable or Ox hair watercolors brushes, Water bowl, Paint rags

A still life is a very useful subject of study when learning to paint. Trying to correctly represent these objects through a painting medium allows an artist to develop his or her artistic ability. These stationary objects are a challenge to paint even if their shapes are simple. In this exercise, the color and volume of the elements, as well as the shadows they project, are very concrete. The artist uses a dry watercolor technique so that the outline of the shapes will be well defined.

Step 1. First, the artist draws the still life, leaving the white areas and outlines untouched. In the areas where objects are to be given detail, a yellow masking liquid is applied. Wherever this liquid has been applied, paint will not penetrate the paper. This masking liquid is also applied to the contour lines of the books.

Step 2. The entire background of the composition is painted with red, representing the surface of the table. Then, black is applied to establish a sense of darkness. The liquid protects the perfectly straight lines of the books, and paint can be freely applied without concern for staying clear of the whites.

Step 3. Now, various hues are applied to depict the books and the bottle of ink. Colors are widely and smoothly spread for representing the books, but a fine brush is used on the ink bottle to depict its structure more exactly.

Step 4. Because the details have been protected by the masking liquid, the books can be painted with single brushstroke of color without concern for blending. Then, when the color has dried, the masking liquid is removed with a rag, and the details can be painted.

Step 5. Contrasts and shadows are now added to some of the books and to the ink bottle. A fine brush is used to define the bottle's contours because of its complex shape.

Step 6. Next, black is directly applied for details on the green book. Then, a light gray hue is used to apply a glaze to the feather. After the gray hue is dry, the artist removes the masking liquid and reveals the paper's pure white color.

Step 7. Gray hues are now applied to the feather with a fine brush to depict its shape. Because the artist is looking for a chromatic effect, the color is diluted to allow the white of the paper to show.

Step 8. New, darker-hued brushstrokes are then applied to the feather to give it more volume. Finally, more brushstrokes are applied to the red background to show its velvety texture.

SUMMARY

- The more glazes applied to create a hue, the less bright this hue will be.

- The most intense colors are those in which the least water was added to the mixture. Inversely, the least intense colors are those in which the most water was added to the pigment.

- In watercolor painting lighter hues are applied before darker ones, and transparent colors should be applied first.

- Watercolors dry very quickly allowing the artist to apply new hues more immediately than in other techniques.

- Dry watercolor is the classic technique of painting on dry paper. .

- When using the dry watercolor technique, the progressive color layers applied are called glazes.

- With dry watercolor, outlines are

very exact and defined since there is no color blending.

- When relying on transparency, white hues cannot be used.. Instead, leaving the corresponding area on the paper untouched forms bright areas.

LIGHT DILUTED HUES

Watercolor pigments mixed with a large amount of water make the best light hues. Pale hues such as pink and lilac are created using the effect of transparency. Because of the large amount of water necessary to create these light colors, the brushstrokes spread very easily and are sometimes difficult to control. The artist should begin applying light colored washes in the large areas of the painting and progressively paint with darker shades.

Using pure watercolor pigments as opposed to those diluted with water produces very different results. Either technique is effective for expressing different qualities in nature, and both techniques can be used in the same work of art. Generally, backgrounds and large spaces require washes of very dilute watercolor, whereas defining outlines and details calls for undiluted colors.

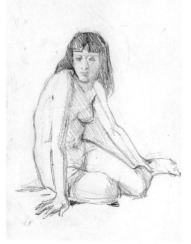

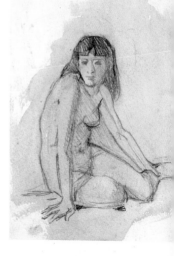

1. First, the artist sketches a correctly proportioned figure. Since all of the model's physical characteristics must be depicted, this underlying sketch is essential.

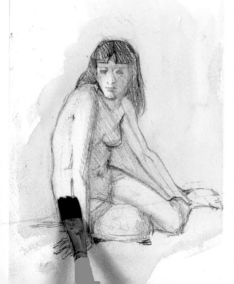

2. Diluted washes are then applied. A very pale orange is used for the background. The artist mixes a large amount of water into the pigments for the flesh-tone and applies this to the figure. This hue is somewhat pinker than the background hue, but it is also transparent.

3. The artist then uses a dry paintbrush to remove some of the pigment from the flesh color in certain areas of the figure, making these areas even more transparent. Since the pigment is still wet, it is easy to remove, and as a result, the flesh color is brightened and looks almost white.

WATERCOLOR LAYERS AND DRYING TIME

The intensity of a color is different-when the painting dries. When watercolor mixtures are wet, they tend to appear more intense. The artist must, therefore, make a color darker than the desired hue. Colors blend spontaneously and immediately when they are applied to damp paper. On the other hand, when working on dry paper, hues are created by using washes of pigments mixed with water. The artist must wait for one layer of color to dry before applying the next.

1. The first contrast is added to the figure by shading the right-hand side of the form. In this painting, light falls on the figure from the left, so both the model's body and right arm fall into shadow. These areas are progressively shaded. Then a black wash is applied to the hair, which becomes the darkest hue used in the painting.

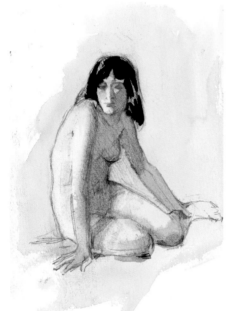

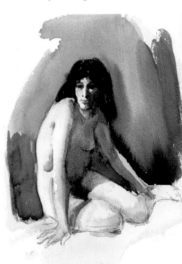

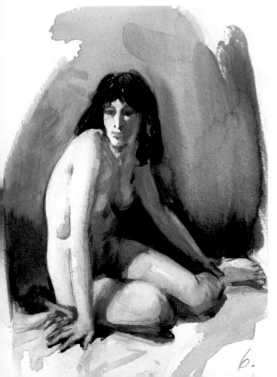

2. Strong, definitive contrasts are added by shading both the background and the figure. Intense washes are used on the background to increase contrasts with tones on the skin. Then, the darkerflesh tones are intensified with sepia-colored washes.

3. The artist finishes the painting by adding necessary details. In the dark areas, shades are alternated to depict the breasts and abdomen. Then, fine black strokes are used to retrace the legs and hands. Finally, the artist portrays the shadow projected onto the floor by the figure.

MAKING HUES LIGHTER

Because of the liquid quality of water-color washes, an artist can experiment with the way water is used. Diluting pigments with water and blending on damp paper are not the only possibilities. The artist can also make colors lighter and correct errors.

If the paint has dried, color can be removed by dampening the paintbrush and then rubbing the paper. The drier the paint, the more difficult it is to remove since the paper will have absorbed it. Also, the intensity of the applied color affects the artist's ability to lighten the hue. Very intense colors can be reduced, but the pure white of the paper is difficult to restore.

1. Since the model being painted in this exercise is facing the light, very transparent colors are required. First, a very wide brush-stroke with a brown wash is applied to the background. Then, a flesh color is smoothly and transparently spread over the figure.

2. Next, dark browns and intense blue hues are applied to the hair, to the model's stand, and to some of the background areas. The use of these hues causes the figure, which is lighter in color, to stand out in contrast.

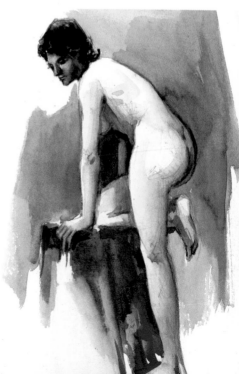

3. Finally, dark hues are applied to give detail to the face and other areas of the figure. In summary, the painting has been developed using transparent, light colors. Dark hues are used for definition of the figure's legs and on the shadowed parts of the body.

TECHNIQUES AND TRICKS

As in other painting techniques, watercolor can be used in versatile ways. An artist can apply washes of color, toning them down, darkening them, and accelerating their drying time. The important thing to keep in mind is that since watercolor is such a direct technique, it is more difficult to make changes than with other techniques.

1. Washes can be used to vary a hue's intensity. A very transparent color foundation can be made almost opaque by adding a new layer of the same color. Also, if a new, thicker color is applied, the foundation will be less transparent.

2. A brushstroke of a new color can be painted over a dry color foundation without blending with it or altering its form. Also, if the new hue being applied is darker, it will completely cover up the previous color layer, and its color will not be affected by the underlying hue

3. To eliminate a new layer so that the underlying color reappears, the artist applies the techniques described earlier to remove color. If the paint is still wet, a clean dry brush will be enough to take it away. If the paint is already dry, the area needs to be dampened again and brushed with a dry paintbrush to remove the color.

A Male Nude

MATERIALS

Fine-grained watercolor paper, Graphite pencil, Watercolor brushes, Watercolors, Water container, Paint rags

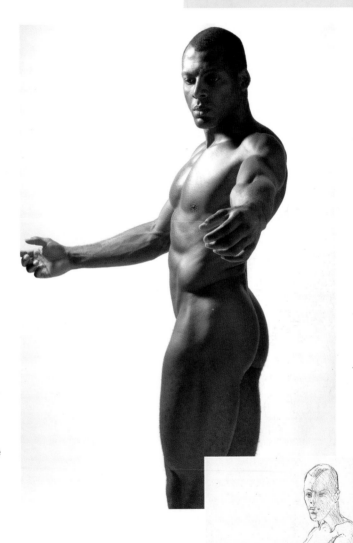

Painting with watercolor is a very quick technique, requiring the artist to spontaneously define a model's form. Also, it is a technique in which the artist must be decisive and confident in working with colors. Perhaps not the ideal technique for detailed studies of the human figure, watercolor does, however, allow the artist to quickly portray a live model in a fresh and natural way.

Step 1. The artist draws a very detailed sketch of the model, so that there is no doubt where to apply the watercolor. Only outlines and broad details should be included in the sketch. Areas of light and shadow should also be established so they can easily be portrayed later, when color is applied.

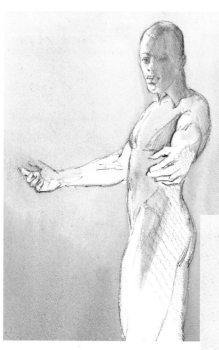

Step 2. Next, washes of grays are applied to the background. Notice that the color washes blend on the paper so that the brushstrokes are not visible. Afterward, the artist applies short brushstrokes of color to the entire upper half of the model.

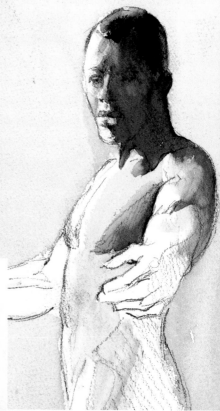

Step 3. Contrasts on different areas of the figure are emphasized from the very beginning by painting black to part of the face and neck. Areas where light falls on the figure are left transparent. The parts of the figure that fall between light and shadow are painted with a copper hue.

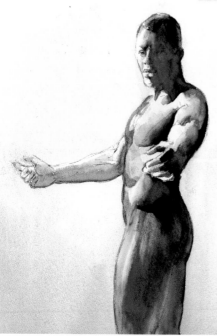

Step 4. Contrasts on the model's skin are brought out with intense, dark hues. Black is used on the right side of the figure, both for contrast and to define the curve of the body.

Step 5. The artist now works on the model's facial expression, using black hues applied with a fine brush to define the eyes, nose, and mouth. A shadow is painted on the right side of the face.

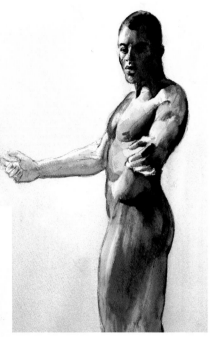

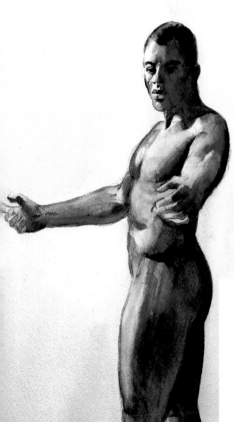

Step 6. The artist now begins to work on the model's right arm, adding black to portray the muscle forms and to darken the areas of contrast.

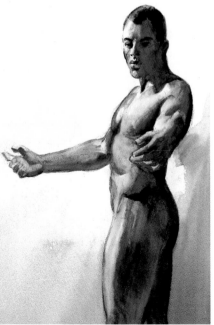

Step7. New brown hues are painted into the intermediate-toned areas so that there isn't an abrupt change from black to white. These brown hues also serve to define volume.

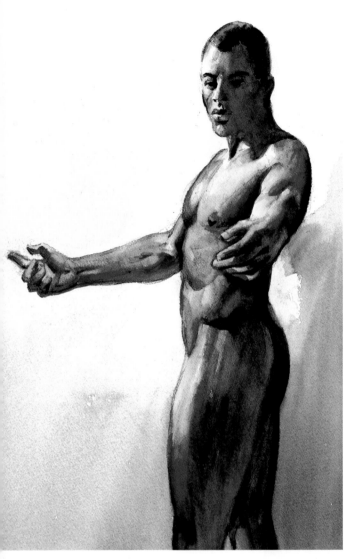

Step 8. The shadows on the figure's legs are deepened to contrast with the upper part of the body, making it appear brighter. In summary, the artist begins the painting with very diluted watercolor washes. Fine details are applied when the foundation washes become completely dry.

SUMMARY

- Painting with undiluted watercolor as opposed to painting with washes produces very different results. Each technique produces different effects in the work of art.

- Watercolor washes are used to establish foundation hues. Undiluted watercolor is used to outline elements and to depict details.

- The amount of pigment mixed with water determines a hue's lightness. Less pigment in proportion to the amount of wate produces pale, transparent colors.

- The true degree of intensity of a hue cannot be observed until the painted area has dried. A hue generally appears to be brighter when the painting is damp, and it lightens as it dries.

- Color gradations can be developed by blending hues directly on wet paper, and those on dry paper are achieved by applying washes. When adding washes, it is important to let one layer dry before applying another.

- To make a color lighterand less intense, excess paint and water must be removed. The darker a hue is, the more difficult it is to tone down.

16 PAINTING ANIMALS WITH WATERCOLOR (1)

Watercolor

THE FOUNDATION SKETCH

The foundation drawing is very important in painting with watercolor. Errors cannot be corrected with white paint as in most opaque media. Therefore, when applying a brush loaded with watercolor, the artist must be able to see where to place the areas of color.

When animals are the subject of a painting, the artist is faced with a very difficult task. The defining forms of animals, their variety of textures, and their distinct coloring require the structure to be set up in advance of the painting.

1. To demonstrate, the artist begins to sketh a zebra, keeping both the animal's contour and inner patterns in mind. In this side view, the contour is very simple and projects only a few shadows. Proportion needs to be considered, however, so that the animal appears natural.

2. Now, a light gray wash is used on the main form of the animal. The lower body should be less lighted than the area of the back where light falls. Black is used for the deeper shadows, toned down with a large amount of water; a small amount of sienna is added to create a pinkish shade.

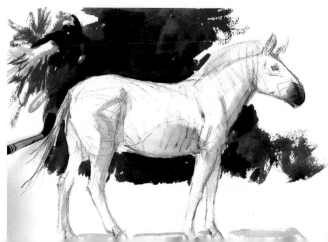

3. Finally, a brush loaded with black is applied to the background, creating extreme contrasts with the lightness of the zebra to give definition to the animal's form. The artist relies on the underlying sketch to carefully place the washes of color.

THE FIRST COLOR WASHES

The artist begins a watercolor painting with light and pale colors. After studying the color of the subject of the painting, the artist mixes pigments with water until the desired hues of the correct intensity are obtained. Because paper will buckkle if too many layers of color are applied, it is better to find the correct hue from the very beginning. Progressively adding intensity is simply a resource used when the artist wants to be sure not to make mistakes.

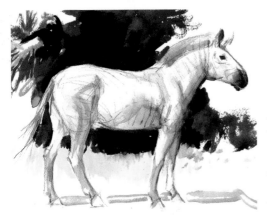

1. First, a wash of a dark hue is applied to the background; then, a green hue is directly applied to represent the grass of the animal's environment. this background wash establishes contrast and helps the artist develop the zebra's color scheme correctly.

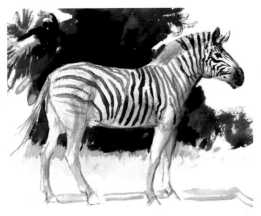

2. Black stripes are now applied to the zebra using a fine brush that allows for brushstrokes of different thicknesses. These strokes should be applied in a controlled manner to emphasize the animal's contour form. Since these black lines diminish the amount of white space on the zebra's body, the animal begins to appear very shaded.

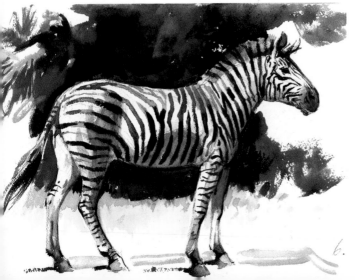

3. Now the artist begins to intensify the contrasts on the animal's body. The legs and belly are shaded with an intense color similar to that used on the background, which further define the animal's color. Finally, the details of the legs and hoofs are given definition with a fine brush.

GESTURE OF THE BRUSHTROKE

Watercolor is appropriate for paint-ing freely and spontaneously. Colors pene-trate the paper quickly and immediately blend and integrate. The drying process in watercolor is also fast, mak-ing it an ideal method for establishing shapes, colors, and movement of a subject. When working with watercol-or, brushstrokes should be decisive, the paint freely and confidently applied.

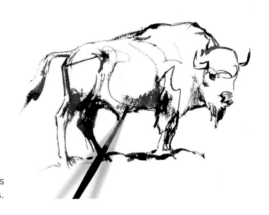

1. In this illustration, watercolor is used to sketch a buffalo. The artist uses a fine brush to paint the ani-mal's outline as well as the interior shapes of muscles and limbs. This sketch allows the artist to establish the animal's gesture. General shapes are defined before capturing details.

2. Next, the artist paints color wash-es into the contoured areas, and these washes blend on the paper with the outlined form of the buffalo. Using a violet hue that combines perfectly with the black foundation, the artist works on the areas where light falls on the animal's back.

3. Then a green hue is applied to the dampened paper to blend into the back-ground color. Even though the artist has made no attempt to provide realistic details, the buffalo's main structure, ges-ture, and movement have been captured to create a loose and fresh painting..

THE UNDERLYING DRAWING

Watercolor is an ideal technique for both quick impressions and more meticulous paintings. In the case of more detailed works of art, a good foundation drawing is necessary to establish the correct places for color and definition. Darker hues are necessary for setting off contrasts, indicating volume, and providing detail to paintings.

1. In this case, a pencil drawing is made to establish the leopard's facial characteristics. No details are left out so that the artist can concentrate on the animal's structure, outline, physical features, and even the texture and pattern of its fur.

2. Because the pencil drawing is so detailed, the main washes of color can be safely applied. The outline, separating the animal from the background, is very clear. Two very distinct hues must now be applied to convey both the animal's yellowish fur and the red and black hues. The white area of the animal's muzzle is left untouched.

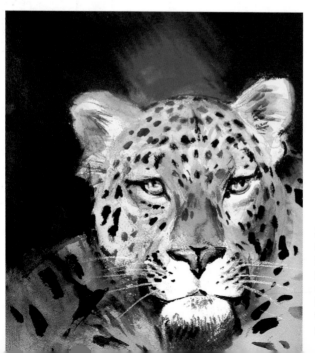

3. The final step is to apply black to define shapes, contrasts, and patterns. The artist depends on the underlyingdrawing when defining the eyes, muzzle, mouth, and characteristic spots.

MATERIALS

Fine-grained watercolor paper, Graphite pencil, Watercolors, Watercolor brushes, Water container, Paint rags

Two Kittens

A painting of kittens conveys a very tender and romantic feeling. Because of the characteristic blending effect of watercolors, they can be used to convey all kinds of different environments, whether controlled or soft and harmonic. In the present painting of kittens, the artist strives for a romantic effect, both controlled and atmospheric.

Step 1. First, the artist sketches the kittens in a simple line drawing conveying their correct anatomical shapes. Volume is not defined in this foundation drawing. The kittens' main features are also drawn in a concrete manner. Then, washes of color are applied to define volume; these should be very dilute and should not interrupt the pencil lines.

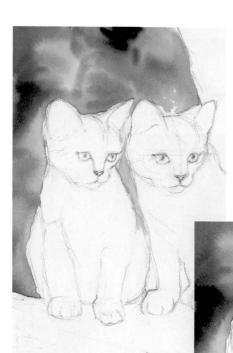

Step 2. Now, green hues are used to paint the background. The artist follows the previously drawn outlines so that color does not penetrate these areas. A variety of hues applied to the background will give the appearance of vegetation. Then, on the upper area of the image, light green and yellowish hues are painted alternately with darker hues.

Step 3. The interior forms of the kittens are left untouched while the artist applies green and yellow hues to the background. In the upper left-hand side of the painting, colors are blended, but they are molded in a fragmented way on the rest of the painting to indicate a difference in texture.

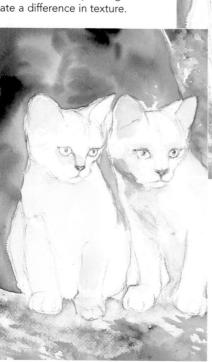

Step 4. Very light washes are now applied to the kittens to paint their fur. A light orange hue is applied to the kitten on the left, and red and black hues are used for the kitten on the right, creating a more pinkish hue.

Step 5. Next, the kittens are shaded with some darker hues placed to correspond with the lines and textures of their fur. Ocher hues, which are similar to those used on the background, are applied to the kitten on the left. Strong contrasts are brought out on the kitten to the right, making its predominantly white fur stand out.

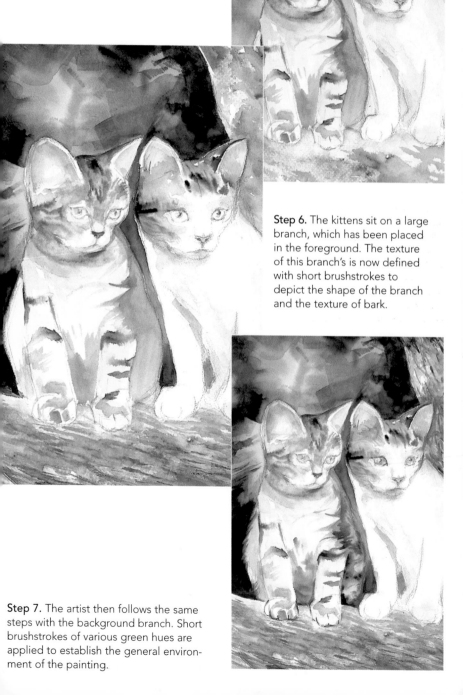

Step 6. The kittens sit on a large branch, which has been placed in the foreground. The texture of this branch's is now defined with short brushstrokes to depict the shape of the branch and the texture of bark.

Step 7. The artist then follows the same steps with the background branch. Short brushstrokes of various green hues are applied to establish the general environment of the painting.

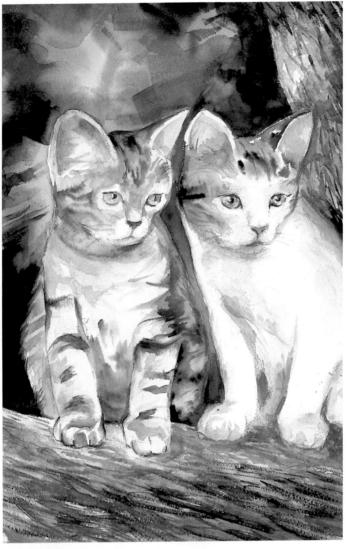

Step 8. To complete the painting, the artist retouches the contour of the kittens, the texture of their hair, and then, their expressions, eyes, and muzzles. Finally, dark hues are added to the branches, emphasizing the general contrast.

SUMMARY

• Pencil drawings are a fundamental foundation for all detailed paintings. The artist uses the drawn linesto establish where to apply the watercolor.

• Because it is very difficult to correct errors in watercolor technique, the foundation drawing is very important. A meticulous drawing process is required especially in cases where animals are the theme of the painting to adequately portray their anatomy.

• When painting animal textures, washes and brushstrokes that are very controlled give a naturalistic look to the animal.

• Watercolor is a technique in which quick sketches are ideal, because they allow the artist to work in a loose and free-form way.

• The first color brushstrokes should be lighter with successive layers applied to create deeper hue. If an excessively dark hue is used, the artist will be unable to make corrections because of the difficulty of removing watercolor.

• In a quick painting, the brushstrokes define the model's gesture and attitude, giving life and animation to the subject.

Watercolor

THICKNESS AND TRANSPARENCY

Obviously, an artist must establish a progression of shapes and colors when painting a picture. Working from light to dark in painting with watercolors, the artist starts with more transparent colors and progressively intensifies them. Overlapping glazes intensifies hues, which is parallel to what happens when the human eye perceives colors.

The atmosphere of a painting refers to the set of colors and shades that make up a setting. Objects and colors are altered according to their distance from the viewer. When considered from a spectator's point of view, these objects and colors appear to be clearer in the foreground and blurred in the background.

2. A medium green hue is used to paint the center of the landscape. This area represents a deep forest. At this stage, the colors are flat and not very intense. These hues establish a base color for the entire landscape in preparation for defining the volume of the elements later.

1. In this demonstration, the first layers of color are blended and blurred. For representing the distant mountains blue and violet hues are alternated to make them appear farther away. In the foreground, warm yellow hues are used to make the ground appear closer.

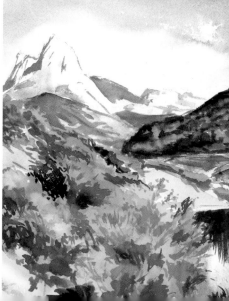

3. Now, contrasts are added and the volumes of the forms are established. Applied with loose brushstrokes, the trees and river reflections are added. The amorphous, blended shapes in the background are left untouched to give depth to the image.

ATMOSPHERIC SCOPE

The air making up an atmosphere influences visual perception. Objects become less distinct as they are placed farther away from the spectator. Foreground objects have strong light and color contrasts. But when atmosphere comes between the spectator and the objects observed, the elements begin to lose definition. Objects that are farthest away are converted into subdued shades forming part of the general atmosphere.

1. The artist begins with a very simply composed sketch over a yellow glaze that has previously been applied to the paper. Only a few lines are necessary. The background color will serve as the foundation atmosphere for the landscape.

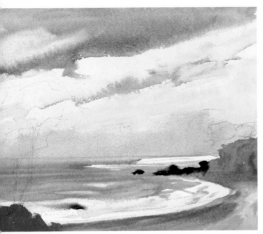

2. New hues are now added over the yellow foundation to form each of the elements in the composition. A layer of lilac color is painted into the area corresponding to the clouds. Then, some fine brushstrokes of green and blue are applied to the sea area, and finally a sienna hue is applied directly over the yellow base in the areas corresponding to the shore.

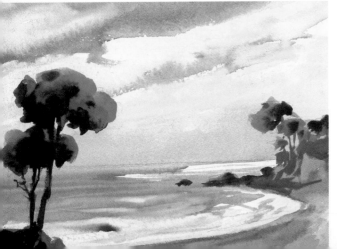

3. The artist now adds dark colors to the areas that form the contrasts on the rocks. Finally, the tree tops and contrasting areas are painted with green hues. The warm atmosphere established by the yellow foundation dominates this picture.

LIGHT AND REFLECTIONS ON WATER

Most people think of water as a fluid and changing body in constant motion. But water can also be calm, with a flat, mirror-like surface, or powerful, with currents that create waves.

The artist represents these qualities of water by varying the light and the shapes of the objects reflected in it. Because these shapes change according to the activity of the current, brushstrokes of watercolor indicate the character and form of the reflections.

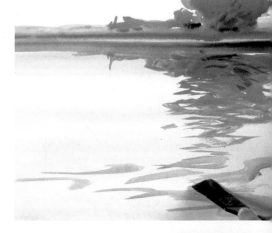

1. In this composition, the image in the water seems to be dominating the land. The ground's reflection in the water is made up of horizontal brushstrokes of green and blue hues.

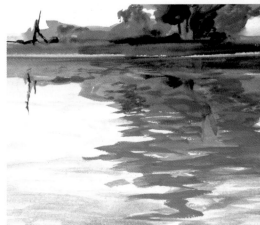

2. The water reflects the objects on the land and the vastness of the sky. Because the sky's reflection is wide and blue, the reflections of the trees are more defined and intense. The shaded areas are painted with brushstrokes of black over the green hues.

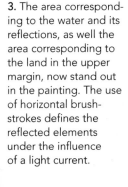

3. The area corresponding to the water and its reflections, as well the area corresponding to the land in the upper margin, now stand out in the painting. The use of horizontal brushstrokes defines the reflected elements under the influence of a light current.

CREATING ATMOSPHERE WITH WATERCOLORS

Because watercolor hues can be easily blended, the technique is ideal for creating atmospheric effects. Forms created by blending are not concrete and the hues give the sensation of an overall atmosphere. The technique allows the artist to make some areas focused and others more blurred. The wet on wet and blending techniques described below make creating atmosphere an easy process.

1. The colors of the clouds in this exercise will be blended to convey a sense of amosphere. The artist begins by dampening the paper and then applying brushstrokes of intense grays and blues. These brushstrokes blend together forming cloud shapes over the blue sky hues.

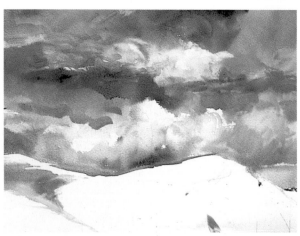

2. The wet on wet technique is used for the space corresponding to the sky. Since the watercolor hues blend together, the strokes of the brush leave no distinguishing marks, creating a very real sense of atmosphere. The mountains are left untouched since they will be painted using a different technique in the next stage.

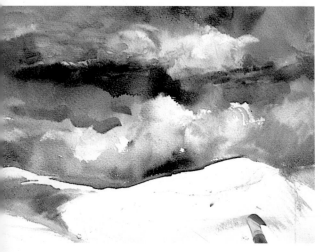

3. Now, undiluted watercolor is used to depict the mountains. Since the paper surface is dry in this section, the strokes are more defined and unblended. The different effects produced for the mountains and the sky demonstrate that colors can be applied in various ways to represent different textures.

A Mountain Stream

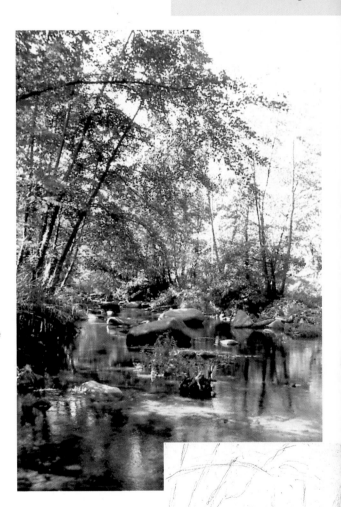

Landscapes offer the artist endless-possibilities for harmonizing color. The seasons, the hour of the day, rain and snow are all condi-ions in the landscape that offer numerous chromatic combinations. Warm hues tend to be connected with strong solar light, and on those days of bright sunlight, the atmosphere has stronger contrasts than on a cloudy day.

step 1. The artist begins by sketching the image. Landscapes do not require detailed sketches because the brushstrokes themselves will indicate the characteristic details of vegetation.

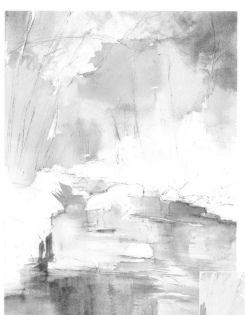

Step 2. Next, the sky is painted with wide brushstrokes which are then blended. The sky and its reflection in the water determine how the blue hue is to be distributed. In the area representing the trees, the artist uses a yellowish-green hue. The brushstrokes in this area are flat and spread out.

Step 3. Now, green hues are applied in the area of the composition corresponding to the ground under the trees and the most shaded vegetation. Dark hues are then applied to define the rocks that are partly visible in the river.

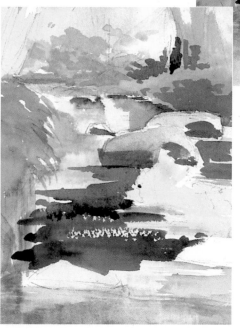

Step 4. The artist uses darker hues of different intensities depending on the proximity or distance of the objects in the foreground. The distant rocks are given contrasts with gray hues, and the closest forms are contrasted more strongly by using a black hue.

Step 5. Tree trunks are added to the woods with a brown hue. Then the reflected tree shapes are consolidated with horizontal brushstrokes that reveal the movement of the water.

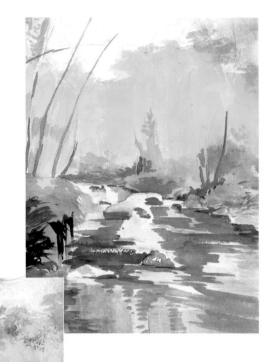

Step 6. Then, in the upper half of the image, brushstrokes of green define the leaves of the tree on the left. It is very important to wait until the underlying layer dries completely so that the brushstrokes do not blend.

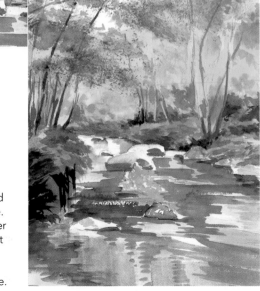

Step 7. Now, brushstrokes are added to the entire upper half of the image. Layers of green hues are applied over the yellow foundation color to depict leaves on the trees. Using an abundance of warm colors applied with fine brushstrokes creates atmosphere.

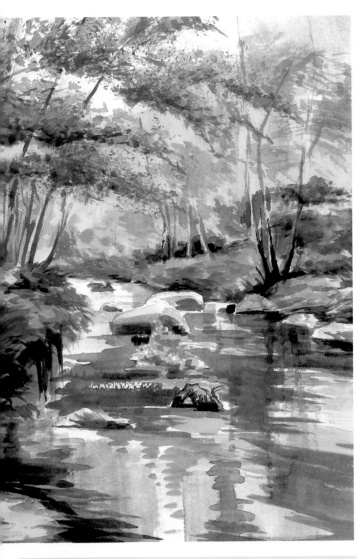

Step 8. To finish, the artist works on the water's surface and on the strongest contrasts. Dark hues, applied with horizontal brushstrokes, create the shadows projected by the trees onto the ground and to the shadows' reflections in the water.

SUMMARY

• The atmosphere in a landscape composition refers to the interpretation of colors and shapes to depict the combined qualities of air, light, and movement.

• To create a painting, the artist must add colors, shades, shapes, and details in a progressive manner.

• Brushstrokes determine the character and shape of a reflection, conveying the movement of the current.

• Reflections in water are always affected by the amount of current. These reflections can be very smooth or very exaggerated.

• The way brushstrokes are applied determines the character, shape, and, therefore, movement of reflections in water.

• The artist paints objects in the foreground of any environment with more detail and with more contrasts than the objects in the background.

• The presence of intervening air causes the spectator's view of objects in the background of a landscape to be less distinguishable.

• A very atmospheric landscape can be depicted perfectly using blended watercolors on wet paper.

FILTERED LIGHT IN WATERCOLOR

To paint light means to paint the affect of that light on the shapes and colors of objects. If there were no light, objects and their colors would not be visible; the image would be absolutely black. Different light sources cause the same object to have distinct appearances depending on whether the light is direct or indirect and from what direction it comes. In interior paintings, light can be natural (from an outside source) or artificial. If light from a window falls on an object, that object will be lit, and the other elements dark.

Interior paintings require a different chromatic study than studies of natural landscapes. Outdoor landscapes possess their own intense light, present in all areas of the composition. In the case of interior paintings, however, light comes from a specific source and is usually limited. Paintings of interior will always have contrasts and shadows in areas where the light does not fall.

1. An interior painting, like the one in this exercise, requires a study of the elements in the image. Before beginning to paint, the artist draws all the elements of the interior composition.

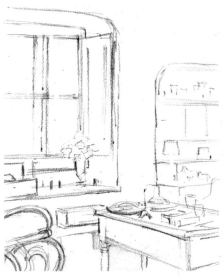

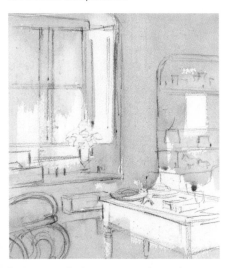

2. To correctly depict atmosphere, the artist begins with broad, general brushstrokes and ends with specific details. In this interior, a pink color is predominant throughout the room. The artist applies a pink glaze to the entire image, except for the window.

3. New colors are then added to define the concrete elements. For the time being, the artist isn't concerned with details. Blue is now used to paint the window, and, for contrast, sepia is directly applied to the furniture.

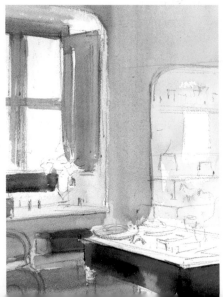

THE IMPORTANCE OF THE UNDERLYING DRAWING

Some themes require a more exhaustive study than others. In a natural landscape, a very detailed sketch is not necessary before applying pigment, but interior paintings tend to be more complex. For an interior composition, the artist starts with a very detailed drawing containing numerous elements and shapes; a simple sketch would not be enough. This underlying, exact drawing allows the artist to freely apply the brushstrokes.

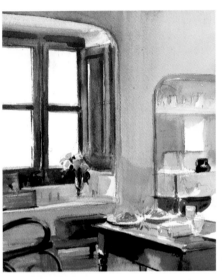

1. Precise brushstrokes now establish the details. After relying on the foundation drawing for general washes, the artist uses more defined brushstrokes to for the individual elements. Details are given to the already established window, and the vase and chairs in front of it are painted.

2. Next, the elements on the table in the foreground are outlined. A dark hue is applied with a fine brush to depict the contours and interior mass of the different objects placed on top of the table.

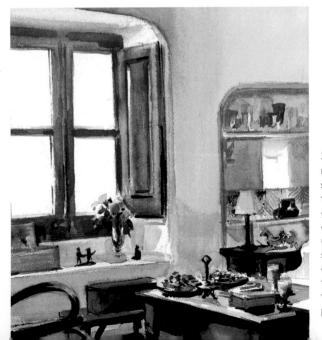

3. The last step is to add more precise, detailed shapes to the table and to the shelf in the background. The artist gives contrasts to each individual element whose shapes have already been clearly depicted in the foundation drawing at the beginning of the painting process.

STUDYING THE PALETTE

"Palette" refers to the colors to be used to paint a work of art. Each painting has its own palette. It is often said, however, that each artist has his or her own palette. This is because some artists tend to repeatedly use the same colors in their paintings. Because of the effect of light in interior paintings, many changes in hue can be found, and the artist must use the proper techniques for developing both light and dark hues.

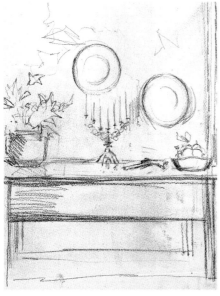

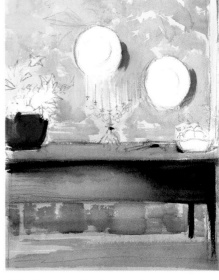

1. This exercise is a frontal view composition of decorative plates hanging on a wall over a table. The first step is to correctly draw the shapes, balancing their distribution on the paper.

2. In this example, the large hue areas are first established. Yellow and orange are used on the wall, and a totally different range of colors is used on the table. In the shaded areas, lilac and broken hues are dominant.

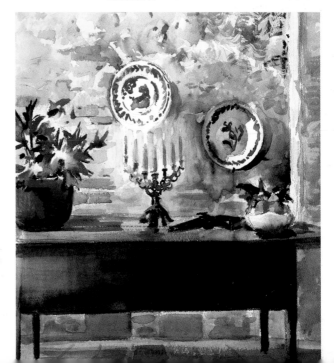

3. The artist now completes the image and details. Short brushstrokes of different hues define the stones that form the wall. The brightest yellow area corresponds to the area lit by the candelabra.

Chromatic Development and Transparency

The interplay of light and dark dictates the variations of hues in painting. These variations are used to depict the volume of objects. Because con-trast determines to a large extent what the final painting will be like, it is as important as the foundation drawing. The artist begins with transparent hues on light areas, adding successively darker ones, and finally black. The darkest shades finalize the work's chromatic development.

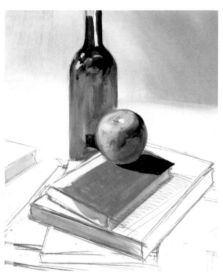

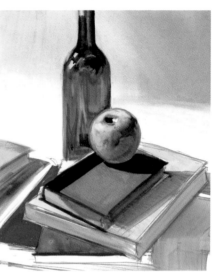

1. This still life will be used to portray the changes in hue for each of the volumes. The artist works on the elements in such a way to give volume and relief from the very beginning. First, black is directly applied as contrast on the bottle. This hue will also be used to form the volume of the apple and the shadow it projects.

2. The books are then defined one by one. Various colors of brushstrokes, added separately to each book, establish the books' forms and contrasts. The yellow, blue, and red colors are then outlined with black. A black hue is then used to shade the shadowed areas.

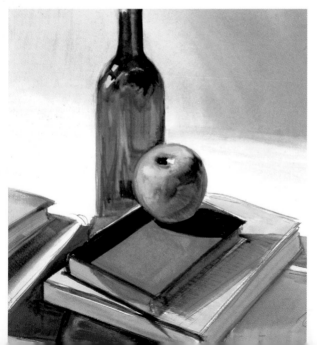

3. Finally, flat, geometric brushstrokes are applied for the definitive contrasts. Books are very simple objects to paint, without the difficulties of irregular shapes and volume.

Step by Step

A Rustic Interior

MATERIALS

Fine-grain watercolor paper, Graphite pencil, Watercolors, Sable or ox hair brushes, Water container, Paint rags

When paint an interior, the artist positions light and shadows carefully. These qualities are not distributed equally throughout the painting, but rather fragmented. In this example, light comes from the background, causing many elements in the foreground to be shaded. The artist is faced with an unusual situation. Normally, the foreground is lighter, more detailed than the background, but in this interior, the background is lighter.

Step 1. First, the entire scene is drawn, including all the details. Since the column is placed in the center of the composition, it becomes a very important element, causing the foreground to appear empty and lacking in details. The background is lighter than the foreground area.

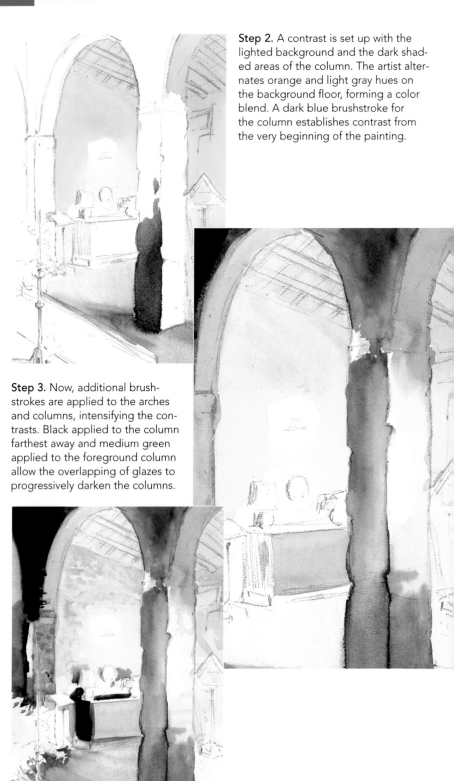

Step 2. A contrast is set up with the lighted background and the dark shaded areas of the column. The artist alternates orange and light gray hues on the background floor, forming a color blend. A dark blue brushstroke for the column establishes contrast from the very beginning of the painting.

Step 3. Now, additional brushstrokes are applied to the arches and columns, intensifying the contrasts. Black applied to the column farthest away and medium green applied to the foreground column allow the overlapping of glazes to progressively darken the columns.

Step 4. Dark hues are then added to the objects of furniture in the background in order to depict the objects' planes. Then, a stone-like texture is given to the arch and the columns.

Step 5. The artist darkens and gives texture to the column in the foreground. A blue glaze is then added to the floor. This glaze contrasts with the warm light eminating from the background.

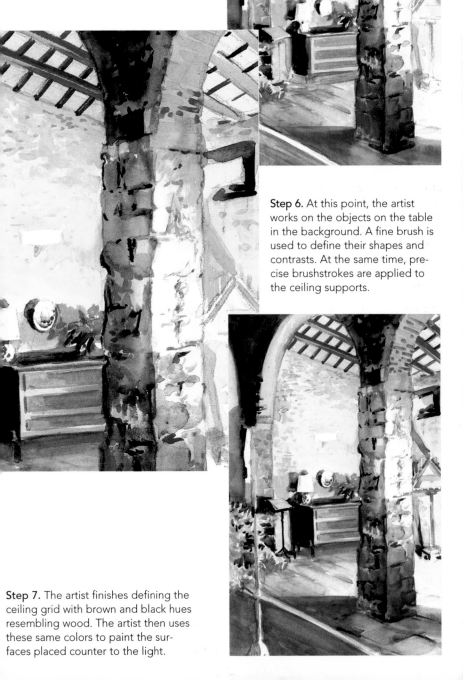

Step 6. At this point, the artist works on the objects on the table in the background. A fine brush is used to define their shapes and contrasts. At the same time, precise brushstrokes are applied to the ceiling supports.

Step 7. The artist finishes defining the ceiling grid with brown and black hues resembling wood. The artist then uses these same colors to paint the surfaces placed counter to the light.

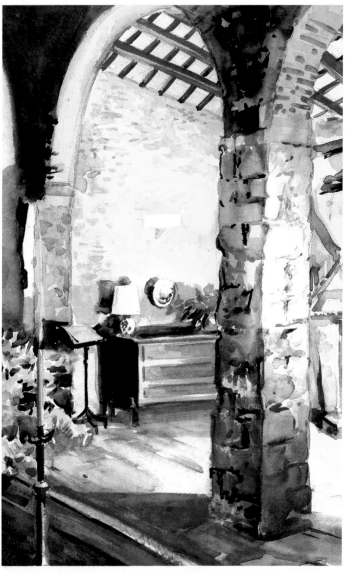

Step 8. The foreground is now shaded. Because it is far away from the light source, the foreground is darker. In general, the bright objects in the background require more detail because the light makes them clearly distinguishable. The objects in the foreground, however, receive very little light and do not need to be very detailed.

Summary

- The "palette" refers to the related group of colors that are used in a painting.

- Many different shapes and hues are used in an interior painting. The palette needs to be rich and varied.

- Interior paintings include numerous objects and details. A foundation drawing is a necessary part of the painting process.

- Absolute black refers to a complete absence of light or color, not to an absence of objects.

- Contrast is as important as the foundation drawing, determining the finished appearance of the volumes in the work.

- Light filtered through a window brightens the objects in its path and darkens the objects placed counter to it.

- Interior paintings usually offer only limited light. This is because the light normally comes from a single source, whether it is from an inside, artificial source or or from outside the space to be painted.

Watercolor

DENSITY AND TRANSPARENCY

Human skin tones are not depicted by a single color. There are many different shades depending on the person's natural color and the surrounding light. Just as in painting any other forms, lighted areas should be very transparent and glazes applied for the other hues until the darkest colors are attained. Flesh colors are usually warm, with cooler shades applied to create volume.

The volume of an object is expressed by variations of hues that range from the brightest to those found in shadows. In painting the human figure, shadows and highlights follow the shape and rhythm of human anatomy and musculature. The underlying sketch of the figure needs to be well developed before color is applied.

2. Now, black brushstrokes are applied to the background, outlining the figure completely. On the figure, brushstrokes of the same hue are applied to indicate the most shaded areas, which will then be blened with the background.

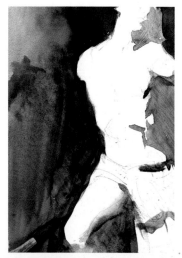

1. Classical artists portrayed the figure with an absolute control of anatomy when painting the shapes with color. In the Dark Ages, contrasts were as extreme as those shown in this image. The foundation to this composition is forcefully drawn, and the use of very deep, black colors establishes volume.

3. Both the shadows and highlights are now defined. A fine brush is used to depict the figure's expression. The right side of the face is almost completely shadowed. The light hues of the flesh should be very transparent, and some areas are left white. The contrasts established will make the flesh hues appear brighter. The main anatomical features are painted with ocher and pale pink hues.

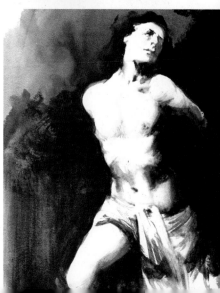

Establishing Volume

The volume of the human figure should be depicted by using black and white tonal values. Certain parts of the body (mainly the hip area, legs, and breasts) require extensive gradation, while the small relief areas of the face and the limbs are worked on more directly. A very diluted blend of watercolor hues creates a sense of volume, but in the areas in which hues change only slightly, the artist has better control over brushstrokes by working with dry watercolor.

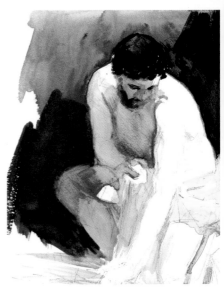

1. Again, the foundation drawing is essential for developing the image. Shading in all the areas where there are shadows helps the artist establish volume from the very beginning.

2. Wide brushstrokes of dense black and blue hues are used for the dark background. Then, an intense red color is used on the part of the body that receives less light.

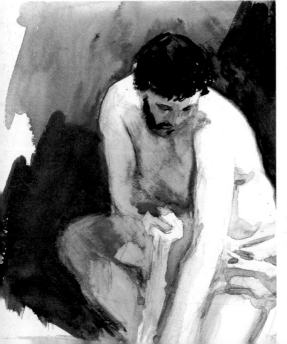

3. Next, darker brushstrokes are added to the midsection of the figure, defining the shape and marking the separation between the arms, body, and clothing. Continuing, the artist portrays volume by means of changes in the highlighted right side, the shaded left side, and the background.

Adding and Subtracting Hues

Adding hues means to apply new layers of paint to enrich the shades and colors making up the composition. Subtracting color, on the other hand, is a different process that involves uncovering bright and mor lighted areas. Color is rarely subtracted from the large areas like the background. Here, the artist relies on the transparency of the paper from the very beginning of the painting. In smaller areas, however, lighter areas can be achieved by removing excess pigment with a clean, dry brush.

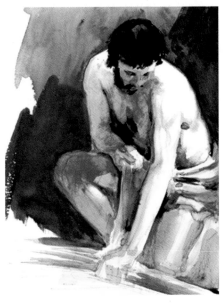

1. Bright areas on the right leg will now be uncovered by subtracting colors. Since the leg is located in the shadows, it has already been painted with dark hues. But some light does fall there, so color is now subtracted to reveal the white hues.

2. The artist continues to use black to develop the intermediate details and to strengthen the light and dark values. The figure's extended arm is traced in black to define its shape and to make it brighter.

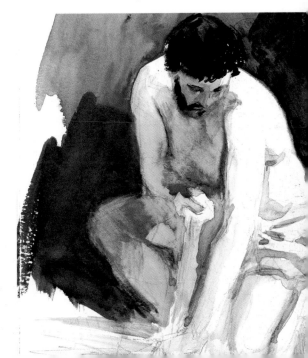

3. Finally, the hands and the figure's gesture are defined. The image now has extreme contrasts. The background and receding body areas appear very dark, and the flesh tones remain strongly highlighted.

THE PLANES OF THE BODY

In reference to shape, the human figure is very complex. Light is strong in certain areas, and in others, shadows will be dominant. Each part of the figure can be divided into planes comparable to basic shapes in order to understand the overall volume. The breasts and bottom usually have spherical shapes, while the torso, legs, and arms are cylindrical. The body's orientation with respect to light produces areas that are either bright, intermediate, or dark, allowing the representation of the figure to be divided into color planes.

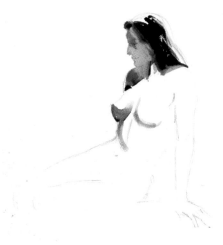

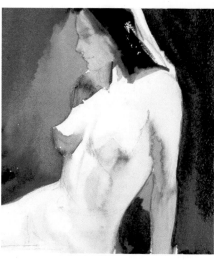

1. In order to depict general volumes of a figure, shapes are simplified. This composition is developed with volume in mind. The artist first looks for the best colors for depicting each body area with respect to light, shading the face and part of the breasts, and lightening other areas.

2. The figure is painted in such a way that form and light are simplified. After the background is painted with brushstrokes of intense reds, the lighter areas gain clarity through comparison and contrast.

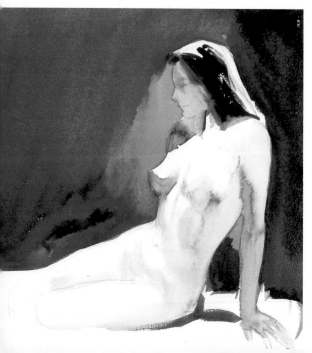

3. Working with planes to simplify the figure helps the artist depict the anatomy of figures through the use of light. Details of the figure could be developed further, but, at this point, its volume is sufficiently depicted.

Step by Step

A Reclining Nude

MATERIALS

Fine grain watercolor paper, Fraphite pencil, Watercolors, Sable or Ox hair brushes, Water container, Paint rags

Sketching the anatomy of a figure in a reclining position can be very complex. To portray such a figure involves altering proportions and having the elements recede into the background in a process called foreshortening. Only with a complete knowledge of anatomy can the artist depict the figure in such a way that it does not appear deformed.

Step 1. First, a pencil sketch is used to define the image accurately. The legs appear bent and distant. The arms, which are also bent, and the head appear closer to the foreground. These forms will be sketched in perspective and appear larger size because of their proximity.

Step 2. A transparent orange glaze is applied to the entire figure. The artist begins to enhance the flesh tones by painting with the lightest colors.

Step 3. Continuing to strengthen the flesh tones, the artist then adds soft shadows to the figure. The same orange hue is used, but it will appear darker due to overlapping. As the shadows are edveloped, the volume of the figure begins to emerge.

Step 4. The woman's hair is painted black in order to develop a very strong contrast. In this way, the artist determines which will be the darkest hue used in the composition. Brushstrokes of black also depict the the figure's hair spread out on the floor.

Step 5. After the hair is completed and the darker areas are intensified, the figure appears set apart from the floor. The shadows projected onto the floor are now depicted, especially in the lower left of the composition.

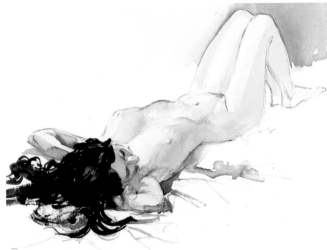

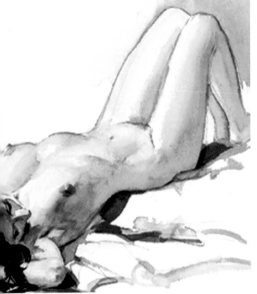

Step 6. The volume of the figure on the right -hand side of the image is enhanced. Then, an orange hue is used to define the breasts, ribcage, and the separation between the legs.

Step 7. The shadows projected on the bed under the body and legs are depicted using directly applied black. In this way, the image stands out in contrast. With the same black, the face and the right shaded breast are then defined.

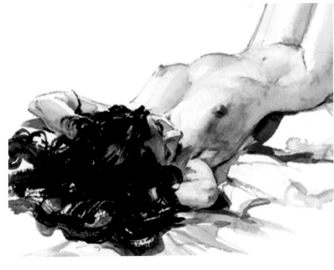

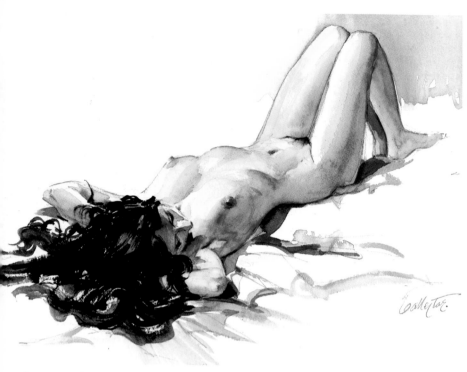

Step 8. Finally, contrast is developed in the navel, the pubic area, the legs and feet. Brushstrokes of diluted black are used to indicate the raised areas of the bed on which the model rests. In general, a fresh and spontaneous result characteristic of watercolor has been achieved.

SUMMARY

• The volume of an object, and specifically of the human figure, is expressed using variations of hues that range from the lightest to the darkest.

• In the human figure, volume and variation of hues are not only determined by the direction of the light, but also by the complex planes of human anatomy.

• Large body volumes require blends and large areas of gradation, but for smaller areas, it is better to work with defined brushstrokes.

• Subtracting hues in watercolor is usual-ly done only in smaller areas, but in large areas, the artist relies on the transparency qualities of hues from the very beginning of the painting process.

• The human body can be separated into planes for a better comprehension of the effects of light and volume.

• Human flesh is composed of a multitude of hues, which are called flesh tones.

• Strong contrasts in the flesh tones are established by light, transparent hues in juxtaposition with darker hued shadows.

Watercolor

INITIAL STRUCTURE

In painting animals, not only are brush-strokes that depict texture important, but also shape and gesture must be defined. The movement of an animal needs to be expressed with the initial brushstrokes, and if shapes are established from the very beginning, all the brushstrokes subsequently applied will clearly show the animal's proportions, contours, and gestures.

A wide variety of textures can be found in wildlife. The artist must use different methods depending on the distinct textures to be portrayed. Wide, even gradations might be considered for smoother furs, while large strokes of color along with a dry medium are necessary for textures like rough coats or feathers.

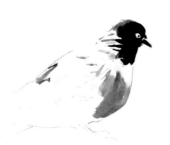

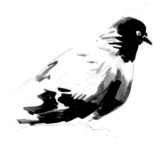

1. When developing the foundation drawing for a watercolor painting of an animal, in this case a bird, the artist needs to have a clear idea of its general shape, proportions, and gesture. First, the bird is drawn lightly, and then its shape is defined by directly applying black hues to represent the head and gray hues on the body.

2. The artist continues working with black in order to create contrasts in the lower area of the image. Brushstrokes should be applied in such a way to define the texture of the bird's feathers.

3. Brushstrokes of black are applied quickly and spontaneously to the bird's tail and feet. Foundation brushstrokes have now been added to the initial drawing to define the bird's shape and other characteristics.

TEXTURES OF SKIN AND FEATHERS

An animal's skin is depicted in a similar way as human skin. Like human skin, it tends to be smooth with indentations and sometimes, wrinkles. Plumage, however, is quite different. Feathers form shapes that can be painted with precise brushstrokes. Because plumage varies a lot in relation to size, color, and shape among different species, the artist must use various watercolor techniques to express these individual characteristics.

1. Birds are drawn according to their morphologic characteristics. Because different speciesof bird have different postures, the artist must have a clear idea of the particular species's nature. This understanding aids the artist in correctly depicting the bird's characteristics from any view.

2. The artist begins by applying the most general brushstrokes. Dark colors are used in the background to create contrast, allowing the birds to stand out. Pink and red hues of different intensities are used to express volume. Because a shadow is projected onto the birds' tails, the hues applied here are also darker.

3. The artist finishes by adding details with a fine brush. The most defined features such as the beaks, eyes, wings, and feet are established. Finally, red hues, overlapping the pink ones previously applied for the shapes of the birds, are added.

Spontaneous Versus Detailed Treatment

Since watercolor is a spontaneous technique, it is appropriate for quick sketches and exercises where brush-stroke and gesture predominate over detail. Elaborate paintings require a slow, detailed process requiring the brushstrokes to be incorporated carefully. In this way of working, the artist must wait for the layers of color to dry so that the details remain well defined and the colors do not blend.

1. The artist starts with a very elaborate drawing to define the volume and muscular anatomy of the horse. For the representation to appear balanced, it is necessary to correctly define the structure and position of the legs and hooves.

2. Now, a diluted brown hue is directly applied to the horse in order to depict light and shadow. The upper area is light and transparent, while the lower area and legs are denser and more opaque in color.

3. A dry brush is used to absorb the paper's wetness and to lighten hues in the areas which that need to be brighter.

A Spontaneous Finish

With watercolor, blending happens randomly, making it difficult for the artist to control brushstrokes. But an advantage to using diluted pigment, however, is that appealing natural blends are created leading to a free-flowing, spontaneous result. In order for the spontaneity to be effective, the artist must have confidence and not be hesitant in applying the brush-strokes.

1. Using a fine brush, the artist continues to define the horse. Precise brushstrokes are applied to depict the eyes, reins, and the smaller, more concrete forms. Wide gradated brushstrokes are applied to represent the background.

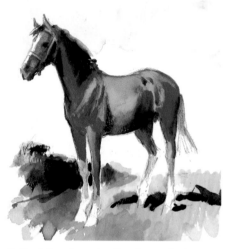

2. To define the animal's volume, the intermediate brown hues are intensified, and the lighter areas are left transparent. Shades are intensified on the mane, neck, and the shadow projected onto the ground.

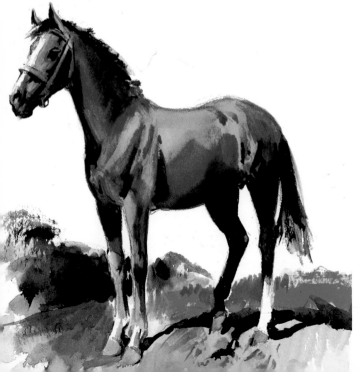

3. The artist completes the exercise by working on the legs and hooves. The horse's coat must be depicted very differently from longer fur or feathers. When the horse is viewed from a distance, the coat is seen as a smooth and brilliant surface, without added texture.

A Dog

MATERIALS

Fine-grain watercolor paper, Graphite pencil, Watercolors, Sable or Ox hair brushes, Water container, Paint rags

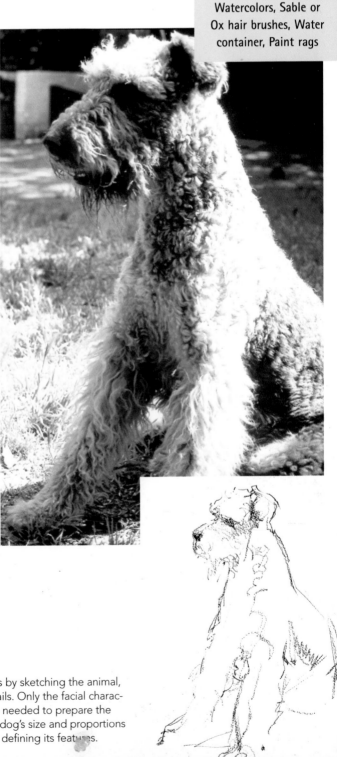

Dogs have unique characteristics depending on their breed. Therefore, there is no single or invariable procedure for representing their texture. The physical characteristics of dogs' coats determine the way textures are depicted. In this exercise, a dog with long curly hair will be painted using fine brush brushstrokes to correctly present this texture.

Step 1. The artist begins by sketching the animal, without concern for details. Only the facial characteristics and contour are needed to prepare the image for painting. The dog's size and proportions must be determined for defining its features.

Step 2. Working on a damp surface allows the two green hues used for the background to form a large blend. The animal's shape is left untouched to assure that colors don't run over and alter the dog's specific characteristics.

Step 3. Now, the background is filled in. The artist takes care to avoid the form of the dog itself, since very different hues will be applied to this area. Light colors are painted first and then successive layers are added to depict texture in the area corresponding to grass.

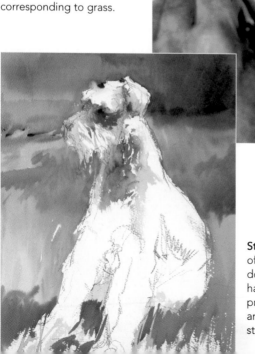

Step 4. Next, the artist applies glazes of various gray hues to the form of the dog. The hues are shaded on the lower half of its head and around its eyes. To present the dog's fur correctly, the artist applies color using short brushstrokes rather than long, broad ones.

Step 5. Contrast is now added by applying gray and black hues to define the eyes and nose and other dark areas. Fine brushstrokes are applied to follow the direction of the hair. Then, the artist adds multiple glazes, increasing the contrast between the bright and dark areas.

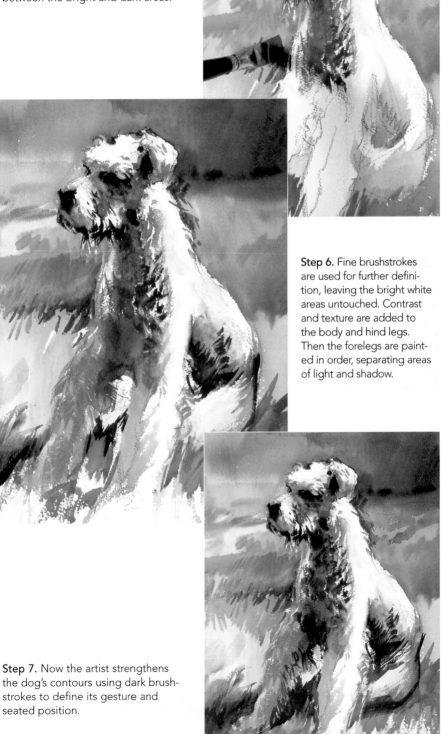

Step 6. Fine brushstrokes are used for further definition, leaving the bright white areas untouched. Contrast and texture are added to the body and hind legs. Then the forelegs are painted in order, separating areas of light and shadow.

Step 7. Now the artist strengthens the dog's contours using dark brushstrokes to define its gesture and seated position.

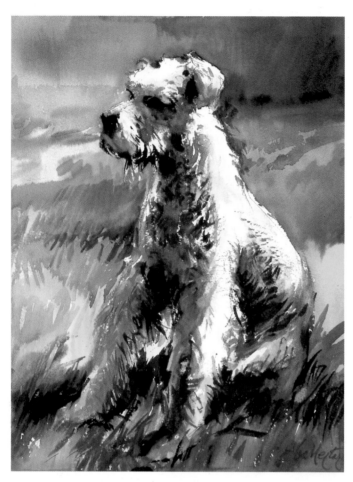

Step 8. Finally, fine dark green brushstrokes are added in the foreground, and short, dark-hued brushstrokes are applied to the front legs. Throughout the painting, the brushstrokes are essential for defining texture of the dog's fur and of the grass.

SUMMARY

• Paintings of animals are always a challenge decause of the variety of textures found in various species.

• Smooth, shiny coats require wide, blended brushstrokes similar to those used to depict human skin.

• To indicate hair or plumage, fine precise brushstrokes on a dry surface are used.

• Bird plumage varies among species, even in different areas of the same bird.

• The texture of fur varies according to where it is found on the animal's body.

• Because animas are live creatures, the artist must define movement and gesture when painting them.

• Painting in watercolors is similar to sketching in that it is spontaneous and fresh.

• Watercolor pigments are not easy to control. The artistwho understands this allows natural blending to occur, giving a fresh, spontaneous look to the painting and making the freedom in this technique especially appealing.

Watercolor

PAINTING BODIES OF WATER IN LANDSCAPES

Many times after a rain shower, puddles and flooded areas form which reflect the sky's hues. The water acts like a mirror onto which the blue and gray huesof the atmosphere are projected. Rain is usually accompanied by a white or gray sky, which can be depicted with a variety of hues included in the rich chromatic range. The character of the sky depends on the colors chosen by the artist.

Paintings of cloudy landscapes offer a number of interesting chromatic variations on neutral colors. When clouds are present, they block the solar light and change the appearance of the landscape as a whole. The absence of light causes colors to be less intense, but still these paintings offer a rich variety of forms, shadows, and hues.

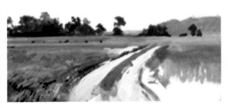

1. Since the atmosphere in this painting is damp, the artist begins by applying a light grayish glaze to depict the cloud masses and fog. Cooler colors, which integrate well with the general atmosphere, are used for the background.

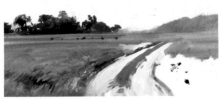

2. Much warmer and more radiant colors are used in the intermediate areas and the foreground. Here, a green hue is applied to depict the fresh, wet grass.

3. The artist finishes by adding contrasts and deffinition to the muddy areas. Dark violet colors are used to indicate tracks in the water. The same colors previously used on the sky are now applied to the wet areas reflecting the sky.

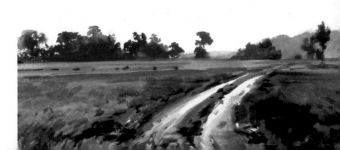

TECHNIQUES FOR PAINTING CLOUDS

An artist usually draws a horizon line when painting landscapes in which the sky is present. This horizon line helps to establish the sky, and also serves as a reference for depicting the atmospheric conditions. Because of the makeup of watercolors, they can be used for color blends and gradation making them ideal for rendering the sky and its atmospheric character.

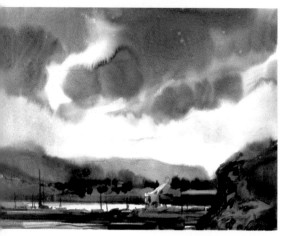

1. The general characteristics of a cloudy sky alter the chromatic range of all the elements in a landscape composition. As can be observed in this landscape, the dark and gray colors of the clouds are reflected in the hues of the vegetation and in the lagoon. These colors are integrated into the atmosphere, and they determine the painting's overall color.

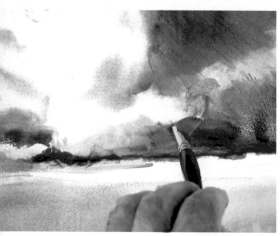

2. When painting the sky, the artist uses wet colors that allow for blending and freely applied brushstrokes. To reveal hazy white hues, paint can be removed with a dry brush.

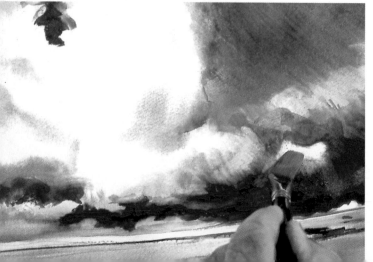

3. The artist intensifies the white color revealed in specific areas by surrounding it with very dark colors. In this example, paint is removed from a small area, and the area is then surrounded with intense blue hues.

FOREGROUND TREATMENT

Because many varied details appear on the ground of a landscape, it is impossible to single out a specific method to be used for depicting all of them. In this image, the foreground resembles a yellow flowered carpet. The strength and power of the colors guarantee a spectacular painting. In terms of composition, the foreground is chromatically varied and includes specific shapes and textures.

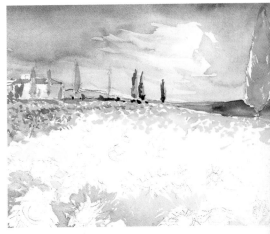

1. The artist begins by applying general brushstrokes to the background, keeping free of the complex foreground. After both the sky and the trees are painted, a yellow hue is applied to represent the distance. For the time being, the floral area is left white.

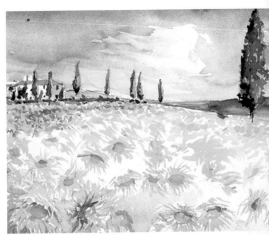

2. The artist now applies yellow brushstrokes to represent the abundant flowers on the ground. These brushstrokes define the flowers' petals. Then a red brushstroke is applied to the flowers' centers. The foreground flowers are given more detail, and the ones father away are allowed to blend together, appearing less concrete.

3. The last step is to define the flowers further by outlining them with a dark green hue. The shaded areas correspond to the spaces between the flowers, leaves, and stems. Just as in the previous step, the green colors are more concrete in the foreground and less distinct in the distance.

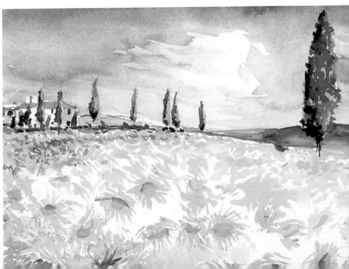

Eliminating Excessive Detail

Many interpretations are possible for the overall color, composition, and technique used for a landscape. When painting landscape scenes, the artist can work quickly and loosely, as in creating a sketch, since in nature, shapes are free and variable. Sketching and painting quickly allows the artist to convey these characteristics better than when working slowly and trying to capture details.

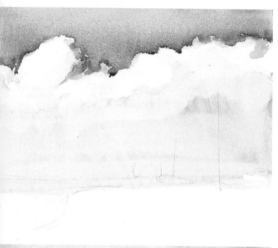

1. In this exercise, a very simple watercolor technique is used to paint the sky. An intense blue is applied to the upper area, and this is blended into a more transparent wash of the same hue on the lower part.

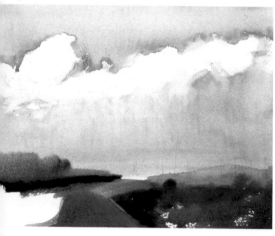

2. Wide, homogeneous brushstrokes are used on the land to develop the chromatic changes throughout the landscape.

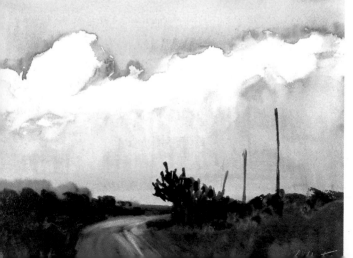

3. The entire left side of the image is now shaded. General brushstrokes are used to apply diluted paint, causing the color to be very integrated. After this foundation is dry, details like the bushes and grooves in the path are added to the painting.

Step by Step

A Rustic Landscape

MATERIALS

Fine-grained watercolor paper, Graphite pencil, Sable or ox hair brushes, Water container, Paint rags

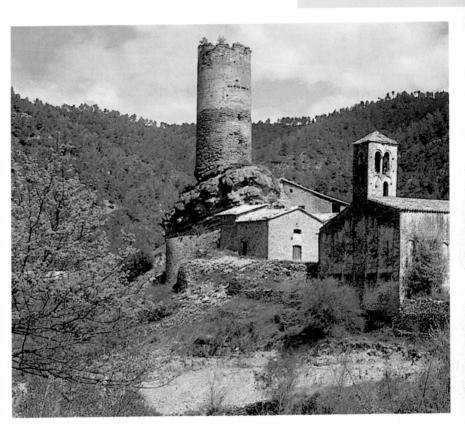

Rustic European landscapes with antique buildings are an ideal subject for painting, offering many interesting details, often including cobblestone streets, rocks, and tiles. These objects are especially appealing because of their difference from what can be found in contemporary cities. The broken and neutral color range used to paint these landscapes often includes ocher, brown, and earth-colored hues.

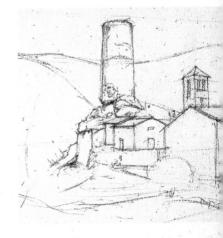

Step 1. First, the artist sketches the image, paying particular attention to the lines of the buildings. The tower stands out from the rest of the buildings because of its height and importance, forming the focal point of the composition.

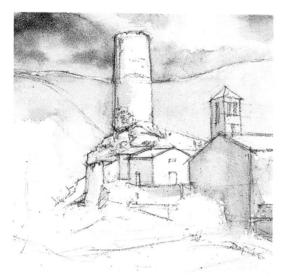

Step 2. A blue-gray glaze is applied to the sky and to the walls in areas where light does not fall directly. The atmospheric effect of the clouds is achieved by using hues of various intensities and blends.

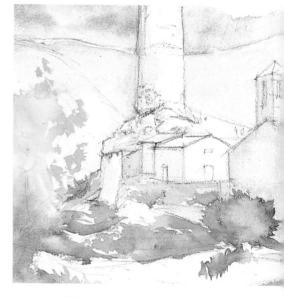

Step 3. The artist now begins to work on the vegetation using warm green and brown hues. The brushstrokes are applied more precisely than when working on the sky, because these areas are much more detailed.

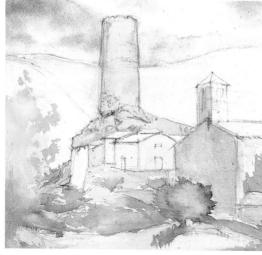

Step 4. The artist continues by applying a light ocher-colored glaze to elements on the ground. Adding this new color causes changes in the building which are extremely evident. The bright, sandy areas on the ground are now defined using an ocher hue.

Step 5. Next, by applying dark hues in the background, the ar-tist sets up a contrast and achieves a brightly lit effect on the land in the foreground. For this background, the far away mountains are painted with a gray blue hue. The brush brushstrokes are vibrant and indicate the presence of trees in the mountain.

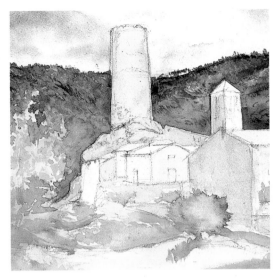

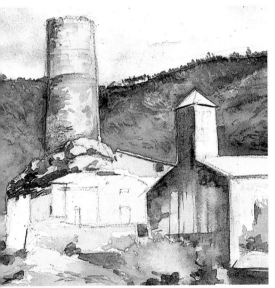

Step 6. Now, contrast in the architectural construc-tions is set up, to differen-tiate the elements oppo-site the light from those directly in its path. This effect is achieved by using darker hues. In this way, volume is correctly added to the shapes forming the houses and the buildings.

Step 7. Straight lines are now added to depict the buildings' structures, and each building is now given detail using a fine brush. Next, the closest doors and windows to the foreground are outlined.

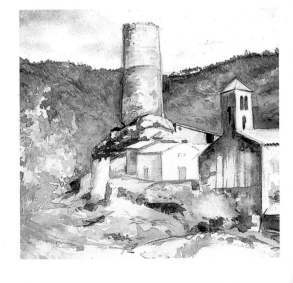

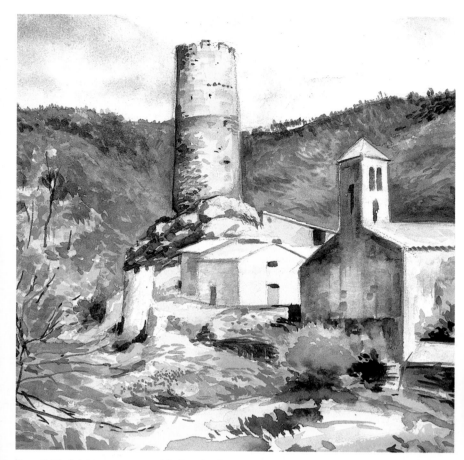

Step 8. To finish, contrast is added to the foreground elements. Lines are added to define the tree trunks, and dark brushstrokes are applied to depict the uneven earth. The last doors and windows are defined, allowing these elements to contrast with the darkness of the tower.

SUMMARY

• Clouds appearing in a landscape change the overall color of a scene. This change occurs because the sun, the primary light source, is blocked.

• In an overcast landscape, the colors used usually come from the neutral range of colors.

• Puddles and flooded areas formed after a rainstorm are like mirrors, which reflect the colors and hues of the sky.

• The horizon line is fundamental for portraying the sky because it helps the artist place the blended washes used to represent this area.

• To portray vaporous clouds, it is absolutely imperative to use the wet on wet technique. In this way, colors blend properly and even the white spaces appear to be hazy.

• In landscape paintings which include rustic buildings, the presence natural elements in the scene and the use of color aid in defining the rustic structures.

• Portraying landscapes generally offers the artist the possibility of working in a fresh and free manner, without having to concentrate on details.

Watercolor

FLOWER STUDIES

For the artist attempting to transform the mundane into the sublime, flowers as subject matter are especially appealing. Offering a wide variety of shapes and colors, they can be brought to life in a fresh way using the various brushstroke techniques.

Nature offers a multitude of themes and patterns, full of beauty and color and ideal for painting. Flowers and gardens, with their capricious shapes, varied colors, and attractive form give open a path toward creativity for the artist.

1. First, the artist paints the background, leaving untouched the flower structures, leaves, and stems. It is best to use a wide flat brush, proportional to the size of the painting, for this type of background. For areas in direct contact with the main object in the painting, a finer brush may be used.

2. Now, the artist applies green hues to the stems and leaves and adds a deep red to the petals. In the case of the green hues, the brushstrokes are wide and general. On the petals, however, the brushstrokes are more precise, making it easier to leave the white and brighter areas untouched.

3. The artist now creates the necessary contrast for depicting the volume of each element. The flowers are gradually darkened with deep red hues, causing clarity in the lighted areas. Next, a linear contrast is set up on the stem with dark green hues. This contrast causes the loose and spontaneous overlapping leaves to stand out.

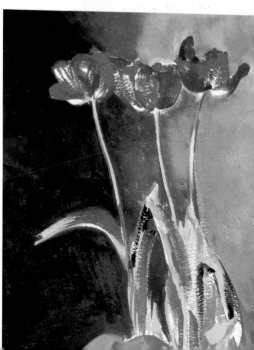

CHROMATIC PURITY OF FLOWERS

Flowers are natural elements, offering great variety and chromatic purity to the artist. Many of their brightest, most spectacular colors are achieved through chemical treatments of some petals. A decisive factor in bringing out color is the lighting. Focused natural or artificial light makes it necessary to use paint directly from the tube, especially for establishing the brightest hues.

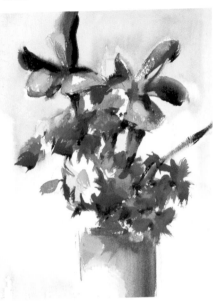

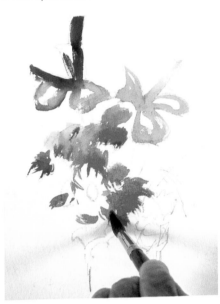

1. The first brushstrokes of color to represent this floral arrangement are intense and direct, establishing the pure colors from the beginning. Bright reds and lilac colors are blended on the topmost flowers.

2. The artist now adds contrast and definition. Red colors are applied carefully so that the white areas of the daisy are left untouched. The orchids are complemented by blending lilac with bright yellows.

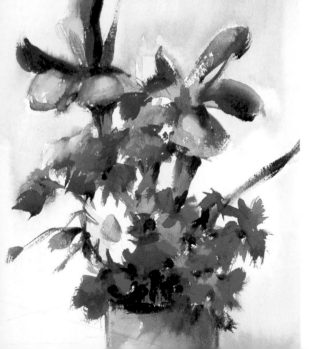

3. Now, the vase is defined, and contrast is added to the area of the stems, defining the outline with a very loosely applied ocher hue. The artist does not quite finish the shapes, so that the painting will appear looser, as in the case of many watercolor images.

ORGANIC TEXTURES

Nature offers the artist multiple chromatic combinations, both in an overall scene and in small, simple details.

Flowers, leaves, trees, and the earth itself present an infinite variety of hues that the artist must try to find in his or her palette and apply to the painting corresponding to what is seen.

1. When the artist works with only one element, the different hues that are present can be observed and contrasted in full detail. For example, this autumn leaf contains many brown and reddish hues.

2. When a small fragment of the leaf is studied, a series of rich and varied hues appears. In the case of representing this small area on a leaf, the artist applies many hues including brown, sepia, red, and yellow.

3. Linear elements are now added, from the veins to the leaf stem. The foundation colors are blended, and the leaves on the surface are shaded with a bluish, diffused color.

FLOWERS

When flowers are farther away from the viewer, they begin to lose detail and to present a more diffuse image.

Colors continue to be intense, even more so in comparison to the shapes and elements surrounding them. But the more exact petal shapes do not appear as distinctly as when seen up close.

1. General brushstrokes are applied to the background to establish the external shape of the flowers and leaves. For the time being, brushstrokes are applied lightly and without contrasts. General pale pink colors are added to the flowers. These are intensified with red hues in the areas that require contrast.

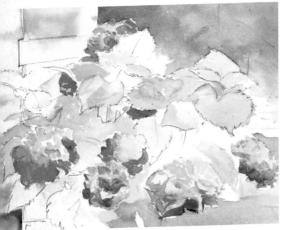

2. The leaves are painted with a very diluted emerald green. In some areas, the white color of the paper has been left untouched to indicate the very intense, reflected light.

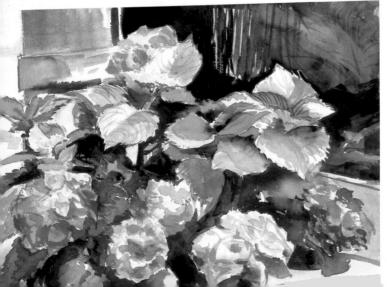

3. The entire floral area is contrasted so that it stands out against the background, which has been defined with dark hues. Next, the leaves are separated by contrasts, and the shape of each flower is depicted.

A Floral Arrangement

MATERIALS

Fine-grained watercolor paper, Graphite pencil, Sable or ox hair brushes, Water container, paint cloths

Floral arrangements make up an important theme in art history. Flowers are very gratifying from an artistic point of view, not only because of the chromatic variety of each species, but also because of the variations of shapes and textures from one species to another. For this reason, various arrangements of flowers are ideal subjects for practicing painting. The following exercise allows the artist to practice both composition and color treatment.

Step 1. The floral arrangement in this composition is first sketched with a pencil. The artist carefully balances the elements, centering them within the confines of the paper.

Step 2. A light ocher glaze is applied to the background to separate the light colors from the more intense hues that appear on the vase. On the flowers, directly applied red strokes of oil pastel or crayons are added.

Step 3. Precise, definitive shapes are established with crayon colors, like the lilac flowers in the upper area of the image and the green-colored stems. All the hues stand out against the clear background established in the beginning of the painting process.

Step 4. The flowers and stems are now defined with crayons. This process gurantees that the concrete shapes will last, even when watercolor glazes will be added later. Diluted watercolor forms a chromatic foundation, whereas the crayons are used to define concrete elements.

Step 5. Dark colors are now added to the lower right side. This area corresponds to the leaves that will be left shaded. A layer of red watercolor is now applied over the first hues, and this color stands out in those areas where the crayon has not been applied.

Step 6. Crayon colors have been used to define all the elements and their shapes. And watercolors have been used to strengthen the hues and to establish broad color areas.

Step 7. Because the shapes have been outlined with directly applied crayon hues, the watercolors applied in the background can be touched up and shaded without blurring the outlines. Since different mediums have been used in this composition, consecutively applied glazes of ocher and gray can be easily added to intensify the drape's color.

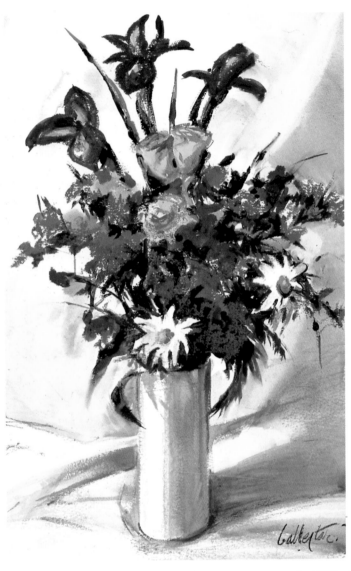

Step 8. The shapes and details of the remaining flowers and vase are now touched up. Working with the resist characteristics of crayon and watercolors is very appropriate for conserving shapes and details that would be lost if diluted brushstrokes were applied over previously applied watercolor.

SUMMARY

• Nature provides a multitude of chromatic combinations, both in an open scene and in small fragments like a flower or a leaf.

• Because of the variety of shapes, hues, and textures that differentiate one species from another, floral arrangements are a challenging subject for the artist.

• The watercolor technique is perfectly compatible with other materials. For a mixed technique, combined with crayons, the watercolor establishes the background and general washes of color while the cray- on colors are used to depict outlines and details.

• When the flowers are distant from the spectator's point of view, color combinations are the important elements instead of the details.

• Flowers are an ideal subject for express ing color in all its intensity and appeal.

• Many pigment colors found commercially sold are the result of a chemical process of pigmentation of metals, especially the purest and brightest hues.

OUTLINING WITH CHARCOAL

To present a subject in a painting, a series of relationships between light and shadow must be developed. To understand the image and how to present it, the artist begins with an outline of the forms and shapes. At this stage, the focus is on approximating proportions and balance in the composition. Later, brushstrokes and the hues necessary for establishing depth, volume, and character will be the challenge.

No theme is more appropriate for artistic study than painting the nude. An important subject throughout the history of art, painting the human figure was particularly significant in the Renaissance, when a revolutionary change occurred in the way nudes were treated. Along with a better understanding of the human body, artists were able to take advantage of new techniques of painting in oils, and nudes became the preferred subject.

1. The artist begins by working on the basic structure in charcoal, at first establishing the linear rhythm that reveals the figure's gesture. Freely-drawn lines define the contours, the internal elements, and the inclination of the figure.

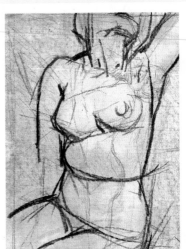

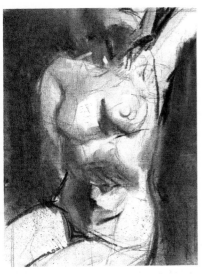

2. Continuing with the charcoal, the artist sets up the tonal values necessary for depicting volume. The dark background influences the contrasts on the figure, the strongest of which are in the midsection and on the neck.

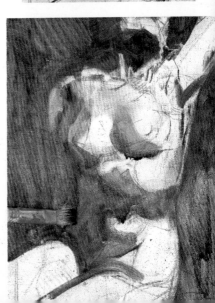

3. Next, turpentine is rubbed into the charcoal to blur the volumes in the image. This technique permits oil paint to be applied in a blended way.

BEGINNING WITN UNDEFINED FORMS

How oil paints are mixed depends to a large extent on the stage in the painting process. In the first stage, quick and decisive applications are necessary. Many mixtures and values are made on the canvas itself to create a basic chromatic range. These mixtures also cover the whiteness of the background support to avoid later confusion. The tones added in later stages will require much more detailed attention.

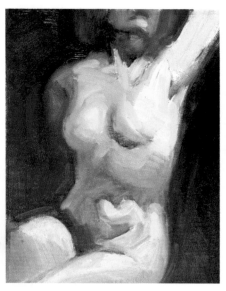

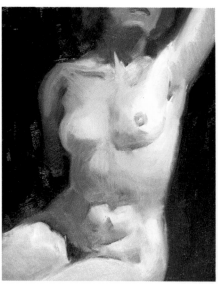

1. The artist continues by painting the general flesh tones. Bright pink hues are used on the figure's right side, and the hues are intensified toward the left. The brushstrokes help to define the areas of relief defining the breasts, abdomen, and hips.

2. Next, the artist blends the flesh colors in order to produce a smooth and continuous surface. The right arm, breast, and thigh can now be clearly differentiated. Broken blue hues are then applied in the shadowed areas of the same body parts.

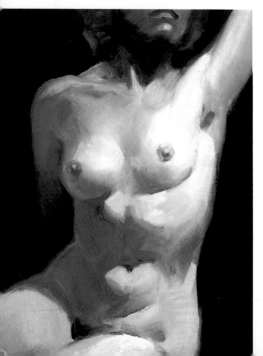

3. Finally, very dark hues provide the definitive contrasts on the right side of the image. These hues are incorporated into the composition in a blended way, allowing the artist to create a continuous, non-fragmented figure. The result is a dark, baroque-style painting of the nude, a style in which the figure appears to be immersed between intense shadows.

APPLYING OILS THICK OVER THIN

In oil painting, the length of the drying period depends on how diluted the paint is when applied. The oil painting process is based on a principle of thick over thin, in which the layers need to become oilier to guarantee that they are entirely set up on the painting. The first layers are thinned with turpentine, and for subsequent layers, heavier mediums, such as linseed oil, are used.

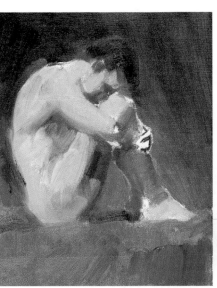

1. The artist begins by sketching the figure with charcoal. The side view pose is contracted, making the curve of the back essential for the figure's rhythm and balance.

2. A warm range of colors is used for the foundation brushstrokes. Sepia and brown are applied on the background, and flesh colors are used on the figure. On the left, highlights fall on the back, arms, and thigh.

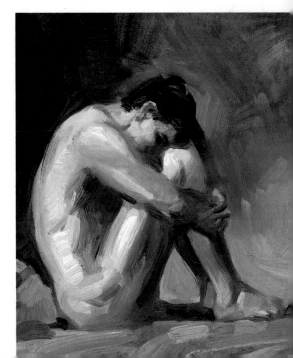

3. Finally, contrasts are giveb to the figure, and the brightest areas and folds in the draped cloth are highlighted with impasto effects. The underlying colors were diluted with turpentine and thicker paint used over these base hues for the definitive effects.

The Strategic Use of Impasto

The process of painting in oils consists of creating a painting by applying successive, overlapping layers of pigment, requiring the first layers to be diluted with turpentine. Each successive layer is then applied more thickly. Because the texture of a painting depends on its subject matter, the artist uses blended colors and very little texture in painting nudes as opposed to painting landscapes.

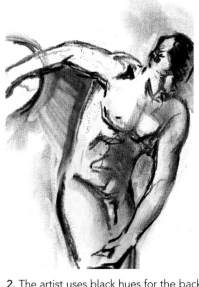

1. The body's linear rhythm requires an established underlying drawing. Since the figure in the study is active, the lines must depict gesture and movement. The inclination of the body and the position of the arms capture the figure's motion.

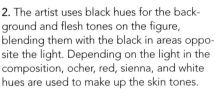

2. The artist uses black hues for the background and flesh tones on the figure, blending them with the black in areas opposite the light. Depending on the light in the composition, ocher, red, sienna, and white hues are used to make up the skin tones.

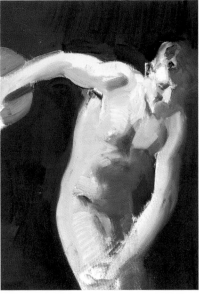

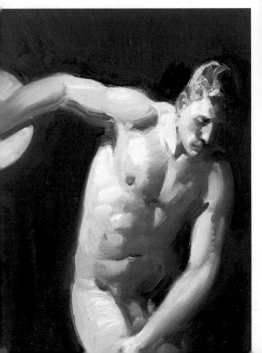

3. The final brushstrokes help to depict the figure's anatomy. First, a fine brush is used for the facial features. Then, the artist uses a medium thick brush to define the muscles, tracing the figure's outline when applying paint.

Nude Reclining On Pillows

MATERIALS

Stretched canvas,
Charcoal, Oil paints,
Bristle brushes,
Turpentine,
Paint cloths

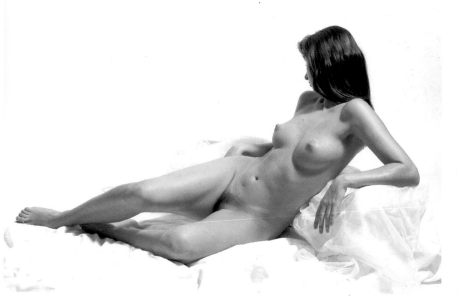

Paintings of reclining figures always give an impression of rest and calmness. In fact, the model's comfort and ability to be still often necessitates a reclining pose. The way that flesh colors are depicted depend on whether the background is dark or light. In this example, a light background has been used, and the presence of shadows that contrast strongly with the background are obvious.

Step 1. To begin, the artist draws a sketch. Since the lines depicting the body follow many different directions in this sort of reclining pose, the artist must be sure the figure is well placed in the composition.

Step 2. The first brushstrokes are applied without concern for detail. At this stage, the artist must find colors that depict the flesh tones in both the well lit and the shadowed areas of the figure.

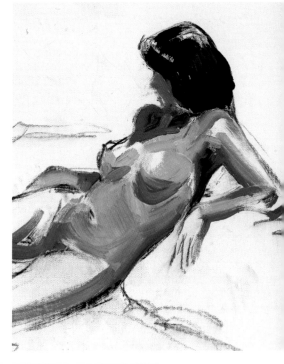

Step 3. The background is painted with a light blue-gray hue, a cool hue which causes the colors on the figure to appear much warmer by contrast. Pink and red colors now dominate the composition.

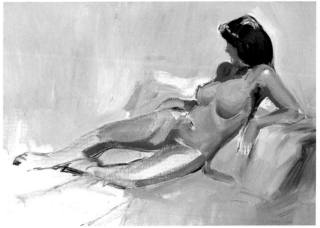

Step 4. The canvas support is completely covered with paint so that there are no remaining white areas. Gray and blue hues are alternated on the bed where the model is resting. Then, pink and brown hues are used on the body to define the shadows.

Step 5. A shaded hue adds contrast and gives definition to the image. The artist relies on this hue for volume and the darkest contour lines, as well as for the projected shadows under the arms and the breats and on the neck.

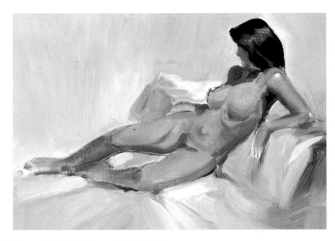

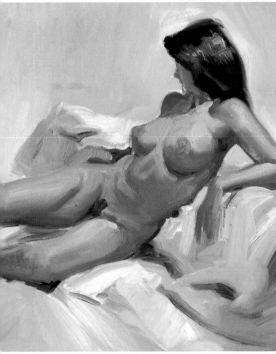

Step 6. The brushstrokes are now blended to make the surface appear continuous and smooth. In this way, the direct application of hues to represent light and shadow are joined to form a compact volume.

Step 7. After the general areas of color have been applied, a fine brush is used to work on details. The artist adds contrast to the legs and defines the form of the breasts and pubic area with dark colors.

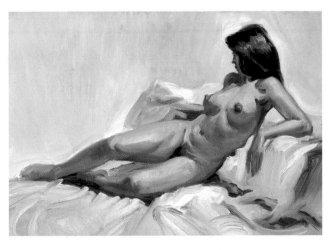

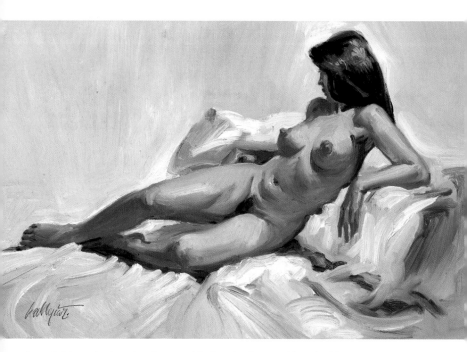

Step 8. Now, the last details are added to the feet and hands. Direct and flowing brushstrokes of white and gray are used to depict the irregular shapes of folds in the fabric on which the model rests.

SUMMARY

• In the first stages, the artist works quickly and decisively. Detail is much more important in the tones applied in the later stages.

• Unlike painting a landscape, in painting a nude, the hues are blended and there is little texture.

• The artist begins with oil paint diluted with turpentine. These layers are overlapped with thicker paint diluted with linseed oil.

• The first stage involves understanding the image to be represented. At this stage, the artist concentrates on line and contour, an approximate calculation of proportions, and composition.

• In the second stage, brushstrokes of values of hues are most important. The artist decides which hues will be used to indicate depth, volume, and character of the figure.

• The painting process is based on the thick over thin principle. The paint is mixed with more oil in each successive stage to guarantee that it is fixed to the canvas.

• It is very important to start with diluted paint. The paint will be successively thicker for each new layer applied.

• The oil painting process consists of applying progressive overlapping layers of paint.

Oil painting

THE IMPORTANCE OF SHAPE

All species of animals have their own unique structural characteristics, features, and proportions. When painting any live being, anatomy is fundamental. Mistakes in proportion are completely evident to the observer, which is not the case when painting other themes. The degree of difficulty in representing live animals depends on the type of animal. Mammals and animals that are very mobile are more complex to represent. It is necessary to start with a foundation drawing before applying brushstrokes of color.

1. The artist begins by sketching a small rodent with charcoal. Among its structural characteristics, the animal's roundness and size of its pointed ears are most important. The artist also needs to correctly depict the voluptuous, arched tail.

Unlike reactions to aggressive animals, small, fragile animals evoke tender sentiments in the observer. There is a special charm in paintings of these animals. But whatever their nature, painting animals is especially difficult. The artist must properly depict the animal's anatomical shape and its varied textures, as well as the animal's gesture and attitude, which will depend on the movement of the animal.

2. The background of the composition is verdant and full of contrasts. Green is the dominating hue of the forest, and orange hues define the ground on which the animal rests. Grays and whites are applied for the rodent's shape.

3. Finally, the artist works on the details of the body, depicting the animal's features and the texture of its fur. Gray, black, and white brushstrokes are combined to paint the small details of the hair and the eyes, snout, and whiskers.

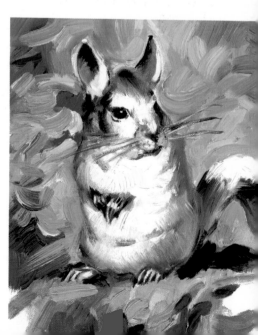

From General to Specific

The painting process starts with an overall study and follows with elaboration of details. Because oil paint takes such a long time to dry, it is possible to work back into areas of the painting, retouching them until the desired elaboration is reached, especially in the range of hues. This possibility exists because while the painting is still wet, it can still be blended, annd new colors can be integrated with those previously applied. At the beginning of work on a painting, only chromatic effects are reflected. In later stages, the artist concentrates on details and specific shading.

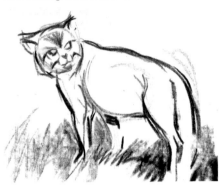

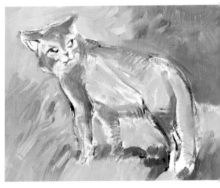

1. The artist begins with a charcoal sketch showing a cat's features, position, and gesture. Special attention is paid to the proportions of the head and body, as well as to the animal's inclination toward movement.

2. The background is painted with alternating warm hues, including yellows, oranges, and greens. Ocher pigment is directly applied to the fur. Brushstrokes for both the animal's texture as well as the background are applied directly.

3. Brushstrokes are then added on the background for the shadows and the grass. Finally, dark colors are added to the cat's body to obtain an effect of volume.

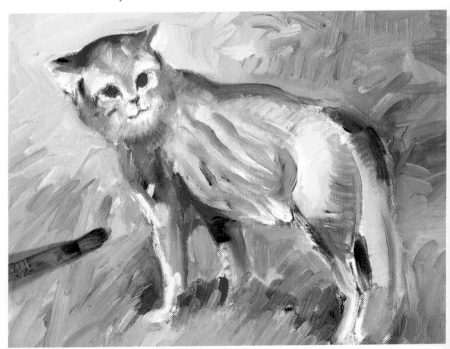

DETAILS AND TEXTURES

Textures of animals vary greatly depending on the species. In painting, these textures must be worked on in a detailed and elaborate way.

The distinctive formations of hair, skin, or feathers in a painting require special brushstrokes that indicate the direction of growth and the impression of textures. This detailed work is always reserved for the final stages of the painting process.

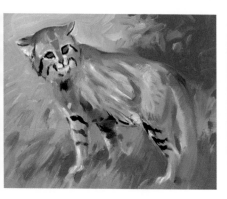

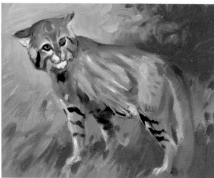

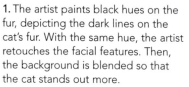

1. The artist paints black hues on the fur, depicting the dark lines on the cat's fur. With the same hue, the artist retouches the facial features. Then, the background is blended so that the cat stands out more.

2. Definition is now added to the face, and the painting becomes progressively more detailed. The internal volumes are shaded, and the eyes are painted to emphasize to the expression on the animal's face.

3. Next, the artist gives detail to the eyes and then adds texture to the shape corresponding to the muzzle. In general, the brushstrokes are precise on the face and less so on the body fur.

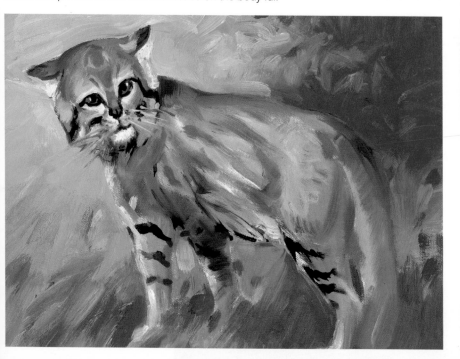

FINAL CONTRASTS

Shadows possess subtle variations worth studying. Since black is an extreme color that easily clash with the rest of the hues, the general chromatic effect it has upon the painting must be considered when applying it. Depending on the artist's intention for a painting, black can be toned down with other harmonizing or contrasting hues. Brown hues, especially, can be mixed with black to tone down the warm hues characteristic of animal fur.

1. The artist begins with an outline followed by monochrome brushstrokes which establish the shapes and contrasts of the squirrel's volume against the background of the composition.

2. Green and yellow brushstrokes are applied to create an atmospheric effect in the background. Then, warm brown and ocher hues are used on the animal's face and body and a reddish hue on the tail.

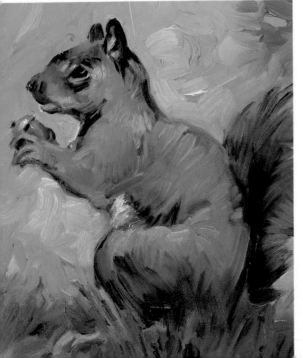

3. To complete the work, the artist uses overlapping and defining brushstrokes to depict the texture and volume of the fur. Since the hair is longer on the tail, the brushstrokes need to be more loosely painted than those on the rest of the body.

Geese

To paint this scene of geese, it is necessary to consider the process from two points of view. On one hand, because of the number of elements found in the picture, an analysis of both the structure and placement of each object is required. On the other hand, from a chromatic point of view, a white hue clearly dominates the composition. This hue needs to be shaded to correctly present volume and the projected shadows.

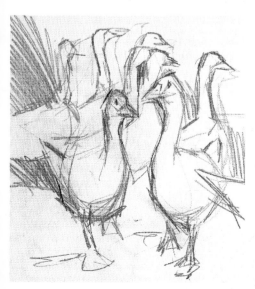

Step 1. To make sure that the brushstrokes are well placed, the artist begins with a pencil drawing. At the same time, features and anatomy are established. The voluptuous shapes of the geese are defined and given the right proportions with respect to the size of their heads and necks.

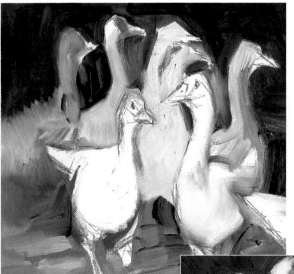

Step 2. The initial stages of the process are based on the general atmosphere of the group of images. The artist continues with the pencil strokes, but also concentrates on the effect off light and shadow in the painting. The floor and background are depicted with dark and green hues. On the geese, the artist uses lighter hues of different intensities according to the viewpoint.

Step 3. The closest geese are painted with a white hue that is slightly broken by adding a gray hue. The artist uses hues that are very bright and applied directly. However, he makes sure that the resulting color is similar to the color of the canvas cloth.

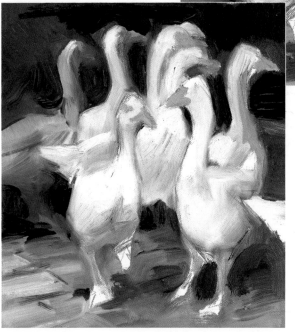

Step 4. Next the artist works on the floor adding the colors, which portray the shadow projected by the ducks. The general range of colors used consists of cooler green and blue hues. On the shadow, the artist adds a great amount of blue and a smaller amount of black paint to obtain an integrated darkening effect.

Step 5. Volume is now created within the geese's' general color which is based on white. Since this color is based on white, it only takes a few a small amount of pigment to quickly change the color into a range of tonal hues.

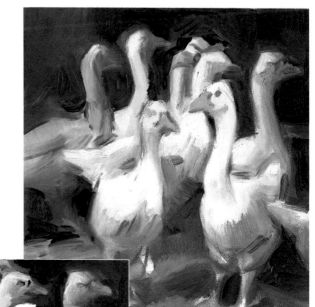

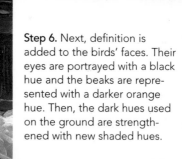

Step 6. Next, definition is added to the birds' faces. Their eyes are portrayed with a black hue and the beaks are represented with a darker orange hue. Then, the dark hues used on the ground are strengthened with new shaded hues.

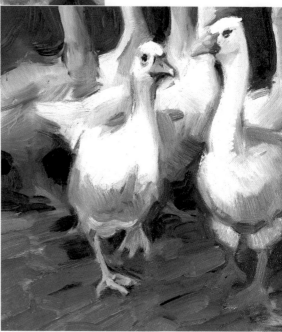

Step 7. The ground is darkened with new grays and browns. Broad, bold brushstrokes are used to depict the ground's cobblestone surface.

Step 8. To conclude, the artist defines the birds' feet using the same orange hues as those used on the beak. In general, different types of brushstrokes were used depending on the surface painted – the atmospheric background, the cobblestone, the feathers, etc.

SUMMARY

• In painting animals and other live beings, correctly depicting anatomy is very important. Any error in proportion can lead to a strange looking final painting.

• Brown and shadowy colors are suitable for toning down the warm hues characteristic of animal fur.

• The multiple volumes involved in the representation of hair, skin, or feathers require special brushstrokes, which help to determine the texture of the surface.

• Animal textures, which vary depending on the species, must be painted in a very detailed and elaborate way.

• A painting's difficulty depends on the animal being portrayed. Mammals and other active animals are the most complex to draw.

• When there are many elements in a painting, the artist must analyze the composition and structure of each one of them.

Oil painting

ATMOSPHERE IN A CLOUDY SKY

Clouds have very distinct shapes and densities depending on the amount of water they contain and whether a storm is threatening. Full, dense clouds filter out light, creating a dark effect. In painting the volume of these clouds, combinations of gray are often used. louds Clouds that are the least dense are the ones in which glimpses of sky show through, and these are the whitest and brightest.

The process in art in which the shapes of figures blend into the background is known as sfumato. Leonardo da Vinci invented the technique and applied it to achieve very blended colors in his paintings. The sfumato effect is spectacular, giving a rich atmospheric aspect to a painting.

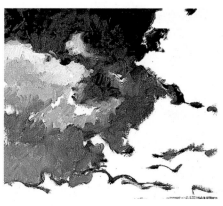

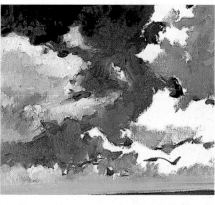

1. All the colors that make up the cloudy sky in this composition are established. Graduated tones of Prussian blue are applied for the background sky areas, and grayer hues combined with varying amounts of white paint are used for the clouds.

2. The artist now paints the clouds on the right with different shades of bluish gray. Mixing the color with black neutralizes the hue, and mixing it with white brightens it.

3. Finally, the clouds are given contrasts with bright hues that are blended with white. Colors are so that the hues integrate, leaving no visible brushstrokes. In this way, the artist creates a hazy effect, characteristic of the sfumato technique.

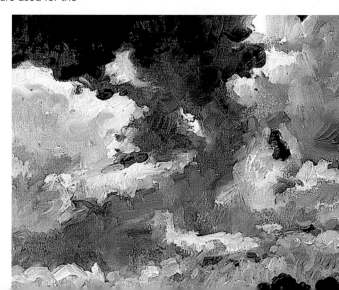

FOG AND MIST

The atmosphere of a landscape is determined by the characteristics of the air and light of its environment. There are scenes, especially landscapes characterized by the presence of fog and mist, which are obviously atmospheric. Since the sky and land in these settings have a direct relationship, the artist blends the sky hues with those of the land or mountains in order to create atmosphere.

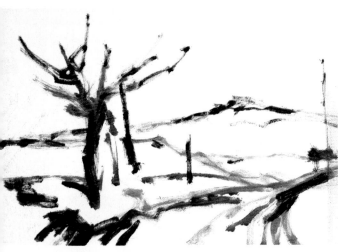

1. First, the image is drawn directly with oil paint. Landscapes call for less developed drawings in order to establish the lights and shadows in the environment. Concrete drawings are more important in figure and still lifes themes.

2. Now, gray-hued brushstrokes are applied to establish the background. The sky is painted with a neutral bluish gray; then, the color of the distant mountains is lightly intensified to assimilate it with the background and to create a sensation of atmosphere and distance.

3. The same hues used on the background are now applied to the foreground. Here on the road area, the oil paint is well-blended and applied thickly, but on the snowy areas, the white of the canvas stands out.

HUMIDITY

Humidity refers to the presence of water vapor in the air. The tiny particles of water produce a blurring effect in the images in the environment and create atmosphere. Humidity in a landscape painting is depicted by the way the sky is painted, in this case, very gray and dark, due to the presence of heavy clouds.

1. In this snowy scene, the artist accentuates the presence of humidity, both on the ground and in the overcast sky. Dark colors are used on the foreground to create contrast and to depict the gloomy areas on the rocks and the bare, dead trees.

2. Now, the impasto technique is used directly to apply white hues to the ground. Lighter areas are blended with the grays previously applied, producing graduated tones for the snowy hills.

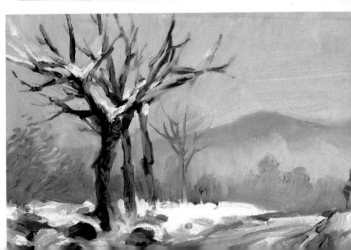

3. The artist finishes by adding dark lines to depict the bare-branched trees, the damp rocks, and the tracks along the road.

A Sense of Calm

Clear and warm landscapes produce a totally different effect than stormy and rainy ones. In the latter, the sky appears full of motion and variety, while smooth skies create a sensation of calm and tranquility. Calm landscapes express their own atmosphere, characterized by bright and lively hues, spectacular chromatic effects, and contrasts.

1.First, a sketch of the landscape is drawn with charcoal. The different planes in the image are established, and the background mountains are defined. In the foreground, the upright trees stand out boldly.

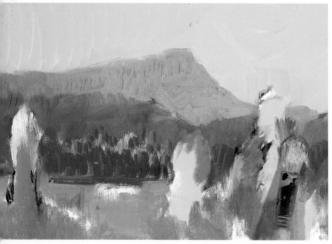

2. Brushstrokes of color are applied to all the areas of the painting. Yellows are used in the sky and pink in the areas corresponding to the far away mountains. A more intense shade of pink is used for the mounds in front of the mountains. Finally, green, yellow, and reddish colors are combined in the foreground and the trees.

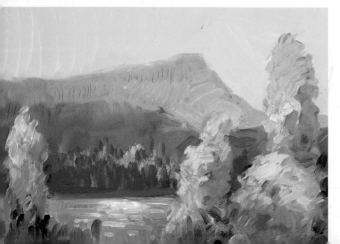

3. To finish the painting, mixtures of tones are used to vary the colors. In the background, the foundation hues are conserved to show distance. In the foreground, short, vibrant strokes of color are used to depict both the reflections in the lake and the various leaf textures on the trees and bushes.

An Atmospheric Landscape

MATERIALS

Stretched canvas, Oil paints, Bristle brushes, Turpentine, Paint cloths

Painting a landscape is an exercise of chromatic richness. In no other theme does such a range of hues come together. The landscape palette is rich and brilliant. The time of day, the amount of sunlight, and the density of the air determine whether the artist chooses vibrant colors or more neutral, balanced ones.

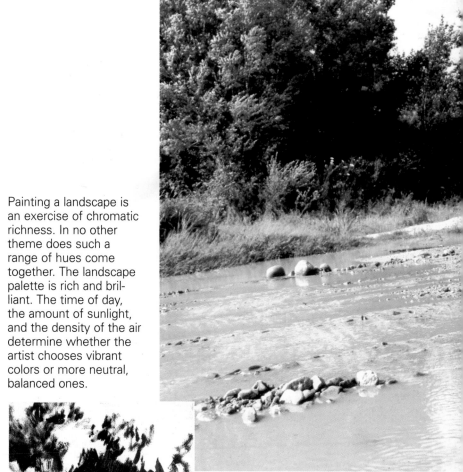

Step 1. First, the artist directly applies black oil paint to draw the landscape. With this same hue, the different planes are established. Then, the entire tree-filled area is painted so that it appears extremely dark.

Step 2. New hues are added to the larger masses. In this way, a blue base is formed in the sky. Then, the ground is painted with a combination of unblended blue, ocher, and white hues.

Step 3. The trees are defined with brushstrokes that create an effect of a multitude of leaves. On the left, green hues alternate with blue, and on the right, the original dark hue (black) is conserved to contrast with the light blue of the sky.

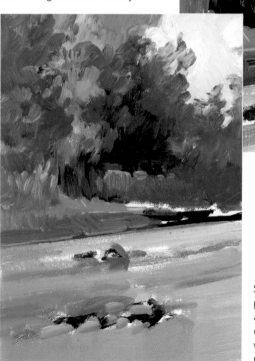

Step 4. The ground of the painting is covered with brown and green hues. Brushstrokes of color are applied in a general way so that later, other hues may be progressively added.

Step 5. New hues of green are added to the ground to represent the plants that bordering the trees. In general, cool bluish greens are used to integrate with the color of the sky and the trees.

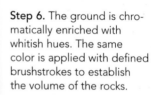

Step 6. The ground is chromatically enriched with whitish hues. The same color is applied with defined brushstrokes to establish the volume of the rocks.

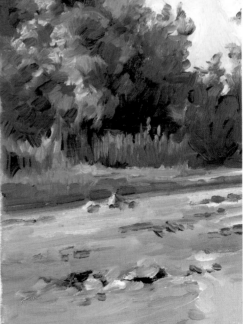

Step 7. More intense brushstrokes are added to define the ruggedness of the terrain. Then, dark hues are applied to indicate the outlines of the rocks and the shadows projected onto the ground.

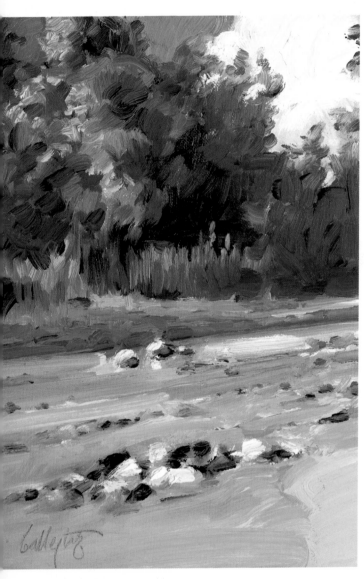

Step 8. Finally, dark hues are applied with a fine brush to create contrast on the rocks in the foreground. Yellow ocher is used on the sand so that the foreground appears warmer and nearer, while the background is given a sense of depth and atmosphere.

SUMMARY

• The term sfumato describes a process of art in which the elements blend with the background creating a totally atmospheric sensation.

• A characteristic atmospheric landscape is one of fog or mist, in which the density of moisture in the air obscures, and, therefore, deintensifies, color.

• In atmospheric landscapes, foregrounds are clear and defined, while more homogenous hues and less concrete brushstrokes are used for the background.

• Dense, stormy clouds are usually created with a great variety of gray hues that convey the lack of light, while thin clouds are depicted with white hues.

• Rainy and wet landscapes are characterized by the abundance of distinct colors and the almost complete absence of light.

• Clear, smooth skies lead to a sense of calm in a landscape. Without the movement that characterizes stormy scenes, they contain very bright color.

26 TEXTURE AND FORM IN STILL LIFE PAINTING

Oil painting

THE TEXTURE OF FRUIT

Realistic painting involves a study of reality in order to convey objects on a two dimensional surface. The artist's goal is to express the form and volume of objects, concentrating on their surface qualities and on the ways they reflect light. This involves analyzing their roughness, their brilliance or opacity, and their smoothness or coarseness. There are many adjectives that could describe each element; the artist's palate describes them through a process of observation and mastery of a painting medium.

Still life painting is ideal for the creation of a meticulous, elaborate study of forms and their visual characteristics, which includes color. The elements of the still life remain fixed, as does the light, which can be set up artificially for the purposes of the study.

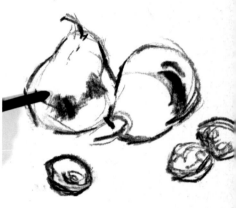

1. First, pears are drawn with charcoal. Because oil colors will cover the charcoal well, the artist freely sketches with dark lines. The form and contours of the fruit are now established, and, through shading, an effect of volume is depicted.

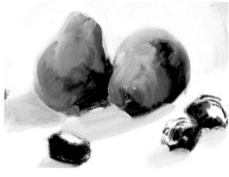

2. The artist uses oils to establish a base of primary colors, concentrating on the broadest areas of color. A light gray hue is used on the background. Dark green and brownish-green hues are then applied to the pears to strengthen the effect of volume.

3. The textures of the pears are developed by adding new red and yellow hues over the initial foundation.These brushstrokes are well defined in order to create specific textures.

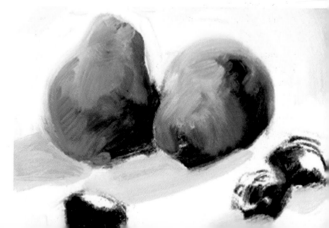

Varying the Texture of Fruit

Overripened fruit has very specific characteristics in color, form, and texture. The hues involved are dark, warm browns. The surface is cracked and wrinkled. To paint fruit under these conditions requires very different treatment from that of painting unripened fruit with its colorful hues and smooth surfaces.

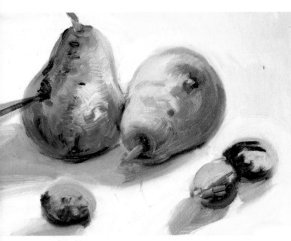

1. Continuing with the previous exercise, the color of overripe fruit is developed with applications of brushstrokes which convey the wrinkled texture. Darker hues are then applied to the most ripened parts of the fruit.

2. Now, texture is developed by applying light and bright colors with a fine brush. New light yellow tones are then incorporated with short brushstrokes to accentuate the wrinkled surfaces.

3. Next, adding reds to the pears strengthens the overripe effect. The same color is used on the nuts, which have been given volume with dark brushstrokes.

THE TREATMENT OF METALS

Metals have a visually unique surface. Old metal has a dull, muted patina, and new metalic material is more like a mirror, reflecting everything that surrounds it. The shape of a metal object determines its reflections, and these follow the outline of the shape. The hues involved are also decisive in creating the effect of shininess and reflections.

1. The artist begins by painting the canvas background on which two copperware pots are to be drawn. Then, the main volumes and the folds in the cloth are laid down with a dark color.

2. General brushstrokes are applied to the background and to establish the objects. Now, a light blue color is used to depict the tablecloth. The pots are painted with a sienna hue mixed with black. These are the colors that make up copper tones.

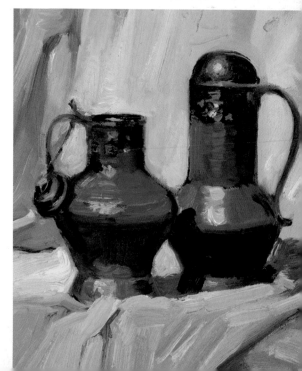

3. Blues are applied in the foreground with direct brushstrokes that define the folds. Intense dark hues are then added in the shadowed areas. The reflections are made with rose hues that result when light reflects off the copper hues.

GLASS

Because of its transparency and the reflective glow produced when light shines on it, glass is a very interesting material to paint In this composition, a frontal image without perspective will be painted for studying this material. The artist concentrates on depicting transparency and the effect of water on viewing each object.

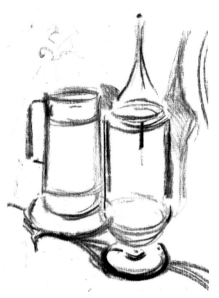

1. The two containers are drawn using charcoal. The oval-shaped contours should be drawn with the appropriate proportions so that the objects will appear straight and balanced.

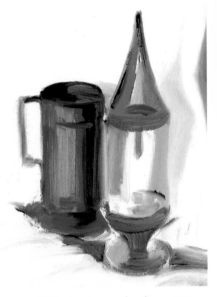

2. The background is then painted with white hues, and the projected shadows are hinted at using a soft gray. The containers are each painted differently, according to their specific na-tures. Red and brown hues are applied heavily to the copper object, and the glass object is painted with oil paint of a very transparent green.

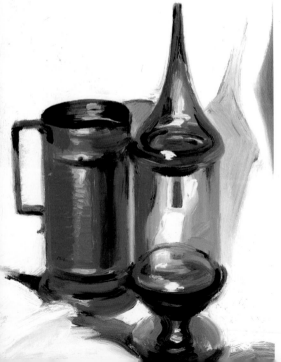

3. Now, the artist concentrates on details and contrasts. On the copper object, black hues conveying shadows are blended into the right side. The dark areas of the glass object are applied more distinctly, with less blending. Finally, the cylindrical body of the glass is painted using transparent colors.

Step by Step

Still Life with Fruit and Vase

MATERIALS

Stretched canvas,
Charcoal, Oil paints,
Bristle brushes,
Turpentine,
Paint cloths

The still life is a very appropriate study for painting textures realistically. The subject offers a close-up view of objects that allow for the true and exact definition of each of its characteristics. In this exercise, the artist works on the diversity of colors and textures in very distinctive ways.

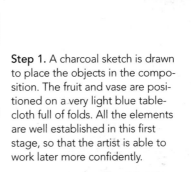

Step 1. A charcoal sketch is drawn to place the objects in the composition. The fruit and vase are positioned on a very light blue tablecloth full of folds. All the elements are well established in this first stage, so that the artist is able to work later more confidently.

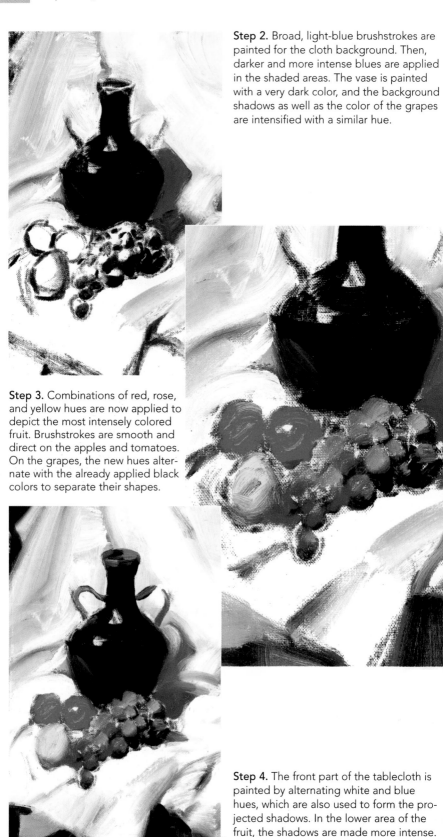

Step 2. Broad, light-blue brushstrokes are painted for the cloth background. Then, darker and more intense blues are applied in the shaded areas. The vase is painted with a very dark color, and the background shadows as well as the color of the grapes are intensified with a similar hue.

Step 3. Combinations of red, rose, and yellow hues are now applied to depict the most intensely colored fruit. Brushstrokes are smooth and direct on the apples and tomatoes. On the grapes, the new hues alternate with the already applied black colors to separate their shapes.

Step 4. The front part of the tablecloth is painted by alternating white and blue hues, which are also used to form the projected shadows. In the lower area of the fruit, the shadows are made more intense. The pure colors now stand out by contrast.

Step 5. The vase is correctly de-fined with an intense color and then it is overlapped with bright colors to integrate it with the general coloring. Next, red shades are added to the grapes to give the setting great chromatic strength.

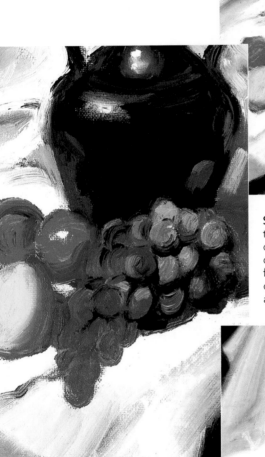

Step 6. Contrast is now added to the grapes. A fine brush and dark color are used to define the outline of each grape. The closer fruit is painted with a darker, violet color, while the more distant ones are covered with lighter colors.

Step 7. Next, shiny areas are a-dded to the grapes to make their volumes pronounced. Afterward, the projected shadows in the background are intensified to strengthen the general contrast.

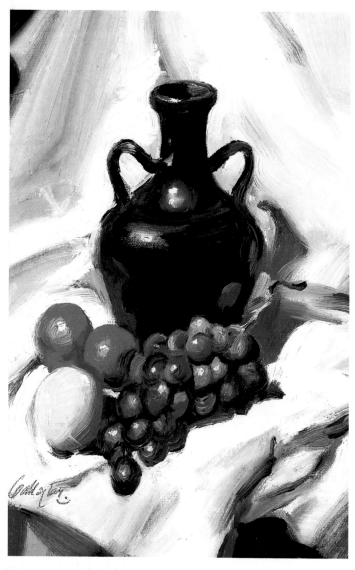

Step 8. Contrasts are now intensified in the shapes forming part of the foreground, both in the tablecloth and in the fruit.

SUMMARY

- Glass is characterized by its transparency in relation to the background colors.

- A still life is an ideal subject of study for representing objects and elements, allowing a detailed and realistic composition.

- When fruit becomes overripe, it develops browner and redder tones. Overripened fruit is also coarser and requires shaded hues to depict the rough surfaces.

- Old metals should be rendered with a dull, matte finish, while new metals reflect light like a mirror.

- Realistic painting is a visual study of objects to represent them on a two dimensional surface.

- The painter describes the texture of each element by using distinctive brushstrokes.

- All elements have their own characteristics, which can be depicted through their textures.

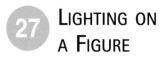

Oil painting

WARM FLESH TONES

Flesh tones depend on many factors, including the way light falls on the skin and the effect of background colors on its tones. Depending on the other hues projected onto the body, very different shades are created. Warm skin colors normally predominate in the presence of a background with warm characteristics. Light originating from a spotlight also creates warm tones on the skin.

Nudes are one of the most important subjects in the history of painting, especially in the academic study of art. Correctly portraying a nude figure involves a complete knowledge of human anatomy in order to understand how light affects its volumes.

1. In this study of a female nude viewed from the front, the sketch represents only the essential volumes.

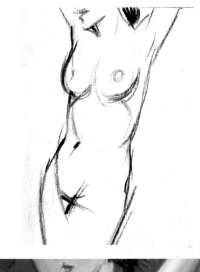

2. The warm flesh tones are established with yellow and rose colors. Yellow, mixed with large amounts of white, results in brighter skin tones. Next, a small amount of red is added to develop the shadows. These red hues blend with the already applied color to form orange hues.

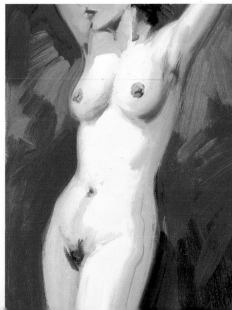

3. To enhance the background, some well-defined brushstrokes are now added. These red hues strengthen the flesh tones by contrast. Continuing, sienna and black hues are added to the shadowed areas of the body.

COOL FLESH TONES

In painting flesh tones, the colors are often very different from those one would expect to use. Flesh color usually implies warm, rose-colored shades. But cold surroundings add very different shades to the skin, especially pale skin. The artist must tone down green and blue colors that reflect off the skin to achieve a realistic effect.

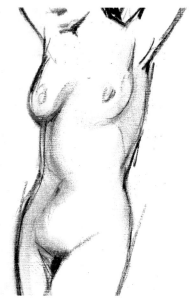

1. First, a preliminary sketch is drawn to establish where to apply brushstrokes of color. Even if the charcoal lines are well defined, the opacity of the oils will later cover all traces of the sketch.

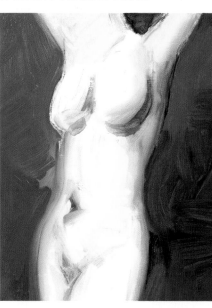

2. The background of the image is cold and very dark, composed of emerald green mixed with black. This makes the flesh appear very illuminated by contrast. In developing the skin colors, a great deal of white is used, and the hues are applied in short, broken brushstrokes, causing the colors to lose some of their warmth.

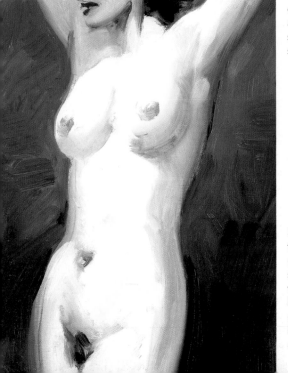

3. Because they are different from the hues used on the dark background, the colors that define the shadows are applied very lightly, without intense contrasts. Light bluish hues are now added to integrate with the flesh colors. These blend in easily with the rest of the already broken colors.

BROKEN FLESH TONES

Neutral backgrounds result in broken flesh tone colors. The required hues will vary according to the environment. but with study, the artist establishes volume by blending a variety of hues well with the general tone of the background.

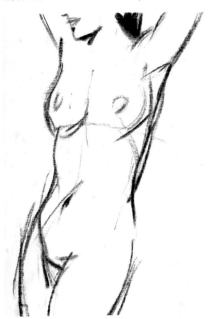

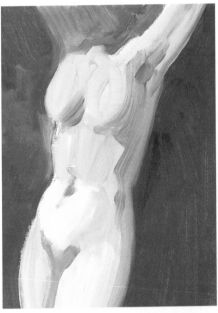

1. The preliminary sketch is drawn, keeping in mind only the basic shapes and contours. This very general sketch does depict the details.

2. A large variety of browns are included in the broken colors making up the flesh tones. The artist now adds white and pink hues to the lighted areas. Then, sienna and pale brown shades are used for the darker areas.

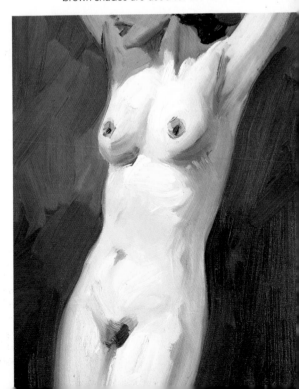

3. Finally, contrasts are created. White is directly blended into the main shapes to project volume. Intense sepia colors are then painted into the linear contours. Here, shades are developed with browns and very broken dark gray hues.

VOLUME AND DIRECT LIGHT

The skin is a surface that reflects light, requiring the artist to not neglect the variations of hues resulting from this light. Sometimes the light is so strong that it produces a highlit area at certain points on the body. In cases where light falls on a figure from a source directly in front of it, the result is a loss in volume

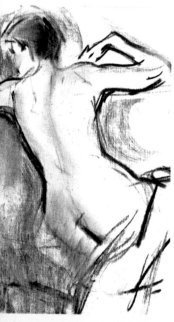

1. With a preliminary charcoal sketch, the figure's contour is defined in proportion to the model's anatomy. Also, the areas of the body away from the light are darkened slightly.

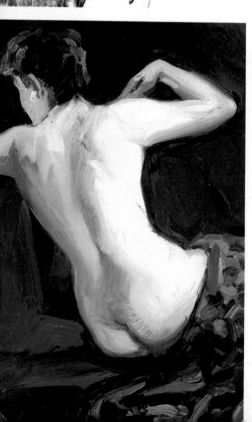

2. The most general brushstrokes are now used to establish color in the painting. The very dark background causes the figure to stand out by means of contrasts with the bright hues. The model's right side gives off very bright reflections. On the left, the color is blended with more intense brown hues to depict darkness.

3. Now, the oil colors are blended to create a homogenous sense of volume. In the most illuminated areas of the skin, white is added for brightness. Dark hues are then blended with medium-range hues to create light, graduated tones, which define the volume correctly.

A Back View of a Figure

MATERIALS

Charcoal, Oil paints,
Bristle brushes,
Turpentine,
Paint cloths

The human body is composed of different parts making up the whole. Multiple contrasts of light and shadow are as important as the anatomical composition. Studying the effect of light and dark on a figure allows the the construction of it in a composition. When a pose has been decided upon, well-chosen lighting helps to emphasize the subject, assuring that the finished work satisfactorily defines the human form.

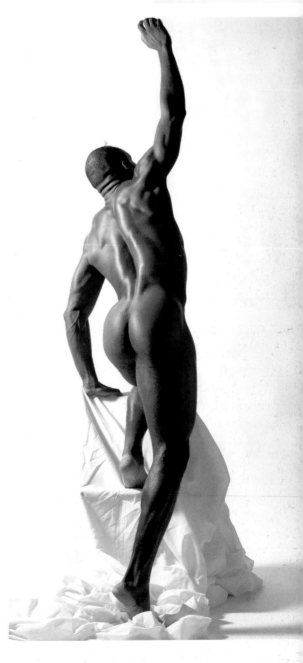

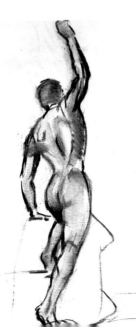

Step 1. A preliminary charcoal sketch of the figure is drawn. Here, the model has dark skin tones, requiring dark hues tol be used.

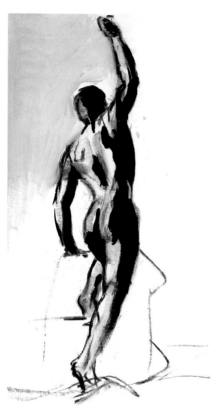

Step 2. Oils are applied to represent both the figure and the background. For the figure, a black hue is applied directly onto the backlit areas. Concentrating on anatomical definition, the artist does not work on details for the time being. A light gray hue is used on the background.

Step 3. Now, in the background, fresh bluish gray hues are applied to create graduated tones for atmosphere. Sienna colors are then combined with the black on the figure to obtain the proper skin tones.

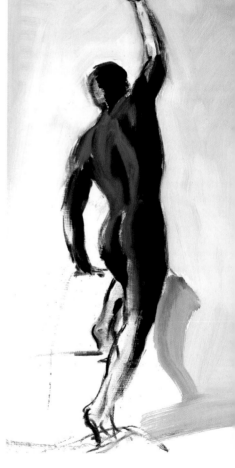

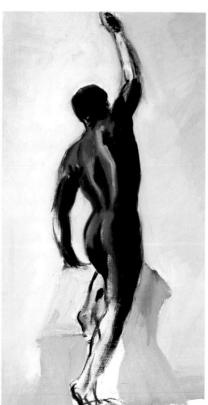

Step 4. Next, bright hues are added to the skin to heighten the sense of volume. In the background, gray hues are overlapped with pink ones, and, in this way, the background color is integrated with the color of the figure.

Step 5. New shades are added over the dark background. Light colors and blues are applied to brighten the skin on the left side of the figure.

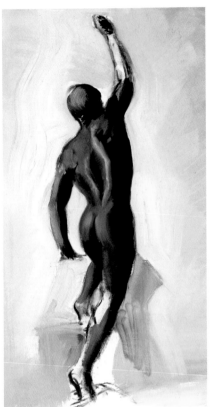

Step 6. To continue, the colors are blended in the interior of the body in order to brighten each part, depending on the volume of the area. Blue hues are applied to the surface on which the model leans, defining each of its planes.

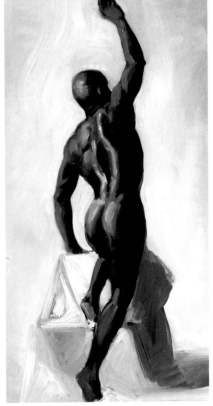

Step 7. New shades are added to the skin using brushstrokes that define the anatomy. The muscles of the left arm are depicted with a light pink hue. Sienna is directly applied to the black foundation color to outline the figure.

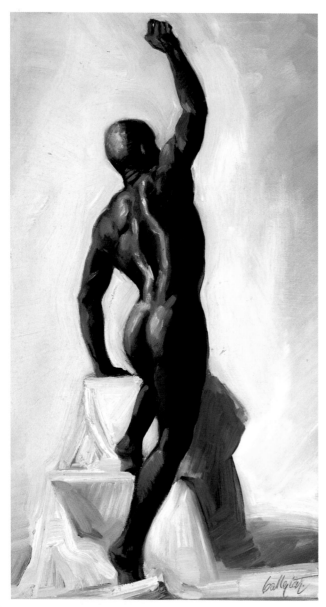

Step 8. Some bright hues are used to define the right arm, strengthening the effect of muscle. Finally, the podium and the cloth that covers it are defined.

SUMMARY

• Cold backgrounds tone down the flesh color with green and blue hues.

• The blue colors on the skin need be applied with short, broken brushstrokes so that the color appears to be natural.

• Direct lighting gives off a yellowish light, producing very warm hues on the skin.

• In the human figure, contrasts of light and shadow define the different parts of the body, and thus express the figure's anatomy.

• Flesh tones depend on factors such as the way light falls on the skin or on the choice of background, which in turn, determines the color of reflected light.

•The skin is a surface that reflects light, meaning that when light falls directly on the skin, bright, highlights are produced at the most projected points of volume.

• Nudes as the subject in painting require a thorough knowledge of human anatomy.

Oil painting

THE ANATOMICAL SKETCH

Accurately portraying a person's face is a difficult process, but when painting animals, variations in features are very slight. Painting the species characteristics of various animals, however, does present a difficult challenge. Since animals are defined by their overall movements, depicting their gestures, positions, and attitude is very important.

This chapter focuses on painting one of the most beautiful of animal species – the cat. Felines are naturally elegant, and their movements and gestures can be difficult to sketch. The artist uses sinuous lines to define face and body features and impasto effects in oil o depict the animal's furry skin.

1. The artist begins the exercise with a sketch, taking into account the cat's anatomical characteristics. In this example, the cat is lying down with its back and tail projected into the foreground. Other elements, like the head and front paws, are smaller due to the effect of foreshortening.

2. Now, the background is painted with diluted oil paint. The color is blended and smooth. Black brushstrokes are then applied to define the darkest areas of the cat's furry coat.

3. Next, the artist applies general strokes to the background and to the cat's fur. A granite hue is directly applied to the area corresponding to the floor. The artist uses wide brushstrokes, filling in the entire space. Brown and ocher hues are alternated on the coat. Then a black hue is applied to the tail, back, and paws.

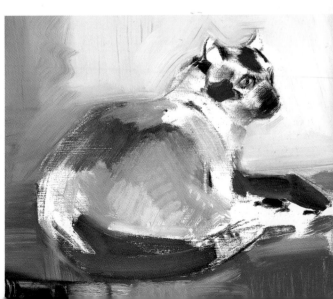

PAINTING WITH DILUTED OIL PAINT

At the beginning of an oil painting, it is best to thin the pigments with turpentine. Then, thicker coats will be successively applied. Oil colors are dense and strong enough to be applied full strength in liquid form, especially darker colors. It is logical, therefore, to begin by applying diluted, dark colors, and to end by applying lighter colored impastos.

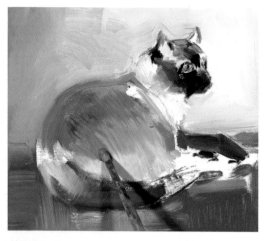

1. The texture of fur is developed with fine brushstrokes applied in the direction of growth of the animal's fur. Various brown hues mixed with whites of different intensities are used to define the cat's color.

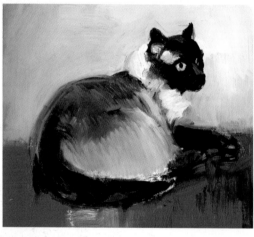

2. Now, black hues on the cat's face are intensified to depict the fur in that area. This fur contrasts with the light hues used on the neck and the painting of the cat's glowing eyes. Definitive brushstrokes of black are used for the tail and back, and lighter hues are used on the lower parts of the body.

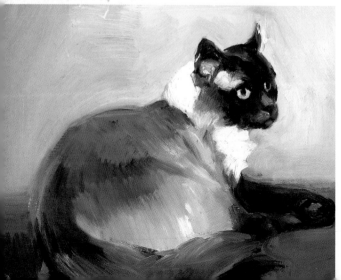

3. To finish the painting, the colors are now blended using the appropriate oil paint techniques. Mixing the hues creates a uniform surface, and the applied brushstrokes create a graduated impression of volume.

USING IMPASTO IN THE FOREGROUND

One of the most appealing aspects of oil painting is the ability to apply paint by impasto. In following a logical oil painting process, different textures will be used depending on how close or far away the area to be painted is from a spectator's view. The artist relies on impasto for giving texture to elements in the foreground and making them appear closer.

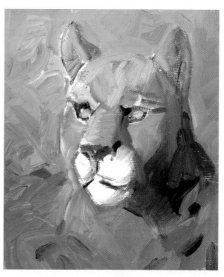

1. To begin, the artist draws a sketch of the feline to establish the appropriate lines for defining the features of the eyes and muzzle. The sketch also assures that the head area is well proportioned.

2. The artist then applies the first coats of paint in a very general manner. The purpose is to cover all spaces with a hue that represents the chromatic range of each fragment. Soft greens are used on the background, while colors and textures are intensified in the foreground. The artist uses brown hues for the cat and black for the strong shadows.

3. Dark colors are distributed widely for the shadows projected by the ears, head, and neck. The brushstrokes are applied in a linear way that depict the main facial features. The jungle-like background is softer and smoother than the foreground. The paint is more textured in the bushes in front of the animal's body in the foreground.

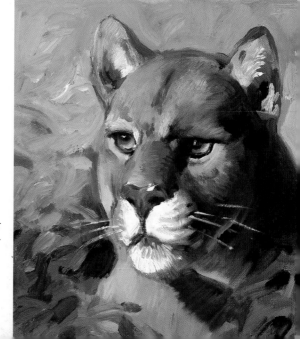

QUICK SKETCHES

Animals can be portrayed both by quick brushstrokes of paint and in a detailed, precise manner. However, Quick sketches produce the best depictions of the characteristic movement of animals, however. By observing and synthesizing the resulting knowledge of the movements of animals, an artist can capture an animal's spirit and gesture.

1. Beginning the work, the artist sketches directly with charcoal or graphite, searching for correct proportions in drawing the animal. Since the animal is in motion, the artist must adequately capture its gesture.

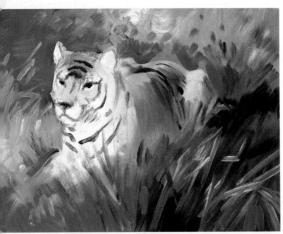

2. Now, rather thick paint is used on the background since it makes up a large part of the image. The artist then relies on impasto effects, using vertical brushstrokes to define the leaves. Applying yellow alternately with brown and sepia hues creates volume on the tiger.

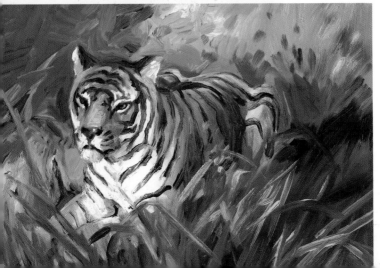

3. Next, the artist paints the lines depicting the tiger's stripes and facial characteristics. For this entire painting, the oil paint is applied directly and freely, and the colors are left unblended.

Step by Step

A Lion

MATERIALS

Stretched canvas,
Charcoal, Oil paints,
Ox hair brushes,
Turpentine,
Paint cloths

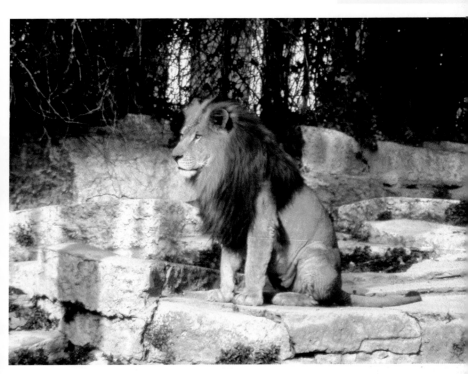

The oil painting process is always based on a study followed by a complete elaboration of the image. In other painting techniques, the artist can choose to apply the paint in layers, but in oil paintings, the artist can change the development of the painting freely, so there is no need to plan the work in layers. Hues can be determined from the very beginning of the painting process, and the artist keeps the overall painting in mind while working on it as a whole.

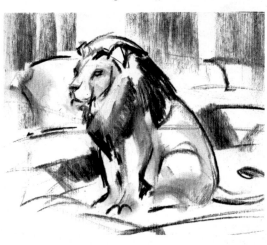

Step 1. The artist begins by orienting the figure on the background using charcoal. At this stage, the artist takes shadows and contrasts into account but does not try to realistically portray the image or add detail.

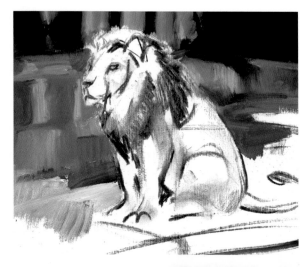

Step 2. Now, the background is painted with very dark hues so that the foreground stands out and appears brighter. Black, brown, and ocher hues are used in the background to depict the distant rocks.

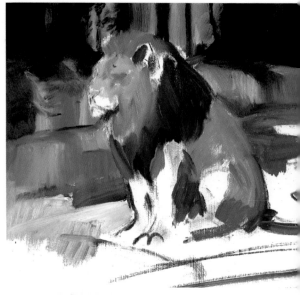

Step 3. Next, the artist begins to paint the lion using loose brushstrokes and impastos. The intention is to apply general hues without concentrating on details. The light falling on the animal's side affects the color of the body fur and the mane.

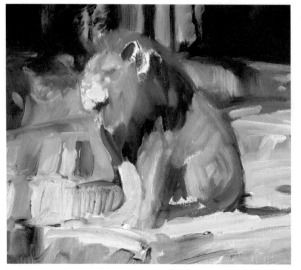

Step 4. The entire rock area is painted with light ocher hues. The same hues are incorporated onto the lion's paws, causing them to appear lit by the sun. Defining brushstrokes are used on the foreground, and the same colors are blended with the hues previously applied to the background wherever it becomes darker.

Step 5. Now, the artist applies black for contrast on both the rocks as well as the on the main volumes of the lion. The mane is given textures, and the paint is applied in the direction of the hair.

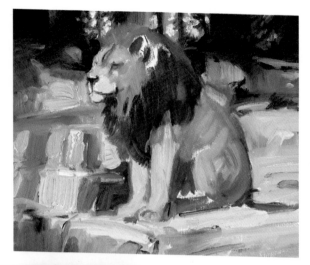

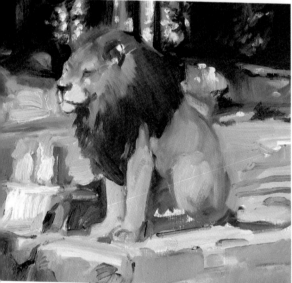

Step 6. Next, direct brush-strokes are applied to depict the volume of the paws. Contrast is created in this area and on the tail, as well.

Step 7. Small, light brush-strokes are now applied to the lion's mane. These are painted over the dark background. In this painting, details and contrasts are added in the upper area, and the direction of every strand of hair can be observed.

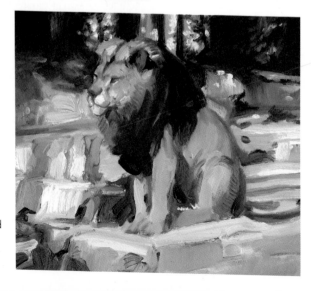

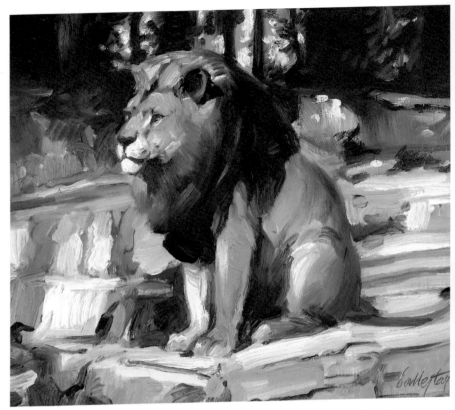

Step 8. Finally, directly applied, dark colored lines are used to define the lion's face. These directly applied colors are characteristic of quick paintings and are used to define the features, volumes, and contrasts in each area of the painting.

SUMMARY

• Felines are naturally elegant. Sketches are ideal for expressing their movements and gesture.

• At the beginning of a work in oils, it is best to dilute the pigments with turpentine. Then later, impasto effects can be incorporated.

• Animals are characterized by constant movement. The artist must synthesize observations and studies so that the animal's character and gesture are captured in the sketch.

• In a logical oil painting process, different textures are depicted according to how close up or far away the area is from a painter's point of view.

• A good draftsman should create sketches of all types of animals, constantly observing animals' gestures, positions, and attitude.

Oil painting

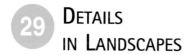

THE FOREGROUND

To create depth in a painting, background elements are usually painted with loose, undefined brushstrokes that result in amorphous shapes. In choosing background colors, a similar process is followed. Even if the same hue is needed in both the foreground and the background, to create depth the color should be a neutral color in the background and a purer version in the foreground. The treatment of details also follows this principle, more defined in the foreground and imperceptible in the distance.

In painting landscapes, the artist usually emphasizes the random wildness of nature and its sporadically scattered elements. But paintings based on nature can have very patterned foregrounds, skies, and horizons. The artist recognizes the relationships between color and light, patterns and textures and incorporating them into the wildest of settings.

1. The artist begins work on the painting by drawing a charcoal sketch of the landscape and centering a tree in the foreground. As in painting other landscapes, the sketch establishes elements in the given space.

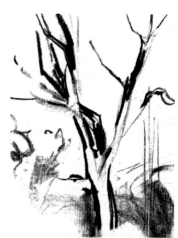

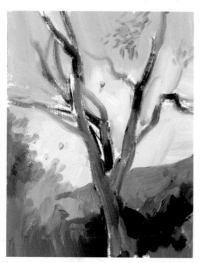

2. Smooth brushstrokes of color define each distinct chromatic section of the painting. First, a pale blue is applied to the sky. Then, blended brushstrokes form the forests and mountains.

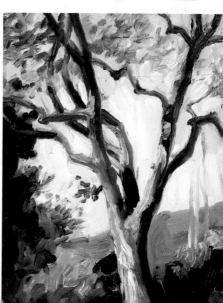

3. The landscape is more detailed in the foreground. Fine brushstrokes and contrasts are applied to the sunlit, textured tree trunk and to the branches and leaves. The dark areas of the tree and bushes stand out from the background colors causing them to appear closer.

TREE TRUNKS

Irregular surface textures are easy to depict with brushstrokes of pigment that contrast both in color and method of application. There are an infinite variety of textures in nature. If one looks closely, a world of shadows and shapes worthy of the most abstract of paintings can be found.

1. In this exercise, the artist depicts a sawmill with piles of cut wood scattered about. In this foundation drawing, the artist must establish perspective.

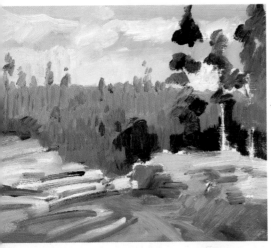

2. A wide range of hues is used for painting the background. Blues and shades of white are used on the clouds. Various shades of browns are alternated on the distant trees, and a light yellow hue stands out on the cut tree trunks.

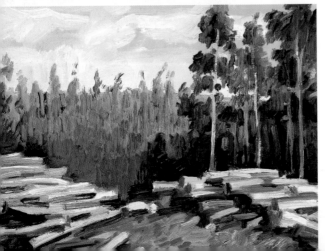

3. When the final details are added, various textures in the landscape become distinguishable. Broken-up, vibrant colors are used on the last trees to be painted. Straight lines depict the horizontal position of the cut trees lying on the ground.

STONES

Painting rocks and stones calls for a range of gray hues. By using brushstrokes of broken hues, the rocks are given cold, hard characteristics. In the following exercise, the artist's use of violet and blue colors for the rocks demonstrates imagination and creativity. If the neutral and broken hues found in nature are studied in depth, they often reveal almost abstract compositions of rich and vibrant hues.

1. The artist begins with a quick sketch using directly applied charcoal. The shapes of the stones can be simplified with circular forms of different sizes, depending on their distance from the spectator.

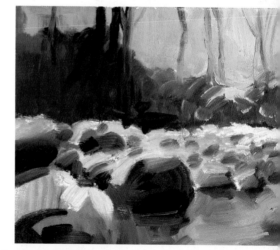

2. Various processes are then used to paint the rocks and background. In the background, the brushstrokes are wide and comprise all the colors used on the sky and bushes. On the rocks, the brushstrokes are shorter because they depict the framented surfaces of many elements.

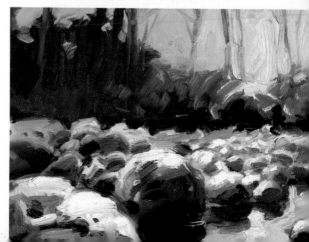

3. The varied shades used on the rocks consist of gray, white, and violet hues. The placement of the dark colors combined with the light hues creates a sense of shadows as well as separations among the stones and other elements.

OTHER ELEMENTS

The chromatic range of a work of art depends on the painting as a whole. Colors are related and complement one another in such a way that the brightness or the neutrality of a color is conditioned by its relationship with the rest of the hues. Regardless of the nature of the object portrayed, light gives the painting its character and color. The same landscape will appear very different if light conditions change.

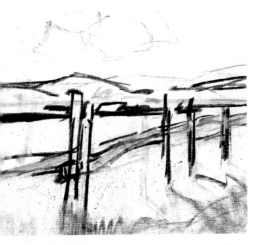

1. First, a wooden fence is portrayed in the foreground against a richly colored background. In the sketch, the distribution of the planks making up the fence is very important. The rest of the elements are straightforward.

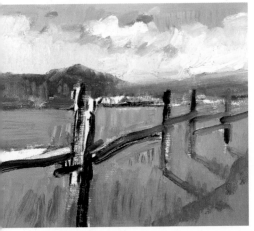

2. Now, large blocks of color are used to paint the entire surface. Blues of different intensities are used in the distance. These hues are lighter in the area corresponding to the sky and more intense in the distant mountains. Vertical, dark green brushstrokes are used on the grassy surface to depict the row of bushes.

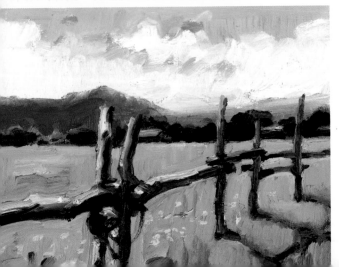

3. The artist then works on the fence using dark hues in the areas opposite the light and pale brown in the well-lit fragments. Dark hues are applied on the shadows projected onto the ground.

A Landscape with Foreground Elements

MATERIALS

Charcoal, Oil paints,
Stretched canvas,
Bristle brushes,
Turpentine, Paint rags

The style in classical painting was to faithfully represent the texture of each element in the composition. In this way, the artist could make the environment completely tangible, with each part of the overall work forming an individual painting on its own. With the more free style of today, the artist applies brush to canvas in a way that gives his or her personality to each element.

Step 1. The first sketch is based on an outline of the objects in the given scene. On the right side there is a tree, and on the left side there are ruins with a series of rocks below.

Step 2. The painter first fills in the large dark areas with black oil paint. When using oils, the artist always works from dark to light, beginning with the dark colors diluted with turpentine, and then progressing gradually to an impasto application of colors.

Step 3. Black is then used to complete the dark, chromatic tonalities in the work. The brightest areas are painted with colors applied directly to the white canvas support.

Step 4. A variety of blue hues applied in the brightest areas corresponds to the sky, ground, and distant mountains.

Step 5. Precise brushstrokes are applied to specific areas in the background. In this way, texture is given to the distant mountains, and then the leaves in the upper part are painted in a random manner to indicate the leaves spread out on the branches.

Step 6. The artist now concentrates on the foreground, especially on the pile of stones on the ground. Short brushstrokes are used to apply the light hues and fine brushstrokes for the darker ones defining the separation between the stones.

Step 7. The chromatic range is developed in the tower with new hues applied over the black foundation. Since the tower is very dark, the lightest colors come from the range of gray hues.

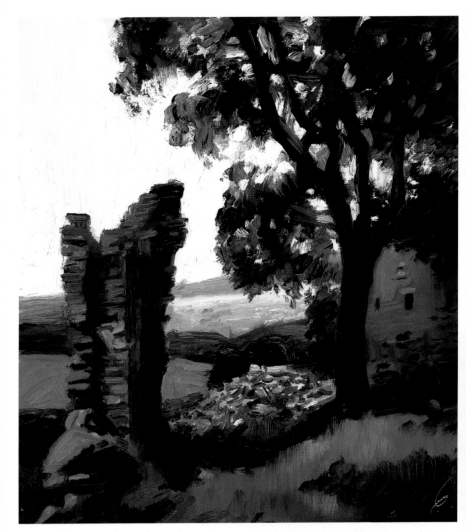

Step 8. The stones that make up the tower are painted with precise brushstrokes applied in a horizontal direction. Because the amount of light received by the stones depends on natural light, the colors used in this area come from a range of gray colors.

SUMMARY

• In natural landscape themes, the starkness of nature is often emphasized.

• A painting gains depth if the colors are neutral in the background and purer in the foreground.

• A similar practice should be followed in the details–more defined in the foreground and more imperceptible in the distance.

• Regardless of the nature of the element to be painted, the light falling upon it will determine its color and character.

• The stones are painted with a range of colors made up of mainly gray hues. Varying these broken gray hues gives the rocks the impression of a cold, hard texture.

• In painting, the brushstrokes determine the personality of each element. Objects will be painted with more detailed to cause them to appear closer to the spectator.

• Because of their contrasts and textures, irregular surfaces are very interesting to paint, allowing for a variety of brushstrokes to be used on each element.

TEXTURES AND LIGHT

Light is directly responsible for indicating texture since, without it, neither colors nor shapes are possible. The brightest point of light, which will not always correspond to white, must be determined in order to allow the volumes to stand out. The way light is distributed in the painting will be determined in reference to this point. In oil painting, white is intense and deep; it is used to tone down the rest of the colors. When an oil color is mixed with white, the hue becomes lighter and brighter.

To refer to textures is to refer to the combined characteristics of surface quality, colors, and form. The whole world of shapes and colors has its own unmistakable characteristics, and the main objective of a realist painter is to depict these properties correctly.

1. In this painting, the distinct elements are spherical in shape. The artist pays careful attention to the ellipses drawn to depict these forms. The lines of the table must also be taken into account, both to represent them in perspective and to achieve a balanced outline.

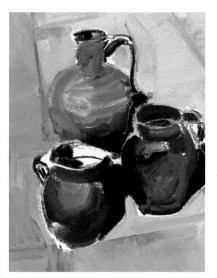

2. Sienna, ocher, and red hues are used on the background. Neutral hues are toned down with white for the highlights. Sepia hues are painted into the shaded areas.

3. All the shades of the clay pottery texture are now included. In the most distant pottery, the color is lightened with white hues, and the pots in the foreground are painted with brown, black, and red to intensify the shadows.

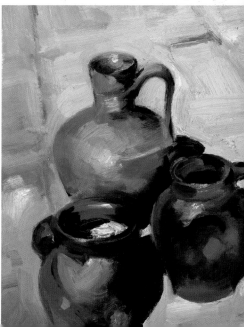

THE IMPORTANCE OF BRUSHSTROKES

A brush is the most valuable tool the artist has for creating a painting. Used for both outlining and filling in surfaces, the brushstrokes give volume to shapes, keeping both the direction of the brushstrokes and the applied colors in mind to accomplish this. The decision of which type of brushstroke to use depends on the desired effect. Dry brushstrokes leave marks on the surface, and brushstrokes of diluted oils cause spreading and blending.

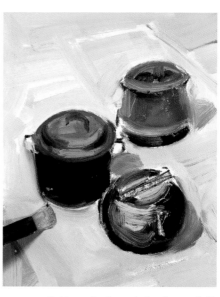

1. First, the artist draws an outline of the composition. Three well-differentiated elements are palced on the table. The charcoal is applied heavily to shape and balance the composition before the painting begins.

2. Next, the foundation hues of all the areas of the painting are established, approximating the specific hues to be used for each element without attention to details. The artist uses a light pastel hue on the table top. Then, the objects in the painting are colored using much darker hues of intense blues and copper shades.

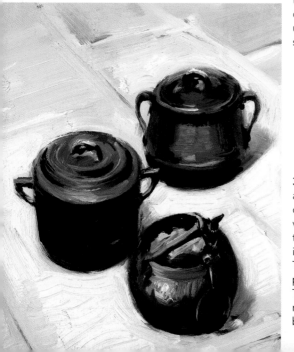

3. Contrasts and details are now added to more closely define the objects in the painting. Contrast is very light on the blue objects, so to depict this, a very light blue hue is used on the elliptical shapes. The intense light on the copper pot produces its metallic quality. This effect is achieved using hues related to those applied on the background.

METALS

The color of metals is formed through developing contrasts between light and dark hues. These hues establish shapes that are normally in harmony in outline and volume. Metals present a series of contrasts, which are not only those set up between light and shadow, but also those between complementary hues. Consequently, in painting copper, wherever golden hues have been applied, blue hues can be found, and in painting chrome, yellow hues can be found.

1. In the underlying charcoal drawing, the elements of the still life are composed and balanced. The bricks in the background form another level of the painting.

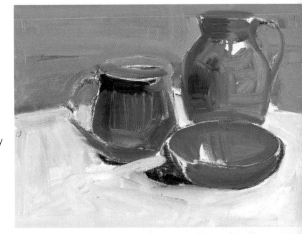

2. The colors are applied smoothly to define each of the principal shapes. The lightest color is the white of the table. The rest of the hues are darker, particularly the objects painted with cool colors like blues and greens.

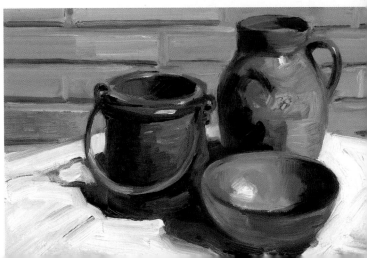

3. The shapes are then defined and contrasted, both on the background of bricks and in the foreground. White, shiny areas appear on the objects with smooth surfaces, and contrasts are given to make them stand out.

GLASS

Because of their transparency, glass objects are an excellent subject for understanding the subtleties of color and surface. Transparent glass doesn't have a color of its own, so its shapes are defined by the colors of the surrounding background or the objects near it. Shiny areas are defined by the shapes and light reflected off the smooth surfaces of the painting.

1. In this example of a complicated still life, the preparation of the underlying drawing is very important. The objects in the still life are simplified as much as possible; only their outlines and proportional sizes are defined and balanced in the composition.

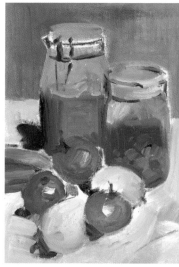

2. Next, brushstrokes are applied to depict the colors of each element in the still life. The dominance of red is obvious both in the fruit and in the background. The glass bottles, which reflect the surrounding colors, are strongly influenced by the red hues.

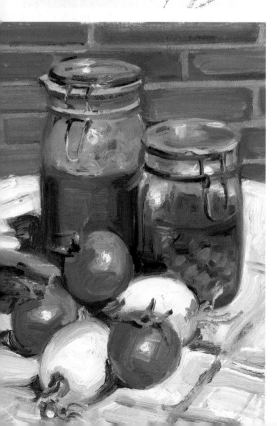

3. Now, the artist concentrates on the details, defining the shapes and contrasts. In the background, details of straight lines represent the brick wall. For the fruit, contrasts and volume are represented using highlights and darkened outlines. In a similar procedure, the glass bottles are painted with various warm grays and given shiny highlights. The artist also adds a dark maroon hue to the area inside the bottle.

Glass Bottles

MATERIALS

Stretched canvas,
Charcoal, Oil paints,
Bristle brushes,
Turpentine, Paint rags

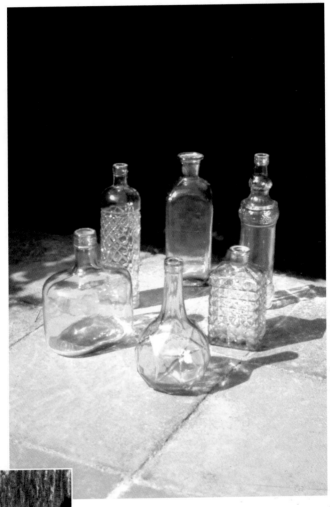

Two elements will be the focus of this exercise: color and shape. In this painting of bottles, some have the same color as the background and others have their own color and appear more opaque. On the other hand, the shape and the engraving on some of the glass will result in all sorts of reflections and variations of hues. The background of a composition with glass de-termines their colors, and for the glass bottles that are engraved, reflections and changes in hues are produced.

Step 1. The dark background makes it possible to create contrast from the beginning. The more objects there are in the painting, the more difficult it is to produce the crystalline effect on each bottle.

Step 2. The background and the foundation are painted to cover large areas of color. The artist applies the first gray hues on the bottles, starting with those farthest away.

Step 3. Gray hues are now applied to the bottles in the foreground, without concern for contrasts at this point. In this stage of the painting, the artist establishes a base hue for portraying the color of the glass; other effects such as contrasts and reflections will be added later.

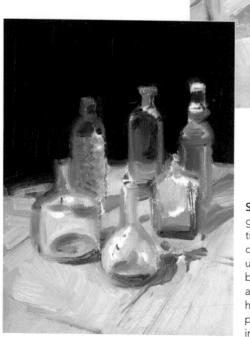

Step 4. The artist finishes painting the glass objects. Because of their position with respect to light and their closeness to the foreground, the grays used on each bottle differ. Some bottles include more transparent hues at their bases. Others include green hues, or darker hues where very transparent bottles stand against the intense, dark background.

Step 5. Details and contrasts are now painted into some areas. The shadows projected on the table are intensified, and the artist begins to add the last colors to some of the bottles, especially those in the background and the square bottle on the right side of the painting. Basic colors are used here and black is used for the shadows.

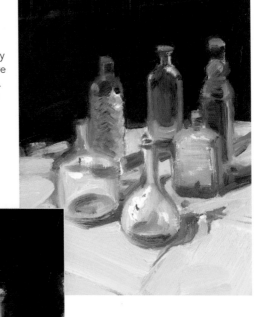

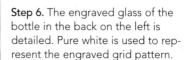

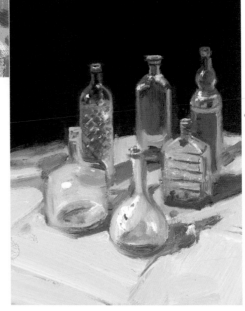

Step 6. The engraved glass of the bottle in the back on the left is detailed. Pure white is used to represent the engraved grid pattern.

Step 7. Details are progressively added to the bottles using a fine brush. Green is directly applied to the square bottle. The two bottles closer to the foreground are smooth and without engravings, so the brushstrokes in these areas are more blended.

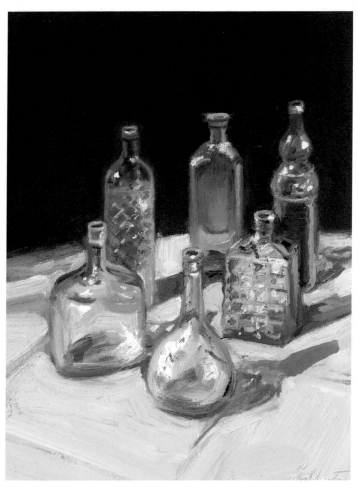

Step 8. The last contrasts are added to the bottles in the foreground, and the artist works on the shadows projected on the table. In summary, painting glass is based on using an established hue to which contrasts can be added in certain areas to define its forms and shadows.

SUMMARY

• For a realist painter, depicting the exact properties of objects is one of the main objectives of the painting.

• The color of metals is achieved using contrasts between light and dark hues. These hues give way to shapes that are in harmony with an object's outline and volume.

• A brush is a painter's most useful too, used to both outline and fill in various surfaces.

• Light defines all textures since it is what reveals the shapes and colors of surfaces.

• Dry brushstrokes leave marks of the brush on a surface, while brushstrokes of diluted color make the paint spread, creating effects like blending.

• Because of their transparency, glass objects are an excellent subject for understanding the subtleties of color and highlights.

• The background of a composition of glass objects determines the painting's color, since it is responsible for the overall coloring and for the contrast between light and shadow.

BEGINNING WITH FLAT COLOR

When applying brushstrokes in an oil painting, the overall composition has to be considered so that a color foundation can be established that defines the most general areas of the work. In painting the human figure, the artist must determine the hues to be used for the foundation flesh tones depending on the contrasts of light and shadow in relation to the background. Contrasts and volume are established with each new hue added.

Foreshortening of a figure represented in two dimensions is essential if the figure is not viewed parallel to the picture plane. When different parts of the body need to appear oblique or perpendicular, it is necessary to know exactly what shape the parts will take on in order to convey this. The artist must depict these dramatically changed contours.

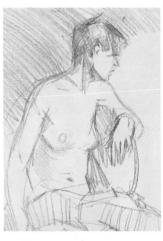

1. A correctly adjusted sketch is drawn in graphite pencil, ideal for a base sketch because it doesn't rub off as much as charcoal. The artist correct errors while drawing, establishing a foundation for the painting technique to follow.

2. Using flat colors for the general brushstrokes, the artist fills in the large spaces in the painting. Deep red and black are mixed on the background to create extreme contrasts with the pink hues used on the figure and the green hues used on the model's clothes.

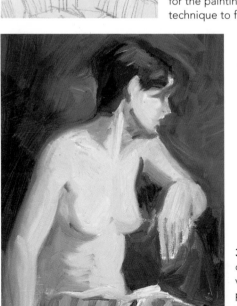

3. The figure is given contrasts with dark hues that depict the shadows and volumes. Gray hues, specifically, are incorporated on the neck area and on the left side of the body opposite the light.

THE STUDY OF LIGHT

When painting the human figure, the artist must continuously study the model in order to accurately establish the forms of the body. To begin, the area of the lightest color is established.

This color may not always be white; in nude figures, for example, instead of using pure white as the lightest value, the artist chooses pink or yellowish shades obtained by directly applying these colors to the canvas, or by blending a white hue with a darker foundation color.

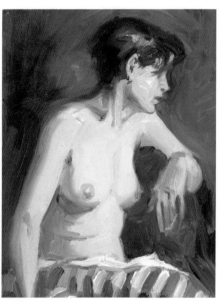

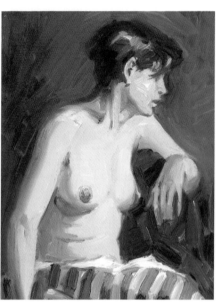

1. The elements of the body are progressively defined. A gray hue is used to shadow the left arm, giving it relief and definition. Shadows are also added underneath the breasts to better define their volume.

2. Now, the artist concentrates on more concrete details like the color and volume of the breasts and the texture of the model's hair. Contrast is developed on the cloth to depict different planes.

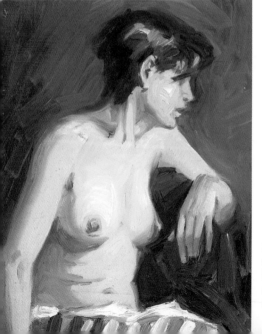

3. The artist finishes the painting by working on the details of the hand and fingers. Shaded areas on the body are added, and the navel and folds in the skin are painted.

CREATING DEPTH AND HIGHLIGHTS

Whatever techniques are used to create highlights in a painting, it is important to remember that white hues are whitest when the surrounding areas are darkest. In the subject of the nude, skin glows with less intensity than smooth, polished surfaces or than other darker-hued elements. Highlights adapt to their location on the body, following the curves of the hips or the lines of the arms and legs.

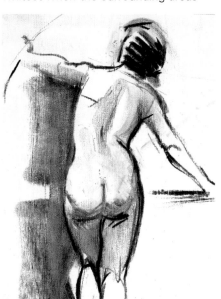

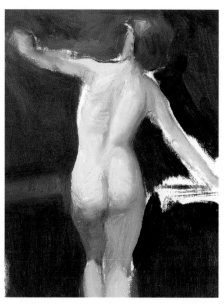

1. Charcoal is very useful for establishing atmosphere and contrast at the beginning stages of a work of art. In this particular study, the artist establishes a dark color for the background and for the shadows projected onto the body.

2. If colors are chosen well, the atmosphere of a painting will be correct. In this example, intense black is used for the background. A variety of flesh tones are used for each body area, depending on the position of each with respect to light.

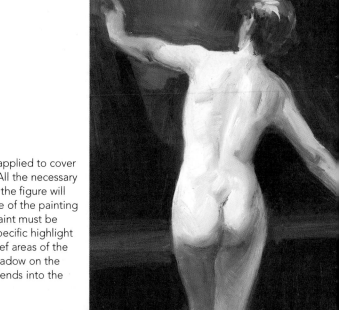

3. Blended oil hues are applied to cover areas in the beginning. All the necessary details and contrasts on the figure will be given in the last stage of the painting process, for which the paint must be thicker. There are very specific highlight points in the highest relief areas of the skin. The very intense shadow on the foreshortened left leg blends into the background.

FORESHORENING PROJECTED AREAS

The effects of light and shadow are fundamental in foreshortening a figure in a two dimensional space. A correctly drawn sketch depicts the position of each foreshortened part of the body.

Later, color brushstrokes and contrasts will establish the different planes of the figure depending on its position. The foreground body parts will project shadows over the others, making the fragment appear to stand out and seem to be placed in front of other elements.

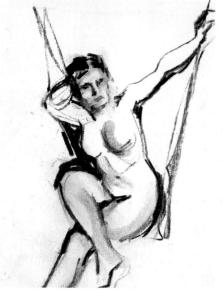

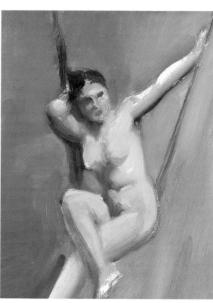

1. First, a charcoal sketch is made of the figure in a frontal, well-lit position, so simple lines will define the figure and shadows will not be too intense.

2. The artist paints the background with a very blended, flat colo, using ocher and yellow hues to give warmth to the background. The figure stands out because of its pale pink color de-termined by the presence of frontal light.

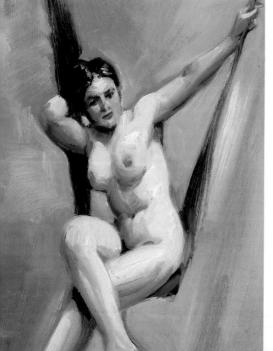

3. The artist now details the face and body using a fine brush. Darker hues serve to define the shapes of the arms, legs, and in the lateral area of the torso.

Reclining Male Figure

MATERIALS

Stretched canvas,
Charcoal, Oil paints,
Bristle brushes,
Turpentine, Paint rags

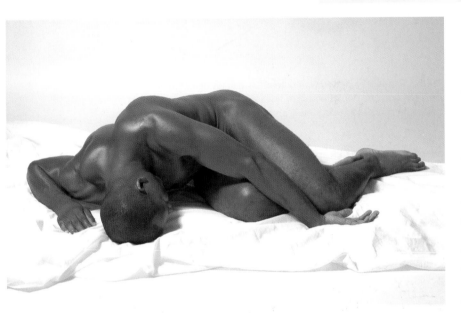

A foreshortened figure always establishes depth in a painting. This means that the body must be distributed in the space in an oblique or even perpendicular way. Under these circumstances, the contours and sizes of the arms, legs, head, and body will be altered. The underlying drawing will reflect this alteration if the artist has a clear control of anatomy and perspective.

Step 1. The charcoal sketch is the first step in depicting the model's pose and the foreshortening it presents. Later, color brushstrokes and light will be used to better depict volumes. The model is arched and lying down, causing the upper part of the body to be set in the foreground and the rest of the elements to appear more distant.

Step 2. Areas are painted with different tonalities according to the light present. Violet and gray hues will be used throughout the entire process to adequately present the dark flesh tones.

Step 3. Next, the artist applyies color brushstrokes to the background and for the figure's skin surface. Gray is alternated with brown on the body to depict the different hues found in the skin. Black is applied directly to the darkest and most hidden areas.

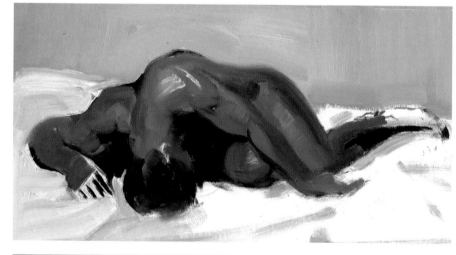

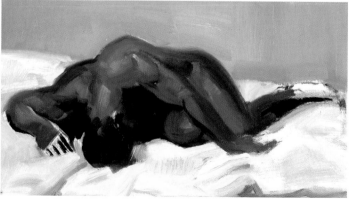

Step 4. The artist now intensifyies the dark color in the more recessed body areas. This color blends with the hues used on the face and the hair. The dark colors now definitively express the recessed areas resulting from the model's pose.

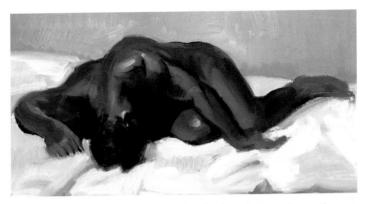

Step 5. A neutral earth tone is used as the foundation color on the hands and feet. A contrasting effect of dark and light is created on the arms to depict the various volumes of the muscles.

Step 6. Now, the artist intensifies the black hues used on the head and in the areas where shadows are projected, causing the knee to appear to stand out from the surrounding dark hues.

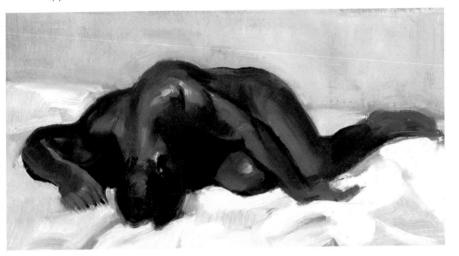

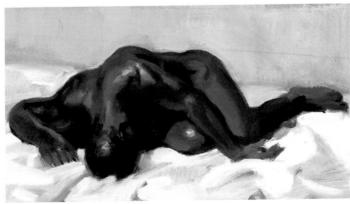

Step 7. The skin's surface is enriched with directly applied sienna colors, which make the skin color warmer and more brown. These colors stand out mainly on the neck and the shoulder, predominant areas because they are in an elevated position.

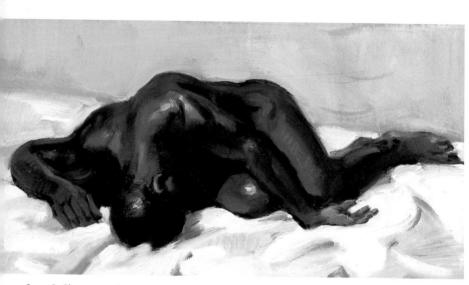

Step 8. Shapes and contrasts are defined in the leg that is still visible. Then, detail is given to the fingers and the shapes of the hands. The neutral background and the white sheet where the model lies emphasize the dark appearance of the his skin.

SUMMARY

• When models are not depicted in a rigid and vertical way, foreshortening, which is difficult to represent, is necessary.

• In nudes, pure white is not usually used to depict the lightest values. These are normally defined by pink and yellowish shades.

• A foreshortened figure always displays depth. This means that, in perspective, the body is distributed obliquely and sometimes even perpendicularly.

• For any painting technique in which shiny areas are to be depicted, it is necessary to keep in mind that white appears whitest when surrounded by darker hues.

• The drawing itself should depict the position of the foreshortened fragment. However, color brushstrokes and contrast aid in showing the different planes established by the figure due to its position.

• The body fragment in the foreground projects shadows onto the rest of the body. The fragment appears to be lighter. Therefore, it stands out and appears to be in front of the other elements in the image.

• In the entire oil painting process, there is a need to look at the overall image to find the color base which best defines the general areas of the work of art.

LIMITING DETAILS WITHOUT LOSING SHAPES

In painting humans, the details of the face are very important, but with animal paintings, a free and spontaneous approach can be used. Brushstrokes should be applied that define the structure and characteristics distinctive of their species. Since there are no specific ways to identify the individual in a group of animals, the artist disregards details and looks for a free, overall effect.

Portraying herding animals was very common in the nineteenth century when outdoor paintings and scenes of everyday life were at their peak. These kinds of themes stressed many different factors, such as the importance of humble objects in country environments and an interest in the anatomy of animal forms.

1. First, the artist draws a charcoal outline of the figures. The two sheep in the foreground are defined in a very detailed manner, using contours and defining elements. The lines used on the background are much less descriptive since they correspond to the flock.

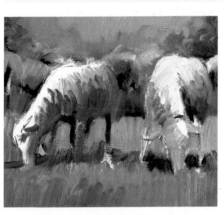

2. The first applications of color are meant to give an overall tone to the painting, emphasizing the moist, green environment of the prairie. Wide brushstrokes of green are applied to the area corresponding to the ground and to the trees that occupy the backgro-und.

3. The blue hues used on the sky are broken. The artist directly applies an orange hue to contrast with this color and to depict the presence of autumn leaves in the trees. Light gray brushstrokes are then added to the flock of sheep. Afterwards, the artist concentrates on the texture of the sheep in the foreground. The surface texture of these animals is portrayed as rough and wool-like.

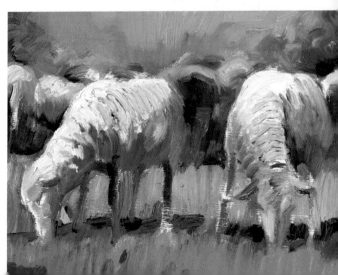

A HERD OF ANIMALS

When an artist depicts a group of animals rather than just one, the atmospheric effect of the painting becomes more significant due to the need to reflect the mass as a whole. Animals in the foreground always attract more attention since they are nearer. Those farther away require an effect of atmosphere. The main characteristic of herding animals is their tendency to act as a body, and atmosphere is very important in portraying this massing characteristic of animals.

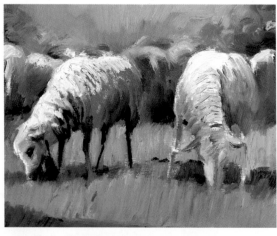

1. The artist paints the background atmosphere of this scene of sheep loosely, and the foreground animals with more details and contrasts. After using a range of neutral gray hues on the background sheep, the ones in the foreground are directly painted with black to establish the necessary contrasts.

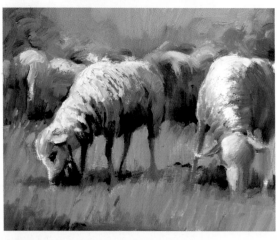

2. Concrete brushstrokes are used to depict the uneven, rough-textured wool of the sheep on the right hand side of the painting. The artist uses a gray hue with green shades that combines with the overall color of the grass.

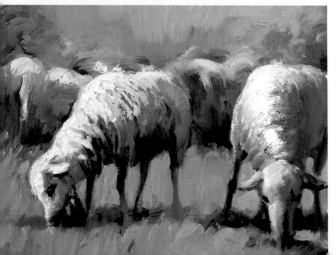

3. Now, the artist concentrates on the details of the sheep located on the left, first drawing the facial features and then its ears and muzzle. Afterward, the grass is painted with more defined brushstrokes. Finally, very dark green hues are applied for the projected shadows.

DEVELOPING
THE FOREGROUND

All paintings are characterized by a search for depth, for an effect of three-dimensions. To accomplish this, each plane is studied differently. This occurs naturally with the human eye; people tend to focus their vision on a given point, causing the rest of the objects in the scene to lose definition. In a painting, this phenomenon translates into depicting the closest objects in a detailed manner, and the objects farther away with an increasing blurring of detail.

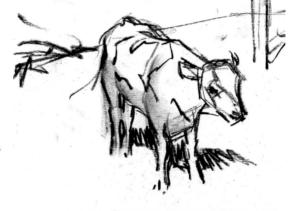

1. First, a cow is sketched with charcoal, centered as a single compositional element. The lines are drawn to define both shapes and anatomy. Lines are not needed for the much more ethereal background.

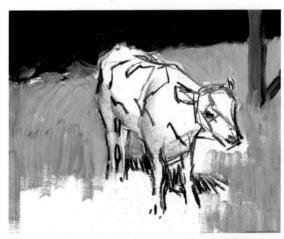

2. Wide ocher and black brushstrokes are then applied to the background. Because the brushstrokes are very general in the beginning stages, the cow's outline becomes defined by surrounding external brushstrokes.

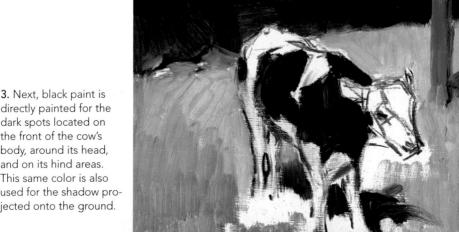

3. Next, black paint is directly painted for the dark spots located on the front of the cow's body, around its head, and on its hind areas. This same color is also used for the shadow projected onto the ground.

FINAL CONTRASTS

Establishing tonal values is fundamental in a painting in order to give volume to the forms depicted. The logical process for achieving this is by beginning with broad, generalized brushstrokes, and then following with shadows and contrasts. Definitive contrasts are added last because these dark hues stand out and define shapes. At this point, the artist also concentrates on details.

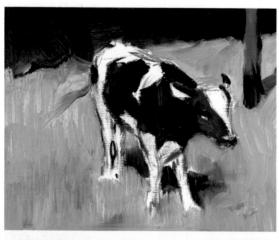

1. Shadows are very important for positioning and sepa-ratating the animal's legs and for helping to define the external parts of the animal.

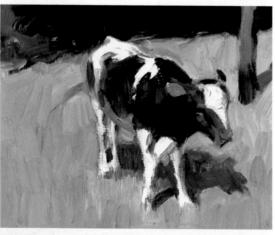

2. The hues that define the cow are multiplied until the correct effect of volume is achieved. White hues are strategically placed with the black spots on the legs and body. The features of the face and ears are depicted using finer brushstrokes.

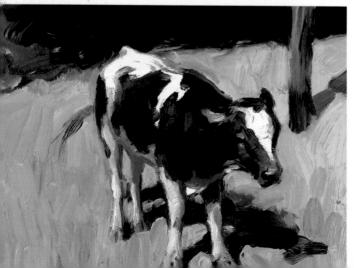

3. A very dark brushstroke of color is applied to the ground area corresponding to the shadow. This extre-mely dark hue is used to give an absolute contrast. In this case, the intense brightness of the light leads to a strong shadow effect.

A Cow's Head

MATERIALS

Stretched canvas,
Charcoal, Oil paints,
Bristle brushes,
Turpentine, Paint rags

When an object to be painted is extremely close up, many details must be portrayed. These details can be seen clearly in the photograph here. The animal is placed in the center of the painting, and the artist paints the cow as though it were a person, concentrating on features, the volume of the head, and even the expression on the cow's face.

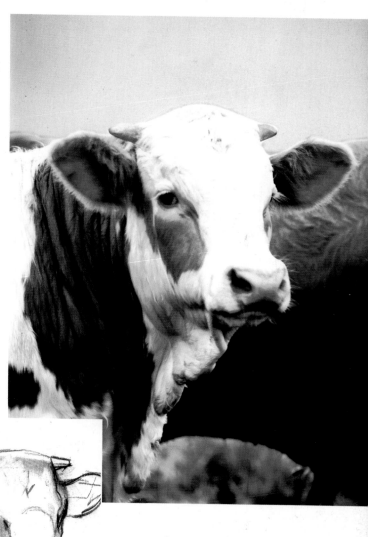

Step 1. The charcoal sketch serves as a solid foundation onto which color brushstrokes are applied. The sketch should take various factors into account, such composition, placement of the head on the canvas, and the shapes of all the elements. The first volumes should be created with soft shadows.

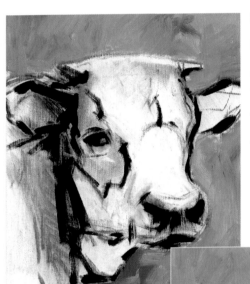

Step 2. A warm yellowish green hue is applied to the entire background, but for the time being, the cow's head is left untouched. Instead of using brushstrokes on the head, the artist uses linear shapes painted with directly applied black hues. In this way the contour of the head and the main features, such as the eyes and the muzzle, are defined.

Step 3. The spots on the cow's coat are now painted. To begin, the artist uses flat brown hues. This hue is applied to the ears and the right side of the face, including the eye and neck.

Step 4. Next, the cow's entire body is painted with the pertinent colors so that the entire canvas is filled in. Broken white hues are used to convey the areas of the animal that are actually white, so that they acquire grayish tones. Lighter sienna hues are added to the cow's brown spots, depending on the plane being defined.

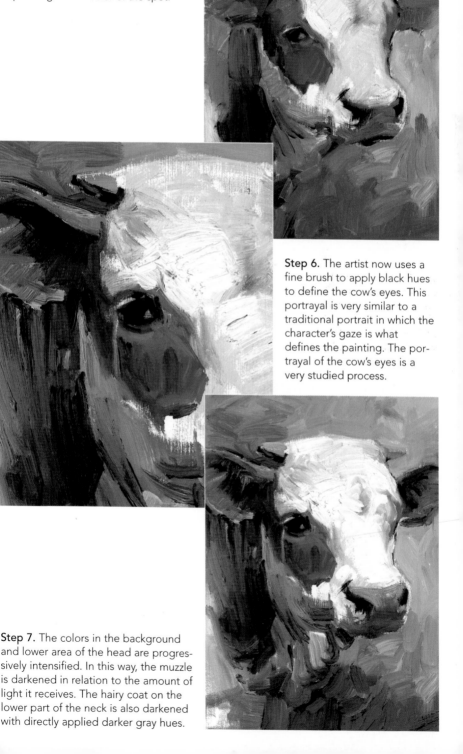

Step 5. Now, definition and contrast are added to the image. The lower part of the head should be darkened to correctly establish the volume. In this way, the neck and the lower part of the muzzle are dark gray or brown, depending on the color of the spot.

Step 6. The artist now uses a fine brush to apply black hues to define the cow's eyes. This portrayal is very similar to a traditional portrait in which the character's gaze is what defines the painting. The portrayal of the cow's eyes is a very studied process.

Step 7. The colors in the background and lower area of the head are progressively intensified. In this way, the muzzle is darkened in relation to the amount of light it receives. The hairy coat on the lower part of the neck is also darkened with directly applied darker gray hues.

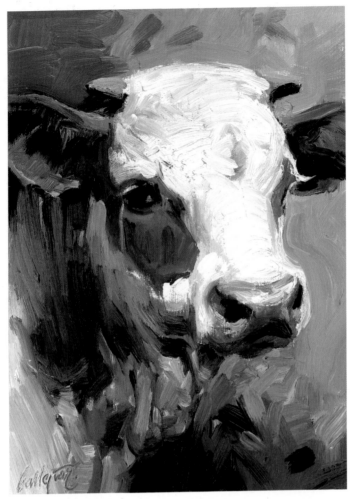

Step 8. Definitive contrasts are then added for the final touches to the painting. The artist applies intense black and green hues in the background to create depth. Contrast is created in the lower part of the muzzle by adding black followed by white hues to portray the highlighted areas.

SUMMARY

• Paintings of country scenes and cattle form part of traditional naturalist paintings.

• What characterizes these domestic animals is their manner of grouping together creating the sensation of a mass. This sensation gives the painting an effect of atmosphere.

• In naturalistic scenes, the artist tries to create a three-dimensional effect by treating every object differently depending on its distance from the foreground.

• Definitive contrasts tend to be added at the end allowing the dark colors to stand out and to clearly define shapes.

• Far away objects in a painting are atmospheric, with little detail or contrasts.

In the foreground, however, details are clear and the shapes more concrete. Foreground contrast is at a maximum.

• When a group of animals is portrayed rather than a single animal, the painting is much looser. Since there are many more objects, the effect of a multitude or mass must be reflected.

• Paintings of animal subjects tend to be more spontaneous than thoses of humans, for which facial details are essential and distinctive.

Acrylics

DILUTED ACRYLIC

Acrylic pigments can be applied thickly like oils, or diluted with water like watercolor. The purity and concentration of acrylic pigments allow thick application, and when they are mixed with a large amount of water, they are capable of dying the paper. To achieve intensely dark or vivid colors, it is not necessary to apply the colors thickly. The more water mixed with acrylic paint, the quicker it dries. In the example below, brushstrokes of diluted pigment are applied as glazes, very transparent colors that allow the underlying color to be seen.

Acrylic painting is one of the most modern of painting techniques. It was developed from the need for a high-quality painting medium, with a simple diluting and quick-drying process. The pigments are of great purity and allow the artist to achieve infinite colos. The easily mixed chromatic range is as colorful as that of oil painting.

1. The artist begins with a simplified pencil sketch of all the elements. Since a landscape is being painted, the sketch should be loose and quickly drawn, the color brushstrokes being more important than the shapes.

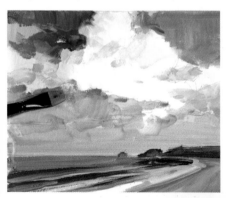

2. Liquid and transparent acrylic is used to apply the first layers of paint. In the sky, the artist is looking for a blended watercolor effect. Working quickly on a dampened support, the artist blends the hues to achieve the effect of mist.

3. This painting involves a mixed acrylic treatment. The sky has been depicted as transparent, using a great deal of water, and for the sand and the sea, the color is thicker and denser.

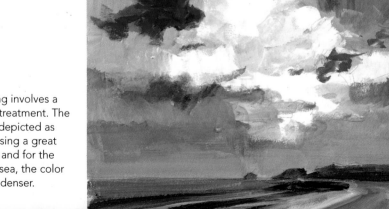

THE DRYING PROCESS

The more liquid acrylic painting is when applied, the quicker it will dry, allowing the artist to work with layers in the same way as with watercolor.

To prevent blending, the artist waits for one layer to dry before applying another, then, when the paint has dried, the first color can either be shaded with another hue or intensified by using more of the same hue.

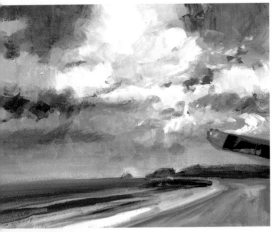

1. The texture of the clouds is enhanced with impasto. Since acrylic paint is very versatile, light glazes can be applied over dark hues by adding white. In this way, the clouds are shaded using white and light gray hues that stand out against the blue and violet colors.

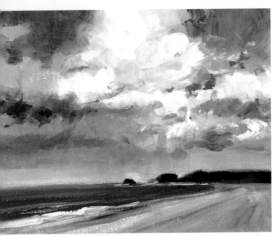

2. Volume is created in the sky so that the clouds are depicted very clearly. Light and dark hues are combined to form a soft contrast similar to cotton in texture.

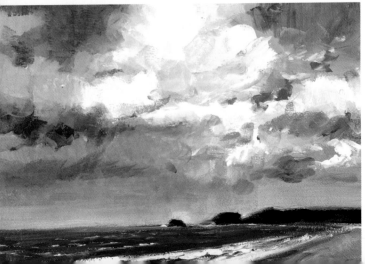

3. The artist finishes the painting by depicting the sea with its waves. Some white brushstrokes have been added over the blue hues to simulate the texture of foam forming on the crest of the wave. These brushstrokes form a diagonal line establishing the perspective of the scene.

Quick Mixtures

Waiting for the paint to dry is essential when applying layers and glazes. If a pure hue different from the previously applied colors is desired, the artist must wait until the first layers are completely dry to prevent the previously applied hues from blending with the newly applied color. Hues that are to be blended should be applied to a dampened support to create a smooth and homogenous effect, which is the same effect as that achieved using oils. Of course, the artist will need to work more quickly because the drying time of acrylic is much shorter.

1. The artist begins with a charcoal sketch in which the principal shapes are established. The contours of the sky and sea surfaces are depicted before adding color, and the rocks are darkened with charcoal to create contrasts from the very beginning.

2. Now, the warm hues to be used in the composition are applied to the rocks and the cliff. The artist uses flat strokes of color since the intention is to paint these masses with their general foundation colors. The closer rocks receive a great deal of shadows, and warm sienna hues are applied to the more distant rocks.

3. The sea is painted with more transparent mixtures of color than those used on the rocks. The new hues are varied so that a turquoise hue is applied to the seabed, and ultramarine dominates the foreground.

SUPERIMPOSING LAYERS

To prevent blending, the artist must always wait for one layer to dry before applying a new one. After a coat is dry, a color can be shaded using a different hue or a second coat of the same hue to intensify the color. Many layers can be used, so there is no reason to apply paint flatly. With this, technique diluted colors can be easily combined with impasto techniques.

1. The artist superimposes hues over the colors of the rocks. A new orange hue mixed with very little water is superimposed over the foundation hues, which were darker. The result is a new layer, fragmented by the rubbing effect, having great strength and projected relief.

2. The brushstrokes applied to the entire painting are influenced by the contrasts on the rocks and the sea. On the rocks, lively oranges and dark browns are alternated, and in the sea, varying blue hues combine with the white of the foam.

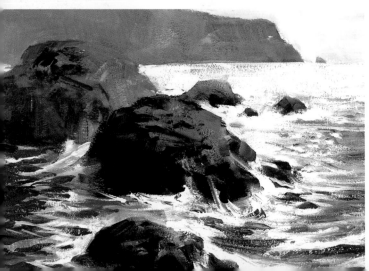

3. The sea is completely detailed to depict the waves and the way the foam wraps around the rocks. These rocks are defined more clearly by incorporating brushstrokes that depict the unevenness of the surface.

Step by Step

A Seascape

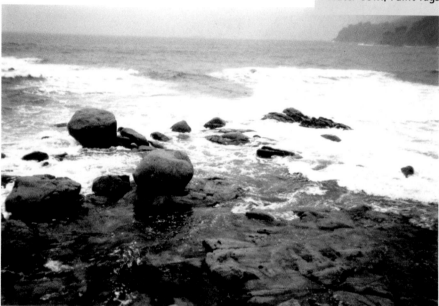

The geographic characteristics of each particular coastal area substantially affect the way a landscape of the area is to be painted. Sometimes, there are rocks sticking out of the water. These rocks are beautiful to portray because of the continuous crashing of waves against them and the white foam that is formed. The characteristics of acrylic paint allow the artist to clearly represent liquid shapes, the foam, and the defined forms of rocks.

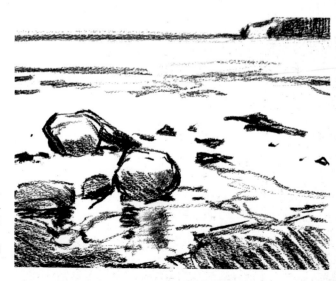

Step 1. First, an composition is sketched with charcoal in a quick and loose way, proper for a seascape theme. The horizon is established in the distance, and in the foreground, the rocks and the changes in level produced by the swell are depicted.

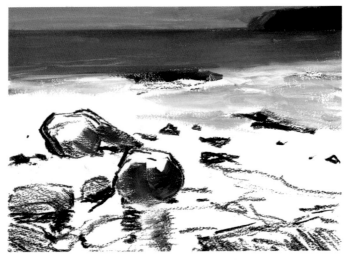

Step 2. Brush-strokes of blended colors are applied to the atmospheric background of the image. A very neutral grayish-blue hue is used on the sky. Then, a new darker grayish-blue is applied to represent the distant mountains. Finally, the artist uses the purest hues within the range of blues to paint the sea.

Step 3. Color brush-strokes from the cool and neutral range of colors are added to the new fragments of the painting. More specifically, broken hues ranging from brown to the coolest grays are added to the foreground rocks.

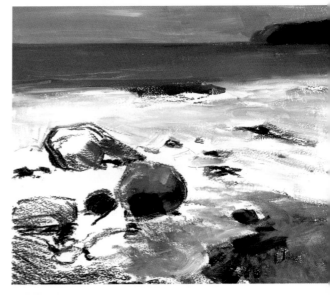

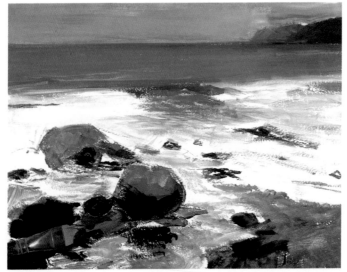

Step 4. Now, color brushstrokes are applied in the foreground to depict the foam and rocks. A very neutral blue hue lightened with white is applied on the foam. In this way, contrast is created between the hues used on the sea and the warmer darker hues used on the rocks.

Step 5. The foreground is given more intense contrasts by including black and natural hues in the range of colors. These hues define shapes and recreate the reflections of them on the sea's surface.

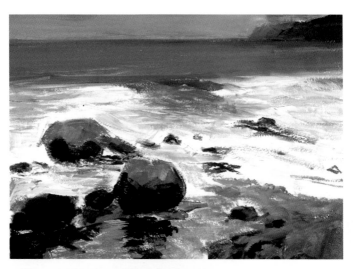

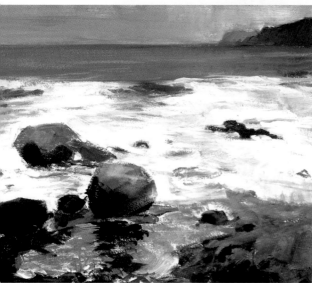

Step 6. The artist now concentrates on the intermediate area of the painting, characterized by the strong presence of foam and the clearness of the hues. To accomplish this, white is directly applied to these areas, and then blue strokes are added to depict the shape of the sea swell. The artist also works on the rocks in this area by directly applying gray hues.

Step 7. The elements of the foreground are depicted with more accurate shapes and richer shades than those used on the rest of the painting, conveying proximity. The dark brushstrokes help to depict the unevenness of the rocks. Blue and gray hues are painted into the sea with vibrating brush strokes.

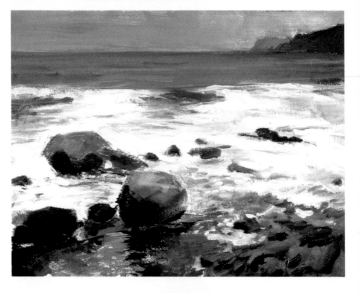

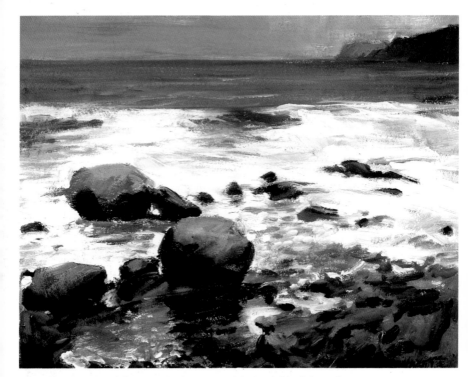

Step 8. Finally, the definitive contrasts are added with black hues for the rocks and their reflections in the water. Contrast is added last to achieve definition and maintain the effect of closeness.

Summary

• Using acrylic paints, the artist can choose impasto effects, as in working with oils, or diluted hues, just as in using watercolors.

• The more water mixed into acrylic paint, the quicker it will dry.

• Glazes are produced by using a very transparent color over an underlying hue so that the hue is still visible.

• In the glazing process, waiting for the paint to dry is essential before applying new layers. Also, if a pure hue is desired without the influence of the previously applied layer, then the artist must wait for the first layers to completely dry.

• With this glazing technique many layers of paint can be applied, and the artist can always end with the impasto technique. There is no need to begin with foundation layers of flat paint. The techniques of diluting pigments and applying impasto can be easily interchanged in a painting.

• The chromatic result of acrylic painting is as rich with possibilities as that of oil painting. Since acrylic pigments dry with a matt finish, a varnish can always be applied later to add gloss.

THE FOUNDATION DRAWING FOR A PAINTING

Achieving bright hues depends on the method the colors are applied. The artist normally starts by applying paint in a liquid form and then progressively thickening the paint. The shiniest areas are depicted with white hues. Creating the work of art using diluted hues has an added advantage – the pencil drawing remains visible allowing details and contours to be followed. The light colors are depicted through transparency without mixing with white hues, so the pencil lines will not be covered up.

The process of painting is by no means quick. A series of shades and touch ups from the most extensive brushstrokes to the most precise details are important to achieve a effect of realistism. Also, working with colors is progressive, and the first tonal values are based on general hues that define each object. Adding shades leads to the enrichment of colors, supplying volume and texture to each element.

1. This still life example is drawn with charcoal, which is more intense than graphite. The paint itself will be applied densely, but the lines will stand out because they are very dark. The artist outlines the shapes and main contrasts with charcoal.

2. Now, the background is painted with straight brushstrokes to depict the texture of bricks. In this case, earth tones, reds, and orange hues are used to do this. Then, warm broken colors are used to paint the transparent glass containers. A yellow hue is directly applied to represent the oil.

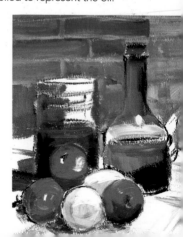

3. The entire work has been painted with general hues that define each element. Now, shades are painted in the most general way possible. Dark red hues are used on the container on the left, both in the lower filled in areas, and in the upper areas that are more transparent and that show reflections. The color of the tomatoes in the foreground stands out since it is the liveliest color in the painting.

MODELING SHAPES WITH DIRECT MIXTURES

Acrylics are ideal for directly applying paint and using intense colors. The pigments dry very quickly, which allows them to be used to blend colors and create new ones through gradation. The alternative to blending is directly applying brushstrokes. In this case, the artist must use the correct hues, so that when these are applied, they correctly define the volume and characteristics of the objects.

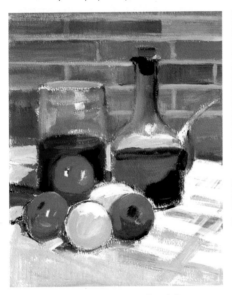

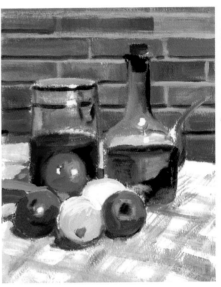

1. The still life is now painted with hues that depict the texture of each element. Gray and white hues are used to define the transparent characteristics of the glass. Defined, straight brushstrokes are used on the bricks in the background. Neutral blue hues are used to paint the squares on the tablecloth.

2. More shades are added to the entire surface to give it more depth and reality. Also, dark lines are added to the background to depict relief. The artist continues by adding a variety of broken blue hues to the tablecloth. Then, various shades are applied to the fruit in a circular manner to give them volume.

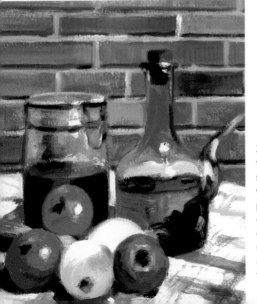

3. Dark hues are used on the entire work to reinforce contrast and help define the shapes. These hues are applied in various ways, depending on which area is being painted. A fine brush is used for lines that define the outlines and details. And for darkening more general areas, the artist uses a flat, more exact, brushstroke, adding contrast to the glass and to the tablecloth where dark blue is used.

CORRECTING AND RETOUCHING

Acrylic is a medium that combines the qualities of transparency and opaqueness. Applying acrylic in an opaque manner makes correcting errors easier and allows the artist to completely cover one color with another. The paint must be thick to cover an area, and dark colors are the most effective for covering sections. When working with light colors, the hues can be mixed with white to achieve an equally opaque color.

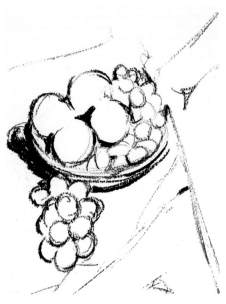

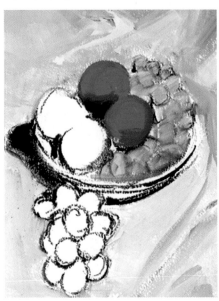

1. First, the still life is drawn with charcoal, and both composition and shape are established. The perspective is much more pronounced than usual, so, instead of adding depth to the painting, the artist distributes the elements quite differently related to the table.

2. The general colors are applied with broad brushstrokes. In the background, various mixtures of grays are applied according to the position of the tablecloth. To establish the desired intensity, colors are mixed with white in different proportions depending on the light. Red is applied directly to the tomatoes and cadmium yellow to the grapes.

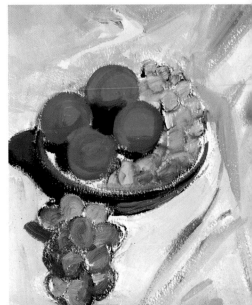

3. The final touches are given, adding dark hues to depict the shadows projected onto the tablecloth. The ellipse of the plate is also made with an exact curved stroke. The artist uses brushstrokes of the same yellow hue on the grapes and adds green to depict the changes in volume and hue.

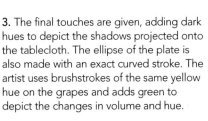

FINISHING A STILL LIFE

A series of steps should be followed to correctly paint a still life. Starting with a drawing, the artist adds general brushstrokes and shades to depict the volumes and textures of each element correctly. In acrylic paintings, the colors can be easily superimposed over the previous layers without the need to blend them. The artist can add as many shades as necessary by superimposing colors.

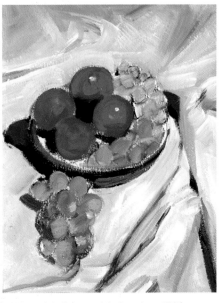

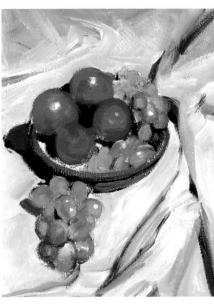

1. New details are added to the still life, making it appear more realistic. Some exact, white brushstrokes are added to the tomatoes to depict areas of highlights and their volumes in relief. Then, the artist adds darker gray hues to the tablecloth to depict its folds.

2. Next, the artist concentrates on the bunch of grapes that dominate the foreground and that require more meticulous work than the rest of the painting. Since the grapes are small and bunched together, volume and detail are given to each one in the bunch. The artist alternates green and yellow hues in this area to create the first contrasts in the fruit.

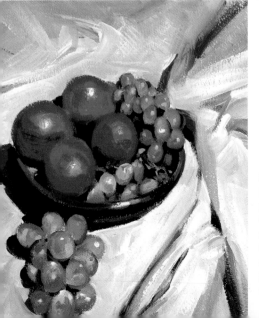

3. The work of art is completed by adding definitive contrasts to the entire painting, especially to the grapes. In this case, the shadow is depicted linearly to separate each grape from the next so that its shape and contour are distinguished. Some highlit areas are painted with white hues which help to depict the highest relief.

Step by Step

A Still Life

MATERIALS

Heavy paper,
Charcoal, Acrylics,
Bristle brushes,
Water container,
Paint rags

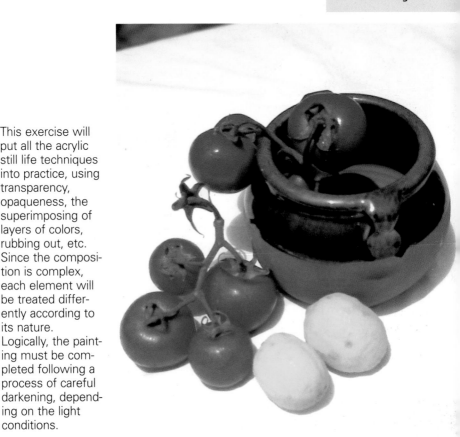

This exercise will put all the acrylic still life techniques into practice, using transparency, opaqueness, the superimposing of layers of colors, rubbing out, etc. Since the composition is complex, each element will be treated differently according to its nature. Logically, the painting must be completed following a process of careful darkening, depending on the light conditions.

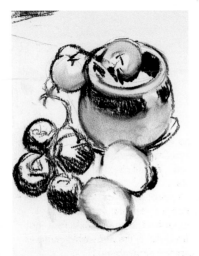

Step 1. First, the artist draws a very detailed sketch of all the elements, the intention being to compose and outline the fruit and pottery dish. All shadows and contrasts will then be determined, establishing light conditions from the beginning.

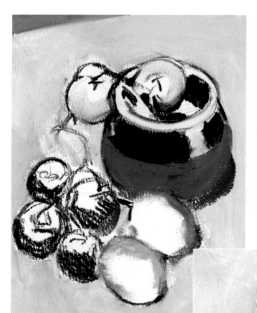

Step 2. Now, the artist works on the pottery and background by adding the colors corresponding to each area. In the background, light glazes of very pale gray are applied, producing an effect of light on the surface, since the transparency allows the white of the paper to show. Two colors are used on the clay pot, sienna on the lower part and black directly applied on the rim.

Step 3. Next, the foundation colors of the elements are painted. Yellow is used on the lemons and a pure red hue is applied to represent the tomatoes. The artist uses a fine brush to apply green hues to the stems joining the pieces of fruit together. Broken green hues are then added to depict the reflections of light against the black color.

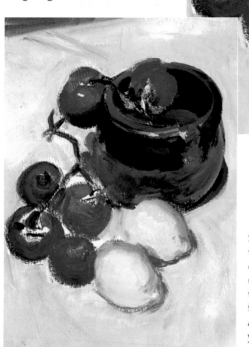

Step 4. The artist continues working on the pot, completing its shape and details. The ellipse that makes up the upper part is correctly depicted. Then, the internal contrasts and separation from the tomatoes is established. Afterwards, the artist uses a very light yellow hue on the lemons to create a sensation of volume.

Step 5. To continue, all the contrasts on the clay pot are defined correctly using a directly applied black hue that reinforces the darkness at the same time as it defines the shapes. White hues are then directly applied to depict the highlit areas on the rim. A blue hue is used on the table to depict the shadows projected from each of the elements.

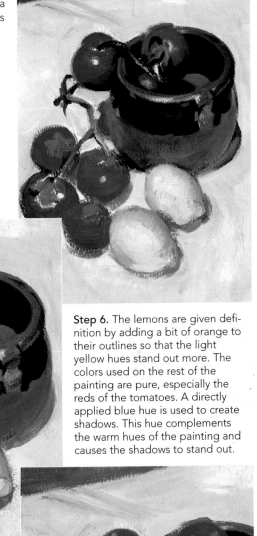

Step 6. The lemons are given definition by adding a bit of orange to their outlines so that the light yellow hues stand out more. The colors used on the rest of the painting are pure, especially the reds of the tomatoes. A directly applied blue hue is used to create shadows. This hue complements the warm hues of the painting and causes the shadows to stand out.

Step 7. The tomatoes and the branches are given as much detail as possible. Red hues are applied to the rounded volumes of the tomato. Shadows are then added in the least lighted areas, and precise pure white brushstrokes are used to depict the reflections. Green hues and shadows are combined on the stems to give them volume.

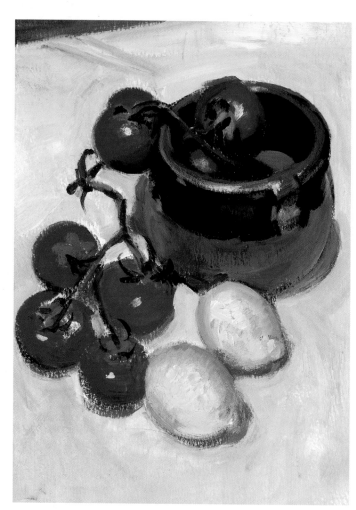

Step 8. The work is completed when all the details and contrasts are treated throughout the painting. Very little paint has been added to the bright white background, which relies on transparency. In contrast, thicker paint is applied to the objects to make their volumes stand out more.

SUMMARY

• Basing the work of art on diluted acrylic hues gives the artist the added advantage of a pencil drawing that remains visible.

• Using opaque acrylic paint makes the correction of errors and covering up of other colors easier, allowing the artist to always be able to retouch the painting.

• Acrylic paint is appropriate for working directly to create color impact.

• The correct painting of a still life requires a series of steps, including drawing, applying general brushstrokes, and adding shades of color until the volumes and textures of each element are depicted.

• Colors are added progressively. The first valuations are based on general hues that define each object. Adding shades enriches these colors and gives the elements both volume and color. With this technique, large blends of color are not made as easily as they are with other techniques.

• To create a realistic painting, the artist must start with the widest brushstrokes and proceed to the fine details.

35 COLOR ON THE FIGURE

Acrylics

APPLYING FLAT COLORS

In acrylic painting, colors are often applied flatly. The artist directly paints with broad brushstrokes that are proportional to the object being represented. These color brushstrokes are transparent at first, but they become more opaque as additional layers are added. It is possible to correct errors in areas where the paint has already dried or to apply smooth and uniform colors, a possibility that would not exist if only transparent colors were used.

The human figure, like any other theme, allows the artist to express his or her inner world. Logically, the colors used in a painting are a direct reflection of the artist's feelings. A painting that combines pure, bright colors reflects a condition of vitality, and is much livelier than a painting characterized by broken, pale, and blended colors.

1. The artist first draws a sketch in which all anatomical proportions are adjusted. When the human figure is being painted, a sketch is fundamental to achieving a satisfactory result.

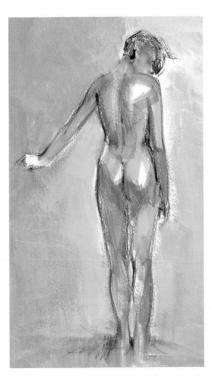

2. Next, diluted yellow is used for the smooth and uniform brushstrokes applied on the figure and in the background. Since the paint is diluted, it appears to be completely transparent, allowing the pencil lines to be completely visible. In the background, the colors are smooth and flat, and on the figure an effect of light and shadow is created with the pencil drawing.

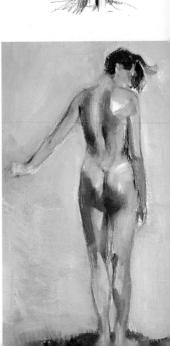

3. Continuing, the artist strengthens the contrasts by using a broken dark green hue. Then, defined, smooth brushstrokes are applied to create shadows on both the figure and the surface of the floor.

STRENGTHENING THE HUES

To strengthen hues with acrylics, the artist works from light to dark. First bright, light hues are applied and then the colors are progressively intensified.

Because acrylic pigments are opaque, the process of applying bright, light colors over more intense ones is also possible. Mixing both techniques leads to a rich, versatile painting and also allows for touch ups and additions.

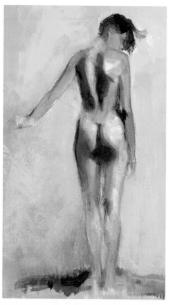

1. Now, new hues are added to the green and yellow composition. These hues are warm, oranges and reds, and will be applied to the painting depending on the intensity of the light that falls on that area. In the more lighted areas, the orange is combined with yellow; red blending with dark green are applied to some areas to create shadows.

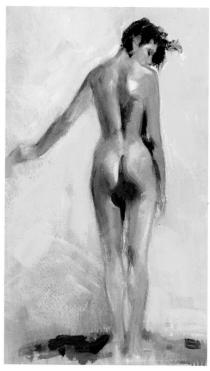

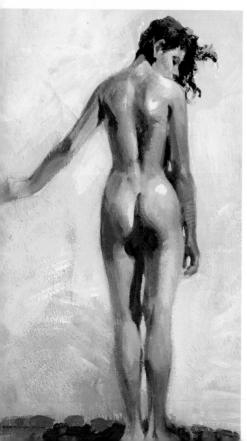

2. Complementary blue hues are added to give contrast to the figure. Light blue hues are integrated with the orange and yellow hues, while dark blues are applied in the internal body areas opposite the light. Black hues are painted onto the main shapes and details, reinforcing the effects of contrast.

3. The artist finishes the figure's legs and the floor, establishing contrasts and details. In summary, the artist has chosen a very unconventional technique for painting skin tones, one that involves the use of primary colors to achieve the desired effects of light, shadow, and volume.

CONTRASTING COLORS

The colors must be well controlled on both the lightest and most shaded areas. If this were not done, the painting would be monochromatic. The artist determines at which point pure whites and blacks are to be added and calculates which colors to blend in order to achieve the desired hues in the painting. Opposite colors will be combined in the darker areas and the areas with shadows. In the bright lighted areas, the artist will blend white with other colors.

1. First, the artist draws a pencil sketch of the image and then adds shadows in some areas. This image, in which the main elements are in the foreground, is in shadow because the figure is placed in an unusual position with respect to the light.

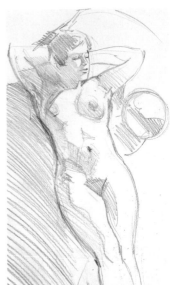

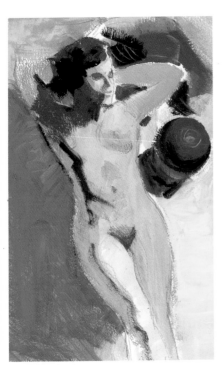

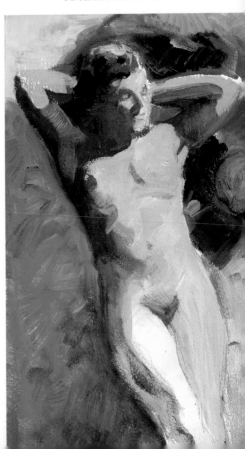

2. The artist follows a process in which wide color brushstrokes are applied to define the general color of each element. Pink hues and earth tones of different intensities are used on the body. Earth tones are used to define the projected shadows. Shadows and ocher hues are added to the background and the ball is painted with a dark green hue.

3. Next, the artist begins to define the colors and shapes in the shadowed areas. Various dark blue hues are painted into the shadows. These hues contrast greatly with the warmth of the flesh tones. Sienna and red hues, as well as natural shades, are used on the shadows falling on the sand.

AREAS OF MAXIMUM CONTRAST

When a painting includes a dominant point of light, contrasts become much stronger. To achieve these strong contrasts, very differing hues must be used. The light areas will include hues mixed with white, or hues that are bright and lighter in color. On the other hand, shadows are created by either using dark hues or by mixing complementary colors that are never quite as intense as pure black.

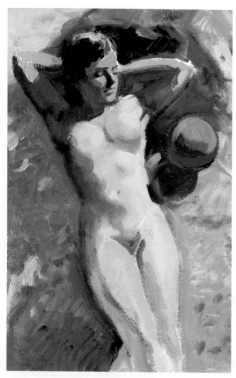

1. First, the artist shadows the figure's face, using blue hues on the cheek, causing the features to stand out. Very light-colored brushstrokes are added to the body's surface to depict the parts of the anatomy that are of the highest relief. Then, the artist directly applies red to the ball, which is then somewhat shaded.

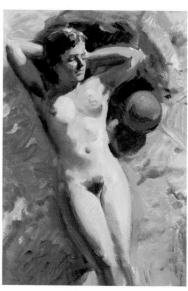

2. Definition and contrast are added to the figure by painting blue-hued shadows on the left leg. The recessed areas of the body (the neck and armpits) are painted with defined brushstrokes of very dark, intense hues. .

3. Concentrating on the details of the face and body, the artist adds defined strokes of color to the face and hair. The hues already applied to the body are blended, integrating light and shadows to produce a continuous volume. In general, the contrasts in this image are due to the direct sunlight that forms extreme and irregular shadows.

Step by Step



Step by Step

285

A Male Nude

MATERIALS

Heavy drawing paper, Charcoal, Acrylic paints, Bristle brushes, Water container, Paint rags

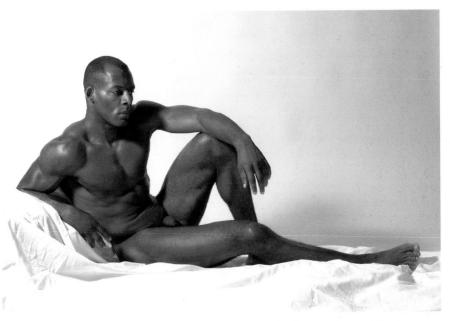

In this study, the model has a very developed, marked musculature. Since the muscular masses require an uneven but continuous treatment, the acrylic technique is ideal for depicting this body type. Relief areas are easy to depict with direct brushstrokes, and acrylic paints can be freely applied.

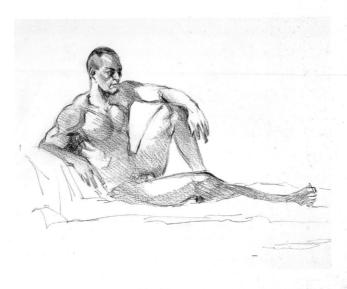

Step 1. First, charcoal is used to sketch the figure. A hard charcoal is recommended because it smudges the paper less. This drawing is very concrete and exact, allowing the brushstrokes to be applied with certainty.

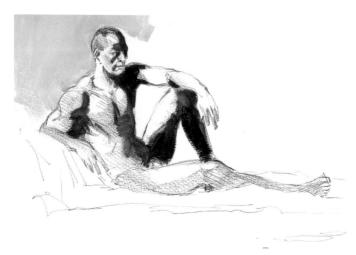

Step 2. The first hues are now added to create mixtures that are faithful to the figure's true color. A warm gray is the first color applied to the wall. A dark shadow is then added to the figure to define the flesh tones in areas with shadows.

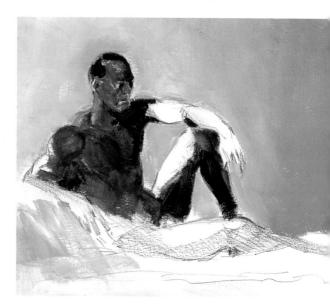

Step 3. The background is now completed using other gray hues until the entire extension of the wall is covered. A sienna hue is then used on the body. Combined with the shaded areas, it creates the first modeling of anatomical volume.

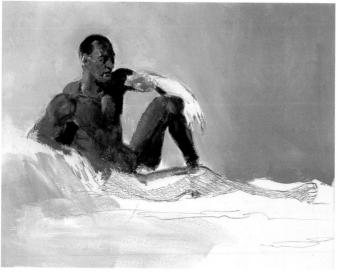

Step 4. The artist continues to work on the figure's flesh tones by including light gray hues to the skin. These hues are incorporated over the most prominent relief to depict the light projected onto these areas and the way this light affects the surrounding colors.

Step 5. Next, a directly applied black hue is used to reinforce the shaded areas and to define the facial features, outlining the eyes, nose, and mouth. Then, shadows of sienna hues are applied to the arms and legs with wide, non-defining brushstrokes.

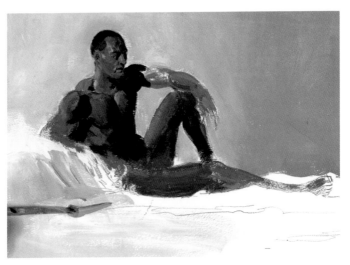

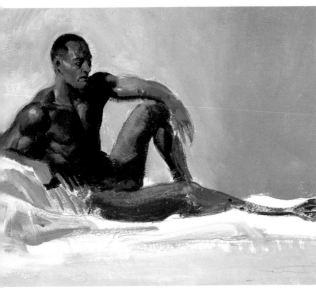

Step 6. Continuing, cool and broken hues, mainly from the gray range of colors, are applied to the body. These gray hues are used in the same way as points of light, and are applied to the muscles that stand out in relief. More bluish gray hues are added to the legs.

Step 7. White and bluish gray hues are now used to finish the floor and the cloth. The face is completely defined and the proper contrasts are depicted on the skin. The colors used on the legs are blended for an impression of continuous volume characteristic of the figure's skin.

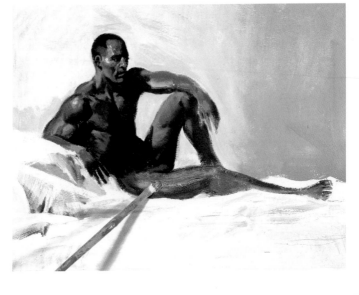

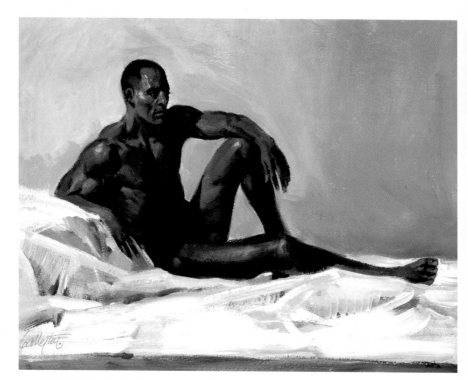

Step 8. The folds in the cloth are now depicted, and finishing touches are added to the figure's skin. Finally, the artist concentrates on the arms and legs, defining the knees, ankles, fingers, and toes.

SUMMARY

• Color is responsible for a painting's final appearance. When bright and pure colors are used, the painting is more vital and euphoric than when broken and blended pale colors are used.

• For highlights and intense shadows, the artist must determine at which point pure white and black hues are to be applied. as well as how to blend the rest of the essential hues.

• When a dominant point of light exists in a composition, extreme, irregular shadows are created.

• Flat color brushstrokes are used to directly apply paint. Since diluted hues acrylic are not often used., acrylics are frequently ap-plied as flat colors. Usually, colors are not diluted when pigments are directly applied.

• When using acrylic paints, the artist works from light to dark. In other words, bright light hues are applied and then progressively intensified.

• Dark hues of opposite colors can be combined to achieve strong shadows, without depending on the use of black.

Acrylics

SKIN DETAILS

The unique characteristics of various animals' coats are completely distinguishable from other textures, such as smooth, homogeneous human skin. According to the particular animal species, a wide variety of textures can be found. Land animals with fur will be very textured. In a painting, the closer an animal is to the foreground, the more identifiable the specific texture of the animal is.

Brushes are an ideal tool for painting reality. Each shape and volume has its own characteristics, which can be represented by the artist with a painting medium and a brush. Color brushstrokes can be long or short, wide or narrow, depending on what an image's texture demands.

1. First, the artist draws a resting deer. The artist defines the anatomy of the animal, its body, head, and legs, as much as possible, according to the animal's posture. A graphite line is used to mark contrasts, and establish the animal's pose.

2. Next, various hues of brown are used on the deer's coat, in relation to the light and shadows falling on the image. Sienna is combined with a natural shade to obtain an effect of volume. The brushstrokes always follow the animal's inclination in order to reinforce the effect of relief.

3. The landscape is painted to establish the background-to-figure relationship. Neutral greens are used in the first plane of the background. Dark brown hues are used in the most distant plane, and bright greens and yellows are applied in the area illuminated by the sun. The background is then given tonal values to correctly contrast with the deer's coat.

TEXTURES AND SHADOWS

Not only does texture influence an animal's fur, but, also, the artist must keep the effects of light and shadow in mind. These effects are due to the impression of volume created by light and shadows falling on an animal's posture, skeletal structure, and muscular anatomy. Volumes are an interpretation of an animal's hidden internal structure. Even though painting the textural details of an animal's fur is important, the artist must also take light and shadow that derive from volume into account.

1. The artist continues working on the painting of the deer to give detail to the terrain. Ocher mixed with white is used in the lightest ground area to represent falling sunlight. For the group of stones adjacent to the an-imal, the artist applies various gray hues.

2. The deer's figure is contrasted with directly applied shaded hues. A small amount of black is also used so that volume can be seen more clearly and the resting position of the animal is well defined. A variety of shadowy and violet hues are blended in to make the foreground appear to be without light.

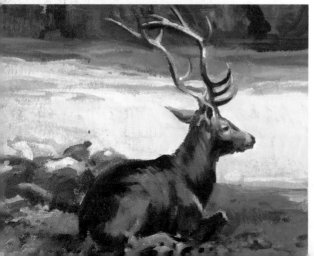

3. The artist finishes by adding details. A thin brush is used to define the features of the head and antlers. Texture is also given to the grass in the foreground with marked brushstrokes. Finally, each stone is detailed, and the separations between the rocks are depicted.

USING MIXED TECHNIQUES

The techniques available in acrylic painting are quite varied dsince it is possible to work with both opaqueness and transparency. The artist can combine both methods to achieve desired textures, taking advantage of the smooth and homogeneous aspect of transparencies as well as the strength and texture offered by thickly applied paint. In animal themed-paintings, texture is very important because of the varying surfaces and defined volumes of the subjects.

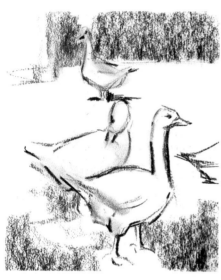

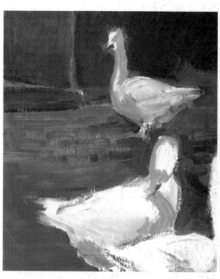

1. First, the image is sketched with charcoal for both defining contours and designating the most shaded areas of the background. The lines are loose and direct, and drawn without much attention to detail; the animals' shapes are quite simple.

2. Next, the entire surface of the image is painted so that contrasts are clearly visible. Black hues mixed with greens and blues are applied to the background giving variety to the somber atmosphere. Gray brushstrokes are applied to the distant goose, and contrast is added.

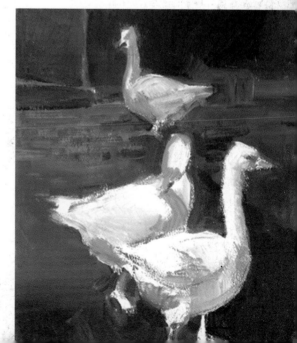

3. The background is completed when all the spaces are filled in. Then, orange is used for the legs and beaks. Finally, the gray and white hues used on the geese are blended to create more continuous and homogeneous volume.

APPLYING TRANSPARENT GLAZES

A glaze is achieved by applying a transparent layer of paint on top of an underlying coat to shade it without completely covering it up. This process calls for using light hues over darker ones. White can be added to an acrylic mixture to make it lighter, or hues can be progressively applied as superimposed layers. When the layers consist of diluted colors, they will be similar to those used in watercolors. For the best results, the acrylic paint should be dry before applying each successive coat, so that the colors don't blend. In this way, a newly applied transparent hue will change the underlying color without blending with it.

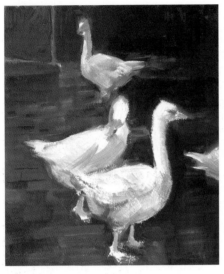

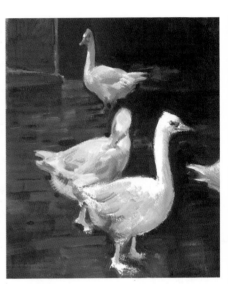

1. The artist continues with the goose that is farthest away until a realistic but integrated appearance is achieved. In the closest geese, the artist concentrates on elaborating the details that are due to the birds' positions in the painting.

2. White and gray hues are alternated on the geese's feathers. Next, the feet are painted with an orange-brown hue which stands out against the dark background.

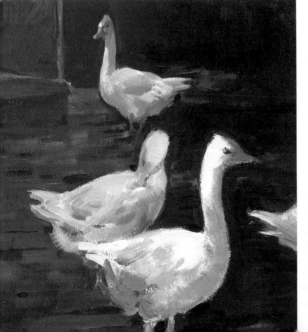

3. The scene is now completely defined, and special attention is placed on the two geese in the foreground. Pure colors are used on the feet and beak to define their contours. The artist also adds brushstrokes to depict volume in the feathers.

A Lion

MATERIALS

Heavy drawing paper, Graphite pencil, Bristle brushes, Water container, Paint rags

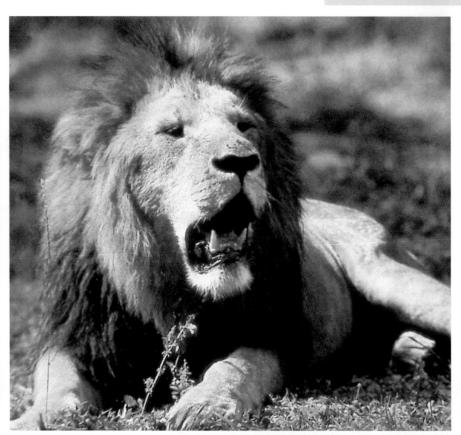

Large cats are illustrative of the creative possibilities for painting offered by nature. An image such as this one is impressive due to the strength and majesty of the animal portrayed. The goal of such a painting is to make these characteristics stand out. The artist will use the brushstroke techniques necessary for achieving the lion's elegance and strength.

Step 1. First, the artist draws the lion, keeping in mind the strong light and dark effects created by its position related to the fall of light. Part of the lion's body, its head, and legs are illuminated, while the rest of the elements are positioned opposite to the light. Lines are drawn to represent these shaded areas.

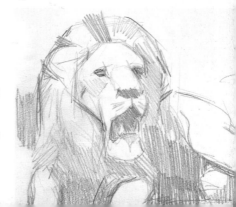

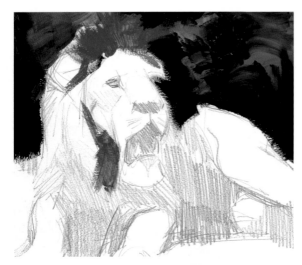

Step 2. Now, green hues mixed with natural shades and black are used on the background. In this way a very dark foundation is established to reinforce the contrasts which will be created on the animal. The fur on the lion's mane is painted with a deep red hue.

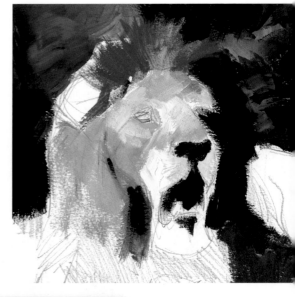

Step 3. The artist continues to concentrate on the lion, adding new hues in each area. On the face, both diluted and more intense ocher hues are used. Then, black is directly applied to the areas with shadows.

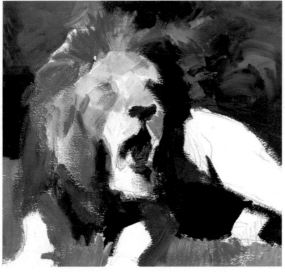

Step 4. Now, brown and reddish hues are used on the left-hand side of the image, representing the lion's mane. Because the right side of the image is opposite to the light, pure black hue is predominant.

Step 5. The fur on the lion's body and paws is painted using a more intense ocher hue than that used on the face. In this stage of the painting, all the spaces have been filled in using flat and general brush-strokes that define the various forms into which the painting is divided.

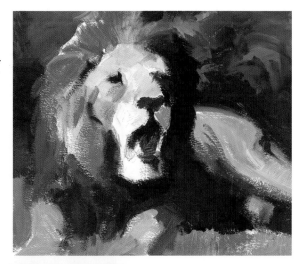

Step 6. More defined shades are now applied to the face. Brushstrokes that define the skeletal structure form the face. Next, brown is added to the snout and integrated with the rest of the colors. In addition, directly applied brushstrokes are painted onto the mane.

Step 7. Pink hues are added to the skin to unify the fur of the mane and face. The left-hand area of the head is painted with sienna hues to give shape to the massive volume of the head. The artist defines the eye by painting the eyelid with a brown hue.

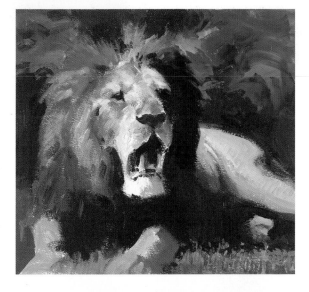

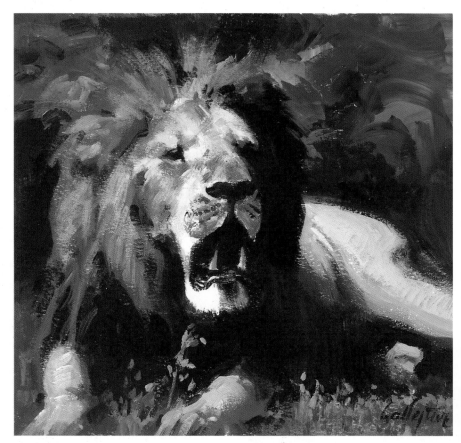

Step 8. The artist now uses a fine brush to directly apply black hues in order to define the open mouth exposing the lion's teeth. A fine brush is also used to apply a variety of bright green hues to the leaves and other forms making up the foreground.

SUMMARY

• Paintbrushes are an ideal tool for portraying reality. Every shape and volume has its own characteristics which can be depicted through the use of a brush.

• The external forms of animals with fur are very textured and become more identifiable the closer the animal appears in the foreground of an image.

• The way an animal's fur is portrayed is not only influenced by texture. Light and shadow are factors as well, due to the volumes produced by an animal's posture, its bone structure, and its muscular anatomy.

• The choice of brushstrokes depends on the technique being usedfor a given theme. These brushstrokes can be short or long, wide or narrow, depending on the textures being portrayed.

• The techniques in painting with acrylics are quite varied, allowing the artist to utilize opaqueness, transparency, or the combination both methods to achieve the desired textures.

• Animal textures have very different characteristics from smooth, homogeneous human skin.

• Glazes are applied by using transparent mixtures for shading an underlying layer. The first layer of paint must be dry so that the colors will change without blending with the newly applied hue.

Acrylics

ACRYLIC GLAZES

Many of the pure acrylic pigments, magenta for example, can be diluted with water and still maintain their staining power. When these hues are applied over another layer of hues, dark glazes form, offering the possibility of achieving new hues without blending. Since acrylic hues mixed with white are opaque, light glazes can be applied over dark hues.

The chromatic range in acrylic painting offers exciting possibilities for the artist. These possibilities can be applied to a variety of themes, forms, patterns, textures, and light variations. The acrylic technique is so varied that it is very appropriate for discovering the visual possibilities in interpreting the world.

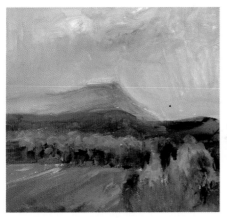

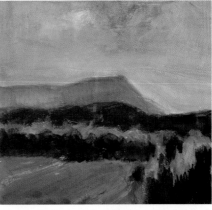

1. Starting with a brown base allows the artist to compose the entire landscape and to achieve the many shades required in this work. A transparent white glaze is used on the sky, completely changing the underlying ocher hue into a pastel-like color. On the ground, glazes of dark browns are used on the bushes and trees.

2. Now, the artist strengthens the contrasts in the ground vegetation. Superimposing layers of natural shades adds the necessary darkness on both the mountains and the rows of trees found in the middle and in the foreground of the image.

3. The artist continues to add pure colors to correctly define each element in the composition. Pure white is used on the sky to depict the cloud shapes. Green and turquoise hues are used on the mountains in the distance. Finally, pure green is applied to the entire grassy surface and the tree tops.

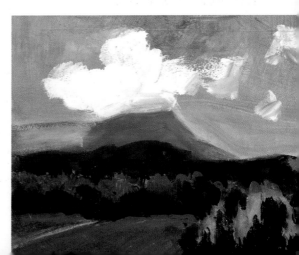

Changed Hues

Hues used in acrylic painting can be developed in many different ways. Mixing colors in the palette, searching for the perfect hue to portray a certain element, is one posibility. Another is to add paint while the underlying hue is still wet and blending the hues together. The most frequently used possiblity, however, is the use of glazes, especially to darken previously applied hues. Colors that are to be used for glazes should be diluted, allowing the underlying layers to remain visible.

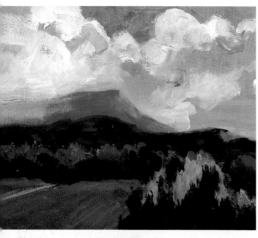

1. First, the artist paints the sky with pure white hues, blending them with turquoise to create an atmospheric impression. The same light, somewhat blue hue is superimposed on the dark green hues used for the trees. The artist observes the landscape to determine what contrasts need to be created.

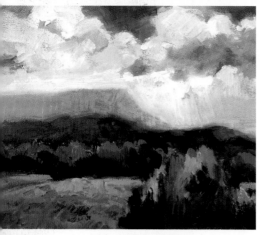

2. The grass is now shaded with light green hues to cause an impression of dampness in the cloudy and overcast sky. The superimposed colors on the ground are lighter in the areas where they come into contact with the row of trees, causing a stronger contrast. In the foreground, the superimposed colors are much more intense.

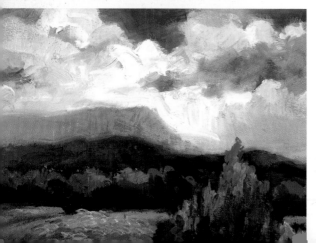

3. Next, exact brushstrokes are painted on the grass to create textures and relief. Dark shades of green and ocher are added to the bush in the foreground. In general, the artist has used glazes of light and dark hues to obtain the appropriate sades for each element.

CREATING THE EFFECT OF MIST

Any paint to which water can be added can be re-wetted to open points of light on the previously applied areas. The artist relies on the paper showing through transparent washes to achieve lighter hues and a blurred, atmospheric effect. Acrylic paint can also be treated as if it were oil paint. In this case, the artist creates a misty sensation by mixing the color on the painting itself, integrating it with the image. This method of working combines and blends colors much more quickly.

1. First, color is blended and spread over the image to create an atmospheric impression. A combination of blue and ocher hues is directly applied to the sky and mixed with white. The lake is painted with the same colors used on the sky.

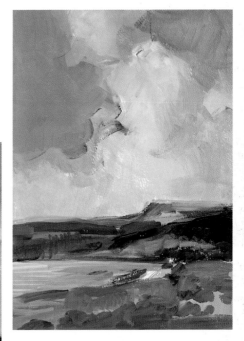

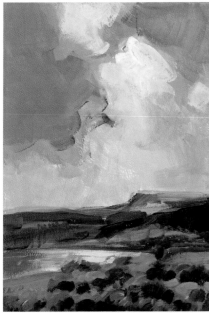

2. The colors are then used on the earth, shaded by adding darker green hues to the vegetation on the ground. The lake is shaded with intense white hues that create shiny areas on the water's surface.

3. The artist continues to work on the atmospheric effect by blending colors. This uniting of hues through gradation creates a homogeneous sensation. The cool and warm hues used on the sky are combined to create a smooth and bright background. Then, blues and greens are used to cause a distancing effect in the far away mountains.

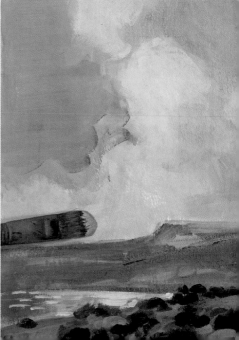

A SENSE OF DEPTH

Depth is achieved by working on the different planes making up the image, depending on how close or far away they are from the viewer. Blends created with either transparency or opaque colors are used on the background. Contours become sharper and more exact the closer the elements are from the spectator. In order for the shapes to stand out against the background, the artist waits for layers to dry before applying new ones.

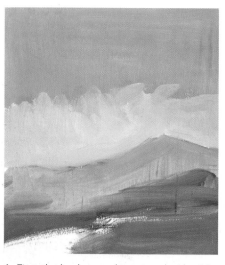

1. First, the background is painted with wide brushstroke filling in the spaces and creating the proper environment. The colors used in the sky and mountains are based on broken blue hues mixed with whites of different intensities. Then, a directly applied ocher hue is used for the earth.

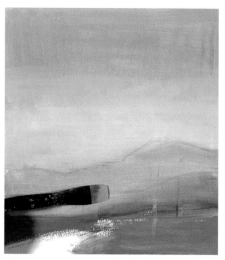

2. Now, the colors are blended with a brush to achieve a background that will be related to the elements in the foreground. When using acrylics, it is common to work in stages. First, the artist works to achieve a gradation of planes onto which new layers can be superimposed. Then, new hues are added to make concrete elements stand out.

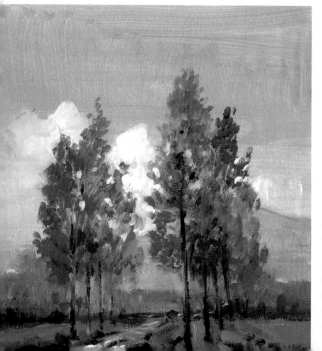

3. Details that stand out against the background are added. In this case, the trees and grass are given textures and definition. The process explained previously prepared the way for this stage, in which brushstrokes defining the elements in the foreground stand out.

Step by Step

A Landscape

MATERIALS

Thick drawing paper,
Charcoal, Acrylics,
Bristle brushes,
Water container,
Paint rags

A woodland stream in a landscape is a very appropriate subject for using transparencies. Because of the presence of water, a variable element with many shiny areas, a variety of brushstrokes will be applied to depict the stream. When there is a current in a body of water, it acquires many shades, movements, and directions. These characteristics cause water to be a true challenge for artistic interpretation.

Step 1. First, the artist draws a charcoal sketch, using very loose lines, for this image that is natural and wild. The lines only indicate direction and volume, and no details are added to the sketch.

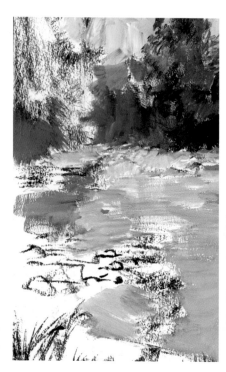

Step 2. The first brushstrokes of color will be distributed throughout the image to begin describing the chromatic relationships present in the painting. A very diluted gray hue is used for the water and for fragments of the sky appearing between the forest masses.

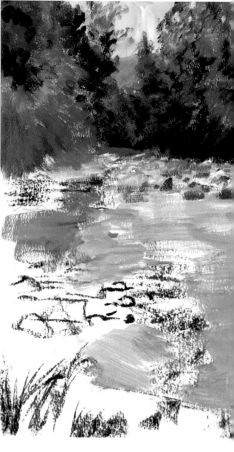

Step 3. The background wash is completed by adding varied brushstrokes to form the trees. A variety of green hues are used to depict the different volumes of leaves and vegetation.

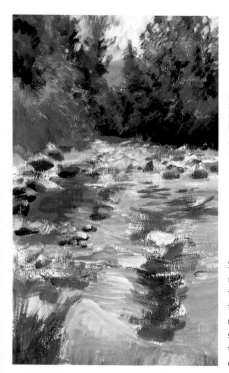

Step 4. Now, the artist concentrates on the river area adding new glazes over the gray foundation. The quality of the brushstroke is fundamental for depicting the current and movement of the water. Darker gray brushstrokes are superimposed over the foundation, and new greens are applied to the center of the painting.

Step 5. Next, dark brushstrokes combined with bright gray hues are used to define the water's texture. All the raised areas formed by the stones are painted. New, purer colors are then added in the foreground to depict the reflections of the trees.

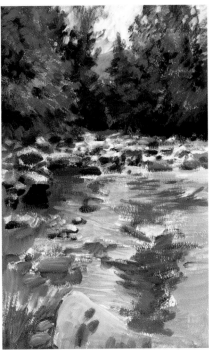

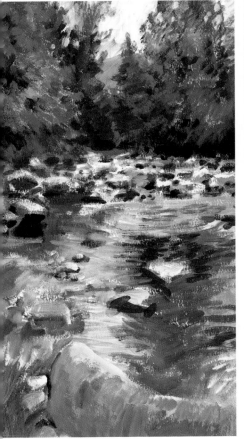

Step 6. New, more intense glazes are added to the foreground. The artist combines very intense blue hues with a small amounts of black to achieve these glazes, which are placed in the center where the stones rise from the water.

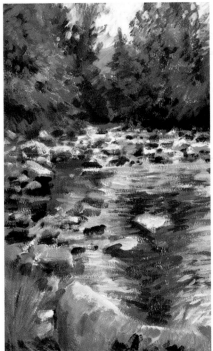

Step 7. The artist continues adding dark hues in the foreground to depict the presence of new stones on the water's surface.

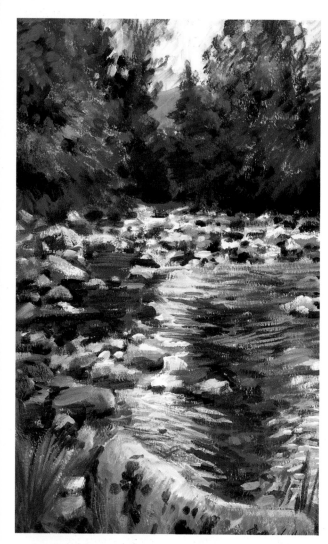

Step 8. Finally, the artist uses a finer more concrete brushstrokes to give detail to the current and to depict the contrasts on the water. The same brush is used to paint a stone surrounded by trees in the foreground.

SUMMARY

• Landscapes offer many possibilities for harmonizing colors and applying textures, depending on the elements to be depicted in the painting and on the conditions of light found in the composition.

• With acrylic paints, hues can be achieved by mixing colors in the palette until the desired color for a given element is achieved.

• Another possibility for forming hues is to add paint when the previous layer is still wet and then to blend these hues together.

• Glazes allow the artist to achieve new hues through superimposing layers without previous mixing.

• Light glazes are not only made with directly applied white hues. Other colors can be mixed with white to become pastel-like,

opaque colors that can be easily used to alter an underlying color.

• Any dark color, or a color that is darker than a previously applied color, constitutes a dark glaze.

•There are two ways to achieve an atmospheric effect. Hues can be toned down when the paint is still wet and colors will be combined, as in watercolors. Or, paint can be treated as though it were oil paint and be thickly applied into still-damp previously applied paint, allowing for blending.

• To achieve depth in a painting, the artist divides the image into planes that will each be treated differently, depending on whether they are close up or far away from the point of view of the painter.

USING AVAILABLE MATERIALS

The artist considers the different types of papers and their textures in order to achieve the particular desired effect. The roughness and transparency of each type of paper varies, and color has different effects on different types of paper. Also, photographic images can be used in producing a collage.

The collage is a relatively modern art form. The first examples of of them date back to the avant-garde movement. Images were formed from various found materials superimposed to achieve different textures and other effects. The result of this type of work vary depending on whether the artist wants to achieve an abstract work of art, or a conceptual image with specific meaning.

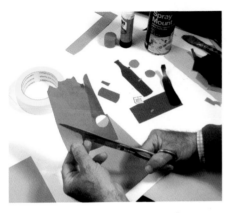

1. After the composition has been chosen, the artist begins by working on the shapes of each element, cutting it out from the pape. The artist uses the correct paper for proper contrasts among the hues and knows where each piece will be located on the composition.

2. When fixing the paper onto the support, it is best to use a spray adhesive, because it is clean and leaves a thin layer without causing wrinkling of the glued paper. An alternative is to use a rubber cement, which allows the artist to change the position of the paper if necessary.

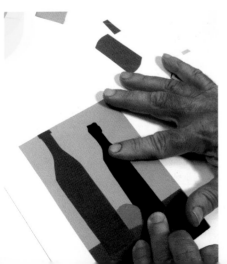

3. A neutral background is chosen to make the rest of the hues stand out. The simple, cut-out shapes of paper form a still life of bottles and fruit.

Painted Papers

As well as being a combination of textures, collages are also a symphony of hues. A mixed technique can be considered when making up a composition, either gluing down colored papers, or applying paper which the artist has painted. When working with mixed techniques, the artist considers the aesthetic result as in conventional painting, applying the rules of light, shadow, and composition.

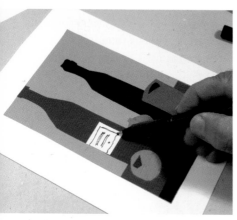

1. Color papers are used to create the foundation of the composition. Afterward, the artist touches up certain areas with paint to create details, highlights, or contrasts. In this case, the artist concentrates on the bottle's label.

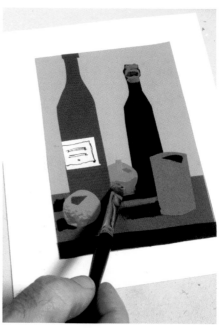

2. A naturalistic effect is given to the image by adding roughness to the fruit with red gouache applied by impasto. A black hue is used to portray the shadows that the elements project onto the table.

3. The artist applies the finishing touches to the blue container, including a directly white hue that depicts the reflections that are characteristic of metal objects. A label and cap are added to the black bottle with color impasto. In summary, the artist has combined the foundation colors formed by the cut-outs with strokes of paint that highlight the object's individual characteristics.

SHAPES AND FINISHING TOUCHES

The means and resources available for making collages are practically inexhaustible, since each kind of paper allows for different effects, just like paint does. For example, rice paper applied over other papers creates a light over dark effect of transparency, characteristic of glazes. Brushstrokes additions are usually left for the finishing touches and are used for details.

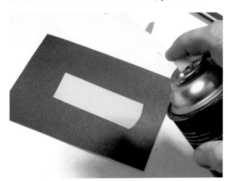

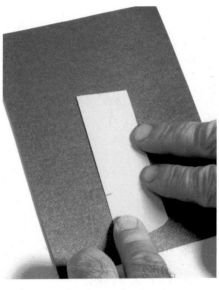

1. The choice of paper is fundamental for creating specific effects. In this exercise, the artist uses a shiny black background to attract attention on its own and tocreate contrasts with all the other shapes. A brown paper is chosen for the jar's base and glue is applied to adhere it to the paper.

2. The paper has been glued to the center of the support paper, and the rest of the composition is based on this central axis.

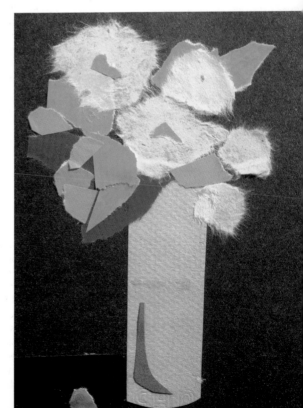

3. The still life is composed of a variety of papers used depending on the object being represented. The edges of the paper jar are cut straight, and the flowers and leaves are roughly cut so that their edges are irregular. The yellow flowers were created with a fibrous paper which spreads onto the background, as if the artist had used a blurred pastel hue.

PAINT

For the collage art form, there are two different ways to combine paper and paint. Paint can be used as an additional element, or as a foundation onto which other elements can be superimposed. In some collages, the texture created by the paper stands out, whereas in others, what dominates is the effect of the paper as a foundation on which to glue or paint details.

1. For this collage, the artist's idea is to create the theme of the art of music based on representations of guitars. In a collage, the context is usually symbolic and not based on realism. Therefore, in creating this composition, the intention is aesthetic, and realistic details are not included.

2. The background is completed using different superimposed layers of acrylic paint. Yellow and black hues are blended for the background and contrasted for depicting the guitars. Fragments of scores are glued onto the composition to reinforce the symbolic nature of the painting.

3. Various musical score fragments are superimposed on the composition in such a way that the notes appear to be floating among the guitars. The papers have been tinted with yellow and green hues to achieve an overall chromatic relationship.

Step by Step

A Collage of a Modigliani Painting

Reproducing a famous painting serves a very practical purpose: to allow the student to discover the resources and tricks of each artist. This painting by the postimpressionist painter, Modigliani (*Lunia Cezechowska with Fan*, 1919, oil on canvas, 100 x 65 cm, Musée du Petit Palais, Paris) has a flat, geometric aspect. It is ideal for a collage, because the shapes in the painting are simple and can be easily formed by cutting shapes from paper.

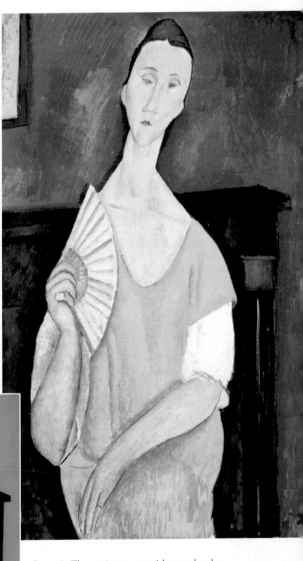

Step 1. The artist starts with a red color foundation paper onto which various papers will be added depending on the elements included in the image. On the upper left-hand side, black and cream colored papers are added to define this fragment of the painting. In the center, a large black cut-out represents the furniture appearing behind the figure.

Step 2. Painted paper is used to depict the woman's dress. The clothes are of an ocher hue and the shape of the arm is left unpainted so that it is clearly visible when new layers of paper are added.

Step 3. New pieces of cut paper that fit with the dress spaces are used to depict the face and neck. This paper was previously painted with flesh-colored gouache to give it the necessary texture.

Step 4. The fan combining white and sienna colors is now added. This shape fits with the dress fragments. To the right, an arm which has the same flesh color as the face is super-imposed onto the dress

Step 5. A dark brown hue is used to depict the hair in the upper area, and the arm that holding the fan is completed. On the arm, various pieces of white paper are over-lapped. These correspond to the sleeve and the skin.

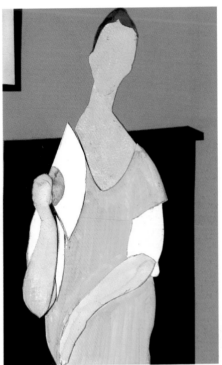

Step 6. Gouache paints are used on the dress and arms to create contrasts and depth. Dark glazes placed over the basic dress color depict the folds and the changes in plane. The arm's shape is rein-forced with a small amount of black to better represent its contours.

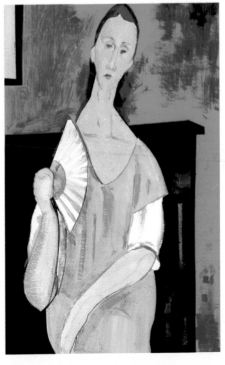

Step 7. The woman's neck, collarbone, and face, and the folds in the fan are all defined. The artist works in the same way as with a conventional painting, supplying the impression of relief and defining details. The only difference is that base is made up of superimposed layers of paper instead of layers of paint.

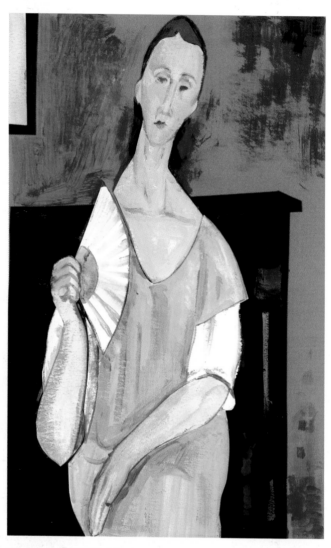

Step 8. The artist finishes creating skin volume by lightening some hues. This collage of the Modigliani image could be perfected by the following method: a drawing is made of the image which is then traced onto successive paper layers, representing the various fragment of the composition. These paper shapes are then used to make the collage.

SUMMARY

• Collage is a technique based on superimposing different images and materials to create textures and relief effects.

• As a mixed technique, the collage looks for an aesthetic result based on contrasting materials. The artist still applies the same rules of light, shade, and composition as in conventional paintings.

• Photographs from magazines are good sources of conceptual elements for the artistic aspirations of forming a collage.

• The roughness or transparency of papers used for collages varies, and the color effect will be different for each one.

• The purpose of the collage varies depending on whether the artist wants to achieve an abstract, aesthetic result, or a conceptual impression that includes a specific meaning.

• Brushed finishes are good for giving a painting the final touches even to the point where maximum detail is included on the already established paper base.

• There are two ways in a collage to combine paper and paint. In some, the paper's texture stands out, while in others, the paint dominates as the basis for color, and paper is glued onto the painted areas to finish the composition.

DRY BRUSH TECHNIQUE

The dry brush technique relies on paints that are very different from soft and malleable acrylics. In order to achieve a dry paint effect, the artist works with very little water and rubs the brush against the paper. Then, when a wash is applied, the wetter areas spread out to produce fragmentations and cracks, which are characteristic of all dry techniques.

Mixed techniques are experimental and innovative in their treatment of different materials. With these combined techniques, various kinds of paint are mixed to produce special effects. Painting mediums that are opposites reject one another, creating interesting contrasts among the textures.

1. First the artist uses acrylic paints to create a loose and spontaneous outline with quick brushstrokes in which impasto and color contrasts are dominant. The outline is based on sienna and other earth hues which are very intense colors that can be toned down with water.

2. While the paint is damp, the drawing is washed under running water so that the colors blend and spread. The damp paint tends to mix with the water to create new transparent hues. The water pressure makes even the thickest areas spread, creating a flat effect.

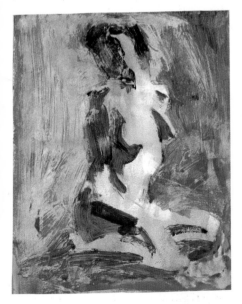

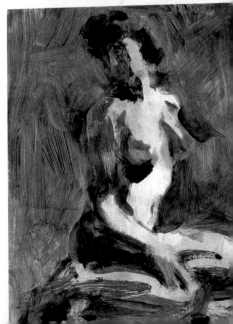

3. Now, contrasts and volume will be provided to the figure to reinforce the curved shapes. This technique allows blending and spreading of paint during the intermediate drying stage.

TEXTURED PAINT

To strengthen the texture and relief in a work of art, materials such as sand or even pebbles are frequently added, especially in abstract art. But in figura-tive compositions, the artist tends to rely on the thickness of materials to represent elements of great volume. Texturing the pigment before applying it reinforces these volumes.

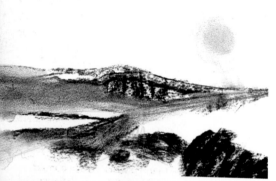

1. First a charcoal sketch of a landscape is drawn to reflect the principal volumes. Brushstrokes of a dark hue are then applied to the represent the mountains. The rest of the paper is left white.

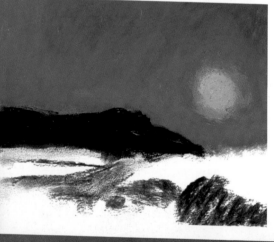

2. Now, the background, including the sky, the distant mountains, and the sun, are painted. Since the artist wants to create an atmospheric painting, fine sand is mixed with the paint to make the paint thicker in certain areas. In this way, the brushstrokes themselves form a shape.

3. The artist finishes adding details to the foreground, using textured pigment mixed with an amount of fine sand so that the texture is more evident. Depending on the thickness of the mixture, the artist will achieve more or less of a textured effect. By adding this foreground texture, the sky gains atmosphere, and the ground is provided with more volume

TRANSFERRING AN IMAGE TO PAPER

It is common in mixed techniques to transfer to a support photographic images that are then changed during the painting process. The artist can paint directly onto the image, as if it were an element of a collage. Also, the shapes and colors will adapt to the support onto which paint will be added. Therefore, it is necessary to use corrosive liquids, such as thinners.

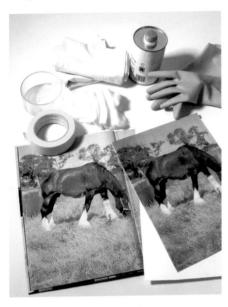

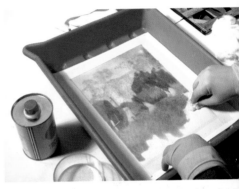

2. The paper that will be used as a support is placed in a tray and the photocopy is placed on top of it with the printed side in contact with the support. The artist wears latex or rubber gloves so that his or her hands don't come into contact with the strong, corrosive thinner. The artist uses cotton to apply the thinner to the reverse of the photocopy which loosens the copy colors and adheres them to the paper underneath.

1. First, the artist chooses the image on which to work, in this case, a photograph from a book of a horse. The artist makes a color photocopy of the photograph, allowing the image of the horse to be transferred onto a different foundation paper without losing the original motif.

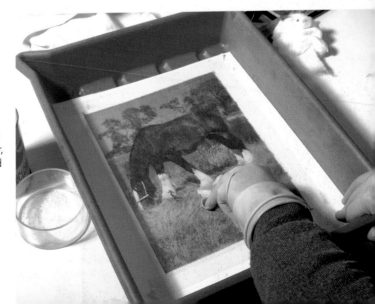

3. The artist now waits until the thinner has dried before separating the support paper, which will be used for the painting, from the photocopy. After being separated, the image of the horse will have transferred to the support paper.

FINISHING A PHOTOGRAPHIC TRANSFER WITH ACRYLICS

After a photographic image has been transferred onto the paper that will serve as a support, it can be completed with any painting medium. To retain the photographic color, the artist paints the support with transparent mixtures or glazes that will not excessively change the image. If, on the other hand, the artist wishes to make the work of art more personal by clearly controling materials, media such as acrylic paints can be used. Acrylics convert the piece into a pictorial work of art with almost no signs of the photograph copy.

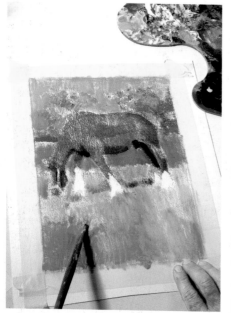

1. The transferred image already offers the necessary shapes and colors. Now, chromatic ranges and contrasts can be created. The artist begins with the grass, applying various green hues with vertical brushstrokes to depict its structure.

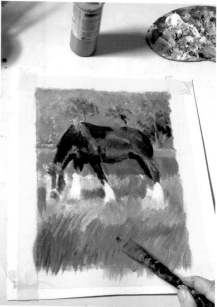

2. Contrast is created both on the horse and in the background. A natural shade is applied to the horse to intensify color and create the highlights characteristic of the horse's coat. Texture is added to the landscape in the foreground using brushstrokes which are more defined than in the background.

3. The artist finishes the painting by contrasting and defining all the elements. The brush is useful for tracing all the definitive shapes and for adding new hues. The copy of the photograph is a good reference for shapes and color, but it is the artist who manipulates it to create a unique work of art.